E A R T H

SPIRIT OF PLACE

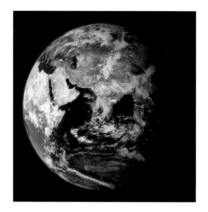

The Earth is a very small stage in a vast cosmic arena.
But to us, it's everything. The place where we live, love, work and play.
The place where we are born and where we die.
From space, Earth is big, blue and beautiful; fragile and inspiring.
It's the only planet we've ever been to,
the only home we've ever known.

Carl Sagan

W9-ATZ-519

MAGIC LIGHT PUBLISHING
OTTAWA

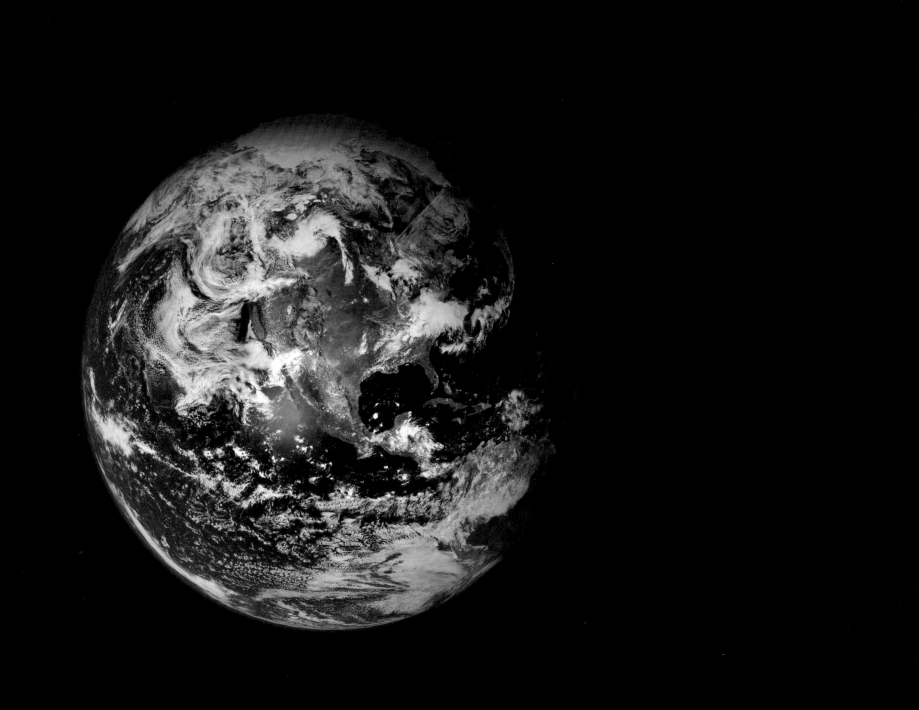

THE BLUE MARBLE

You look out the window and you're looking back across blackness of space a quarter of a million miles away, looking back at the most beautiful star in the heavens. You're not close enough to any other planets to see anything but a bright star, but you can look back on the Earth and see from pole to pole and across oceans and continents, and you can watch it turn and see there are no strings holding it up, and it's moving in a blackness that is almost beyond comprehension.

The Earth is surrounded by blackness though you're looking through sunlight. There is only light if the sunlight has something to shine on. When the sun shines through space, it's black. The light doesn't strike anything, so all you see is black.

What are you looking at? What are you looking through? You can call it the universe, but it's the infinity of space and the infinity of time.

Eugene Cernan, USA
Gemini 9, June 1966
Apollo 10, May 1969
Apollo 17, December 1972
(The Home Planet)

The Gateway to Astronaut Photography of Earth hosts the best and most complete online collection of astronaut photographs of the Earth. Beginning with the Mercury missions in the early 1960s, astronauts have taken photographs of the Earth.

Our database tracks the locations, supporting data, and digital images for these photographs. We process images coming down from the International Space Station on a daily basis and add them to the 1,657,098 views of the Earth already made accessible on our website.

These images include 1,176,409 from the International Space Station. These numbers were determined on April 15, 2013. There were 24,068,390 web hits and 15,066,949 database photo image downloads by February 2013.

To learn more about NASA's photography program, see Richard W. Underwood's 1988 article (page 12) on the origins of NASA imaging.

Our Moon, forever to be graced by the footprints of twelve brave men.

Chris Hadfield, Canada
Atlantis STS/74, November 1995
Endeavor, STS 100, April 2001
Soyuz ISS 34/35, December 2012

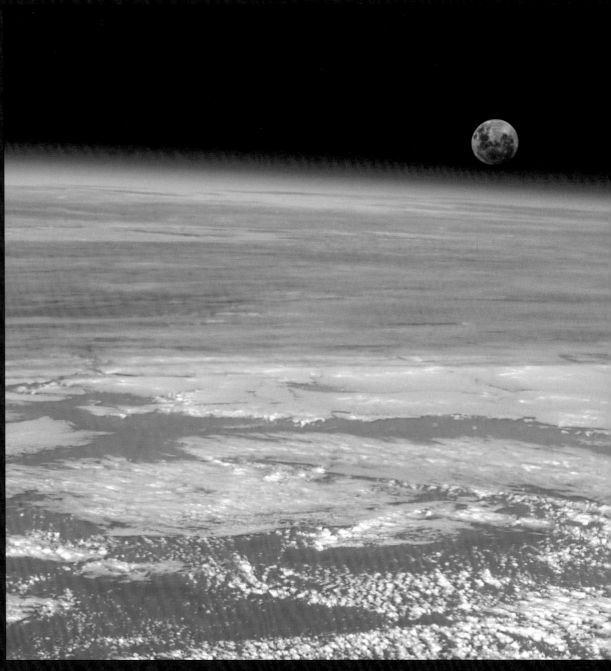

"Tonight's Finale: The full moon rises over the only planet we have ever called home."
Chris Hadfield photo, © Government of Canada/NASA (January 26, 2013 – iss034-e-035658)

Contents

Foreword.. 6

Introduction....................................... 8

Why Space Photography?.................... 12

The International Space Station........... 20

The Russian Space Agency................. 26

The European Space Agency............... 32

The Canadian Space Agency............... 34

Earth as Art....................................... 44

Forbidding Places.............................. 70

Swirls.. 88

River Deltas...................................... 102

Rain Forest.. 112

Mountains... 118

Volcanos... 128

Coral Reefs....................................... 152

Fire.. 158

Weather... 172

The Earth at Night 184

Suggested Reading............................ 192

E A R T H

S P I R I T O F P L A C E

Editor: John McQuarrie
Photography: National Aeronautics and Space Administration, (NASA)
Canadian Space Agency, (CSA)

Copyright 2013 NASA, CSA and the Government of Canada
NASA pictures were obtained from the Media Resources
Center, NASA Johnson Space Center. The use of NASA
pictures does not represent an endorsement of this
book by NASA.
CSA pictures are reproduced under license from the
Government of Canada. The use of CSA pictures does not
represent an endorsement of this book by the Government
of Canada.

Publisher: Magic Light Publishing
192 Bruyère Street
Ottawa, Ontario
Canada, K1N 5E1

TEL: (613) 241-1833 / FAX: (613)241-2085
e-mail: mcq@magma.ca
www.magiclightphoto.ca
Design: John McQuarrie
Printing: Friesens, Altona, Manitoba, Canada

Library and Archives Canada Cataloguing in Publication

McQuarrie, John, 1946-
Spirit of Place, EARTH / Edited by John McQuarrie.

ISBN 978-1-894673-67-9 (bound).--ISBN 978-1-894673-68-6 (pbk.)

1. Earth. 2. Earth, Photographs from space. 3. Outer space,
exploration. I. Title.

FC2161.M339 2013 971.8 C2013-900315-0

Front cover Western hemisphere. NASA, (globe_west_2048)
Title page: Eastern hemisphere. NASA, (globe_east_2048)
Previous Page: Blue Marble. NASA, (globe_west_2048)

*A Man sits alone with a book. The whole world around him grows silent. A voice so secret it can't be heard just felt,
is whispering to him and leading him deep into the world of the greatest wonder and power—his own imagination.*

Morley Callaghan
My Love for Miracles of the Imagination, **More than Words Can Say (1990)**

FOREWORD
GENERAL (RETIRED) WALTER NATYNCZYK

General Natynczyk served as Canada's Chief of Defence Staff from July 2, 2008 to October 29, 2012. Key events over his tenure were the combat mission in Afghanistan, the 2010 Winter Olympics, humanitarian support to Haiti and the NATO mission over Libya.

Nearly 70 years ago, the first photo of the Earth from space was taken by a camera attached to a V-2 missile. Over time, missiles were replaced by NASA's rockets, as space exploration came into its own with the *Gemini* and *Apollo* missions. That first grainy black and white impression of the Earth became the venerable "blue marble" of the 60's. And many decades later with the assembly of the International Space Station – with Canada serving a major role in its construction and maintenance – we've been able to look at our world in all its colour, detail and brilliance. It is with great pride and heartfelt gratitude that we see Canadian astronaut Chris Hadfield artfully capture the beauty of our planet and share these images as he shared his last space adventure with us all.

As you gaze upon his photos of Earth and the striking images of Canadian-built technology – Canadarm2 and Dextre – please consider for a moment the international cooperation and mutual confidence that enabled these images to be possible. As a retired soldier, it is reassuring to witness the spirit of genuine collaboration, and the exchange of technology to advance our understanding of our world and maintain the peace on it. Space exploration is the frontier of the 21st century—these photos stand as a visual testament to Canada's contributions and vital role in the next space age.

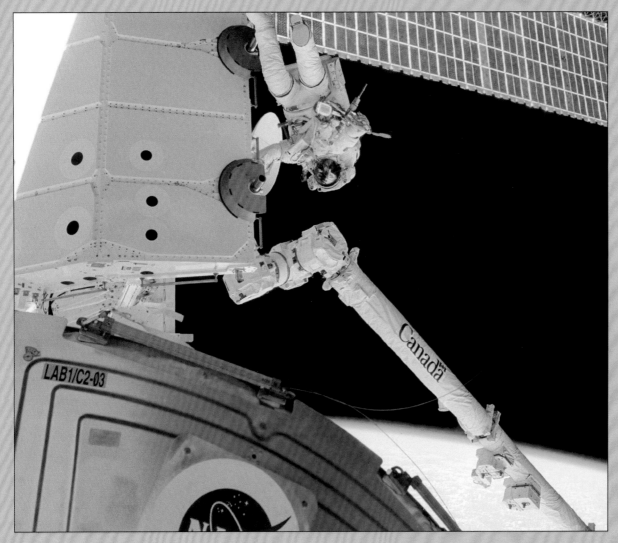

Astronaut Chris Hadfield is near Canadarm2 as the new robotic arm for the International Space Station grasps the Spacelab pallet on mission STS-100. Scott Parazynski photo, © Government of Canada/NASA (April 22, 2001 – STS-100-112)

"To think of how far we have come, as a country in space flight, to go from one little satellite, as a very early experimental thing, through to relay satellites where we could watch hockey from coast to coast… then our arm going on the shuttle, then Marc Garneau going on the shuttle. It almost looks like it was all beautifully planned and laid out but it has really just been building on the success of the past, recognizing that in amongst everything else that is going on, this is something Canada ought to be involved in."

Chris Hadfield, Canada
Atlantis STS/74, November 1995
Endeavor, STS 100, April 2001
Soyuz ISS 34/35, December 2012

INTRODUCTION
JOHN MCQUARRIE

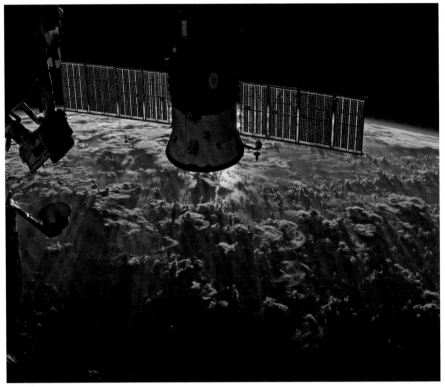

Soyuz spacecraft attached to the ISS is highlighted by the sunglint of a mass of storm clouds over the Atlantic Ocean near Brazil and the Equator. One of Chris Hadfield's tweets from December could also apply to this photograph:
"This brave little ship carried us from Earth to orbit, now safely nestled into Station. Ready when we need her to fly." NASA (July 4, 2013 – 9218629876)

Hadfield brought the space station and the space experience to a large number of people by sharing not only his pictures and his comments on Twitter, but also by sharing his emotions and that's something that people really want to hear about.

Marc Garneau, Canada
Challenger 6, November 1998
Canada's first astronaut, who later led the Canadian Space Agency and is now a Member of Parliament.

Like millions of you, I have taken great delight in following Chris Hadfield since his *Soyuz* launch in 2012. It is now a great privilege to produce and publish this book celebrating a selection of over 100 of Chris's beautiful and evocative photographs captured during his five months on the International Space Station (ISS). Complementing his images, you will also find a number of NASA satellite shots captured by various orbital platforms over the last few years.

The story of his childhood inspiration is a compelling one, beautifully told by Rebecca Tromsness of the Toronto *Globe and Mail*.

Canadian Chris Hadfield's career in space launched the day Neil Armstrong set foot on the moon
Rebecca Tromsness, Toronto *Globe and Mail*, August 26, 2012

Glued to a neighbour's cottage television, a nine-year-old Canadian dreamed of space and eventually made it there.

Canadian astronaut Chris Hadfield reflects on Neil Armstrong's moon landing, his death and the future of space exploration.

"It was a watershed moment in my life, although at the time, I didn't know it was going to be. There had been a build-up to it, of course, with the space race. Because I was about to turn 10, I was aware of that as the first big news item that I knew about as a young Canadian growing up.

We were at my parents' cottage near Sarnia, Ontario, on an island in the St. Clair River. We didn't have a television, so we went over to our neighbour's place and everybody was in their living room—there were probably 25 people. My brother and I were sitting up on the back of the sofa with our backs against the wall. And at the time, you knew it was a big event, this was a major event in human history—even as a nine-year-old kid.

I remember afterward walking outside and looking up, and seeing the moon and thinking that we had managed to figure out a way to go there. That people had organized and somehow schemed and planned and plotted and invented and taken the very edge of what they knew and gotten to that place for the first time in human history. I just found it absolutely inspiring; fundamentally inspiring. And I resolved that night, July 20, 1969, to be an astronaut when I grew up—you know, me and ten million other people. That looks like something really interesting to do with your life. And so, absolutely, Mike [Collins] and Buzz [Aldrin] and especially, of course, just because of the symbolism of it, Neil, inspired me to the life that I've followed ever since.

A note on the photos and captions that grace the book you now hold in your hands: the captions for Chris's photos include his "tweets", identified by quotation marks. The dates reflect the days the photos were taken, rather than the date they were tweeted, and all are in Greenwich Mean Time (GMT). London Time is the same as Greenwich Mean Time less than half of the year. During Summer Time (Daylight Saving Time), London Time is GMT+1, also known as British Summer Time (BST). See wwp.greenwichmeantime.com

Another interesting addition to the captions is a "Location" for many photos that were not located by NASA. This data was provided by Dave MacLean, who just happens to teach a computer mapping course at a community college in Nova Scotia, and Peter Caltner, an Austrian translator. They share an ability and enthusiasm for such sleuthing. Techniques they use include: recognizing geologic and/or topographic features; using photo time and ISS location, and; the online NASA database of ISS images to then fine-tune the location of each image. Some photographs need a portion of each technique; some just need luck. In every case, it's fun to find identifiable features on the ground that match the images.

To view Dave's ISS photo locator go to: www.bit.ly/ISSImagesMapped
Their twitter handles are @pc0101 and @DaveAtCOGS"

Camera equipment aboard the ISS: Currently, astronauts use Nikon D3S cameras with Nikor lenses exclusively, including; 12–24mm f4, 14–24 mm f2.8, 17–35 f2.8, 50 mm f1.4, 180 mm f2.8, and 400 mm f2.8. The last two lenses are the most popular and account for the majority of their images.

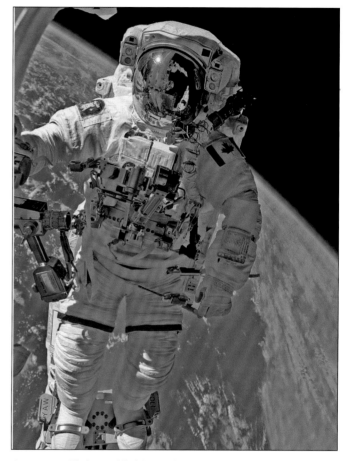

Astronaut Chris Hadfield stands on the portable foot restraint connected to Canadarm on Space Shuttle *Endeavor* during one of two spacewalks (also known as EVAs or extravehicular activities) of mission STS-100.

NASA (April 2001, STS-100-115)

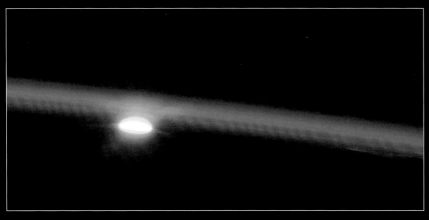

Sunrise Over the South Atlantic Ocean. NASA
(May 5, 2013, 747551main_8720453707_c7ffc1c)

"The Earth smiles broadly as the Sun rises."
Chris Hadfield photo, © Government of Canada/NASA
(January 16, 2013 – iss034-e-030503)

The sun truly "comes up like thunder," and it sets just as fast. Each sunrise and sunset lasts only a few seconds. But in that time, you see at least eight different bands of color come and go, from a brilliant red to the brightest and deepest blue. And you see sixteen sunrises and sixteen sunsets every day you're in space. No sunrise or sunset is ever the same.

Joseph Allen, USA
Columbia 5, November 1982
Discovery 2, November 1984
(The Home Planet)

Our moments of inspiration are not lost though we have no particular poem to show for them; for those experiences have left an indelible impression, and we are ever and anon reminded of them.

Henry David Thoreau

WHY SPACE PHOTOGRAPHY?

RICHARD W. UNDERWOOD

The design for the Mercury spacecraft had no windows. They would put a human being inside a container not much bigger than an oil drum and shoot him into space. Critics said he had to have a window or he would go crazy. The other side said that a window would be very detrimental to the integrity of the spacecraft from a structural point of view. The window folks won.

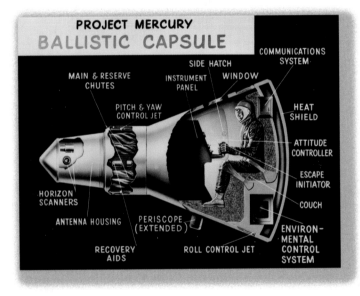

Early diagram (c. 1960) showing the basics of the Mercury capsule.
NASA (326898main_EL-2002-00341)

It's been a long way, but we're here.

Alan B. Shepard, Jr., USA
Mercury 3, May 1961
Apollo 14, January 1971
(The Home Planet)

Here was the first chance to put a camera on a manned spacecraft. The opponents said that cameras are big and the spacecraft had no room. They weigh a lot, and the engineers were worried about fractions of an ounce. Cameras contain glass and that could be very bad news to astronauts. All the different components would "outgas" and make them very ill, or even kill them. "Cameras are out."

The astronauts saved us. They wanted to have a photo record of the journey and not just a memory recall. The astronauts, thank God, prevailed. Cameras went into space. Astronauts would take tens of thousands of photos of their home planet. I have seen them all.

Before space photography, a traveler walking or driving across the Earth or even in an airplane was like a fly walking across the Mona Lisa at the Louvre in Paris. It would be difficult to appreciate the beauty and the genius of da Vinci that way. You have to back off ten feet to appreciate the masterpiece. The same is true in space. You have to back off a hundred or more miles to see what a masterpiece our home planet is. Thus, we would ask astronauts to take plenty of photographs.

At first, we looked at clouds and the geology of the synoptic view permitted from space. Then we quickly realized that we could see nearly every imaginable geoscientific phenomenon. Thus, a formal photographic plan would develop for each mission and its unique features. The launch time, the orbit inclination, the season, the altitude, and so forth, would all dictate where and when and why we would take the photos.

Geologists could use the photos to see the details of their science in large areas and over a short period of time, and to learn about the Earth and its dynamics.

The meteorologist could use them to see the development of weather and its movement. Imagine having the ability to track a hurricane from its start to its end.

The oceanographer could see the state of the ocean surface over vast areas, the ocean currents from a new vantage point, the sources and movement of nutrients to feed fish that feed people.

The environmentalist could see the sources and distribution of air and water pollutants and the destruction caused by them. From the smokestack and pipe to acid rain, we can see it all in space photography. Unfortunately, it is a far more air-polluted Earth today than it was even in the recent past, and so the photographs taken by the space shuttle astronauts are not as clear as those taken by Gemini astronauts over twenty years ago.

We knew that, with infrared films, agricultural scientists could use the photos to tell you what grows on the planet and where; how healthy it is; if ill, whether it is a bug or a disease; the date of maturity; the yield rate per area; and even when to irrigate it. They could detect overgrazing, imprudent land use practices, and even illegal activities.

Others who could use it would be the urban planner, the water resource planner, the forester, and many, many more. One can see from some of the photos how, in Africa, over the years, the great Sahara is expanding ten, twenty, even fifty miles a year in some areas, and that the expansion is a threat to the entire population of Africa. But none of the "experts" wanted to look at those photos.

We would even ask astronauts to photograph views that "just look pretty or different or something you just don't understand." Many are contained herein. Our home planet, from space, can be very beautiful. Occasionally it can be quite ugly as well.

You may wonder why the photos do not represent a comprehensive coverage of the Earth. The Earth is very large, about 197 million square miles. If one space photo covered 10,000 square miles of the Earth's surface, it would take 19,700 of them to cover the Earth with no overlap. Most spacecraft take off nearly straight east from their launch sites, to take full advantage of the Earth's rotation for a boost. That means that US spacecraft, for instance, can only go about 28° north and 28° south, thus covering but a narrow band of the Earth's surface. A number of US missions have been launched with a 50° inclination. That way, you see as far north as the southern border of Canada and as far south as Patagonia in Argentina. Almost all Soviet spacecraft are launched at 51.6°. A few spacecraft can go to about a 58° inclination—as far north as parts of Alaska or southern Norway and as far south as Cape Horn. To cover the entire Earth, one would have to launch straight south into a polar orbit. When that becomes possible, we will be able to see photos of the Arctic and Antarctic areas; and, uniquely, it will always be the same Earth time (am or pm) beneath the spacecraft.

The best is yet to come.

Publisher's note: Interesting to think that this article was written a quarter of a century ago and a lot has happened in the intervening decades. With Richard Underwood's last sentence in mind, read the following article (overleaf) written by William Stefanov in 2005. Underwood's closing sentence above is particularly poignant in this regard. He was right.

This article originally appeared in *The Home Planet*, Addison-Wesley Publishing Company (1988). The book was conceived and edited by Kevin W. Kelley for the Association of Space Explorers. (See jacket flaps)

It's a very sobering feeling to be up in space and realize that one's safety factor was determined by the lowest bidder on a government contract.

Alan B. Shepard, Jr., USA
(The Home Planet)

Astronaut and Satellite Photography from Space

Astronauts on board the International Space Station (ISS) have many tasks, but a consistent favorite is taking photographs of Earth. The ISS astronauts don't just take digital images randomly. The photos they shoot are part of a well-defined program of data collection coordinated through the Crew Earth Observations team at Johnson Space Center. Current research targets include glaciers, deltas, urban areas, coral reefs, megafans (inland deltas), and long-term ecological monitoring sites. Dynamic events such as hurricanes, dust storms, volcanic eruptions, and fires are also imaged when possible. The database of astronaut photography is freely accessible via the Internet (and has made this book possible).

The Crew Earth Observations team selects science targets and uploads them to the ISS crew daily based on the current orbital position of the ISS, local sun angle, predicted local weather conditions, and the task schedule. Satellites, such as Landsat and Terra, that are in polar (pole-to-pole) orbits pass over the same location on the globe at approximately the same time every day. The inclined (angled), equatorial orbit of the ISS and having a "human in the loop" to point the camera allow for a wide variety of local sun angles and ground resolutions (levels of detail) for science targets. These unique characteristics of astronaut photography provide a dataset that includes both scientific and aesthetic, or artistic, value.

William Stefanov, NASA

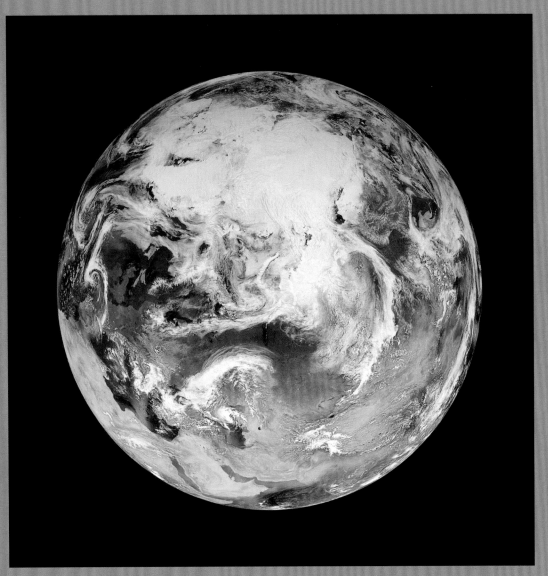

Blue Marble from the Top - June 22, 2012
There have been many images of the full disc of Earth from space but few have looked quite like this. Using natural-color images from the recently launched Suomi-NPP satellite, a NASA scientist has compiled a new view showing the Arctic and high latitudes, made possible by the ever ellusive, pole-to-pole orbit. Ocean scientist Norman Kuring of NASA's Goddard Space Flight Center pieced together this composite image of Europe, Asia, North Africa, and the entire Arctic.
NASA, (arctic_vir_2012147)

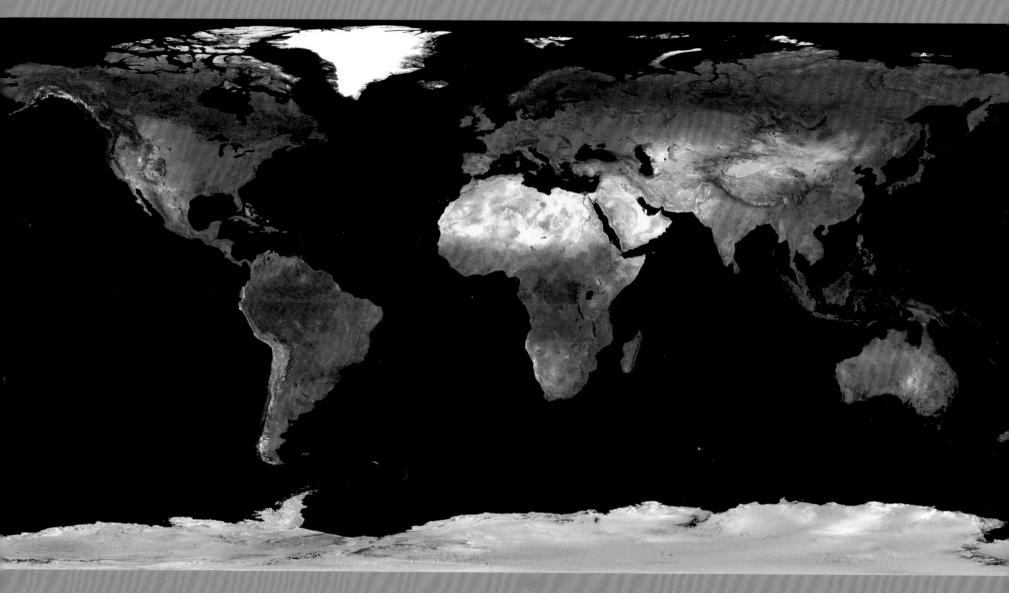

This spectacular image is one of the most detailed true-color images of the entire Earth to date. Using a collection of satellite-based observations, scientists and visualizers stitched together months of observations of the land surface, oceans, sea ice, and clouds into a seamless, true-color mosaic of every square kilometer (.386 square mile) of our planet. These images are freely available to educators, scientists, museums, and the public. NASA, (land_shallow_topo_8192)

The signs of life are subtle but unmistakable: sprawling urban concentrations circular irrigation patterns, the wakes of ships, bright city lights at night, and burning oil fields.

Marc Garneau, Canada
Challenger 6, November 1998
(The Home Planet)

15

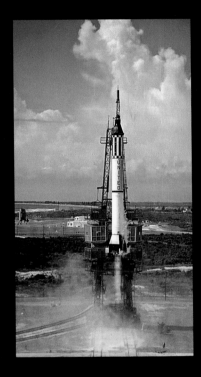

Freedom 7

On May 5, 1961, only 23 days after Yuri Gagarin of the then Soviet Union became the first person in space, NASA astronaut Alan Shepard launched at 9:34 am aboard his Freedom 7 capsule, to become the first American in space. His historic flight lasted 15 minutes, 28 seconds.

NASA

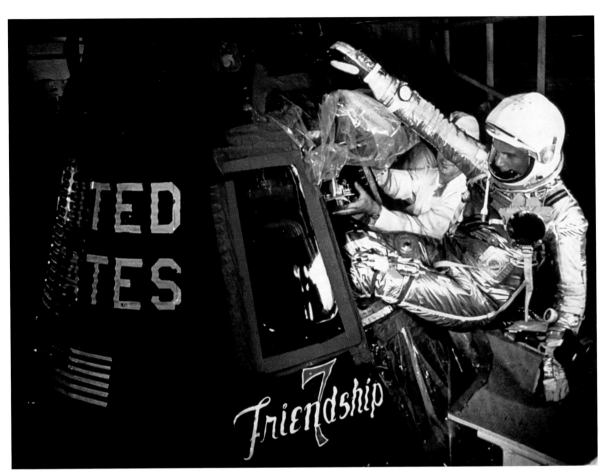

John Glenn enters his *Friendship 7* capsule at Cape Canaveral. NASA (February 20, 1962 – 314095)

Friendship 7

On February 20, 1962 at 9:47 am EST, John Glenn launched from Cape Canaveral's Launch Complex 14 to become the second American in space and the first to orbit the Earth. In this image, Glenn enters his *Friendship 7* capsule with assistance from technicians to begin his historic flight.

It is intriguing to reflect that the impetus for the space program in the United States was the unexpected launch of Yuri Gagarin of the USSR in April of 1961, at the height of the cold war. Who, in the early 1960s, could have predicted that Russians and Americans, alongside a number of international partners, would work and live together on our truly International Space Station?

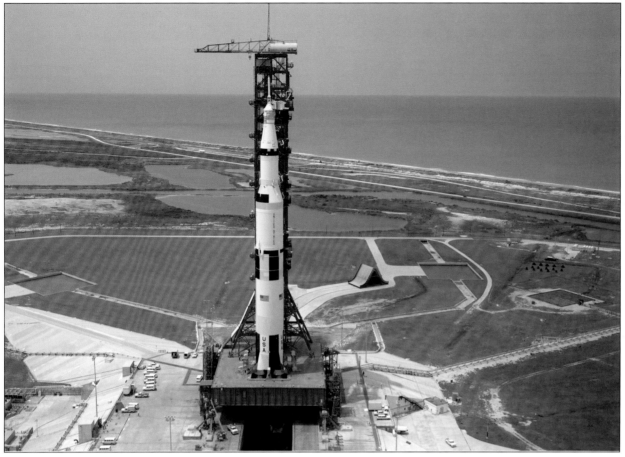

An aerial view of Pad A, Launch Complex 39, Kennedy Space Center, showing the 363 ft tall *Apollo 15* (Spacecraft 112/Lunar Module 10/Saturn 510) space vehicle sitting on the pad. NASA (S71-40365)

Apollo 8

Apollo 8, the first manned mission to the moon, entered lunar orbit on Christmas Eve, December 24, 1968. That evening, the astronauts – Commander Frank Borman, Command Module Pilot Jim Lovell, and Lunar Module Pilot William Anders – held a live broadcast from lunar orbit, in which they showed pictures of the Earth and moon as seen from their spacecraft. Said Lovell, "The vast loneliness is awe-inspiring and it makes you realize just what you have back there on Earth." They ended the broadcast with the crew taking turns reading from the Book of Genesis.

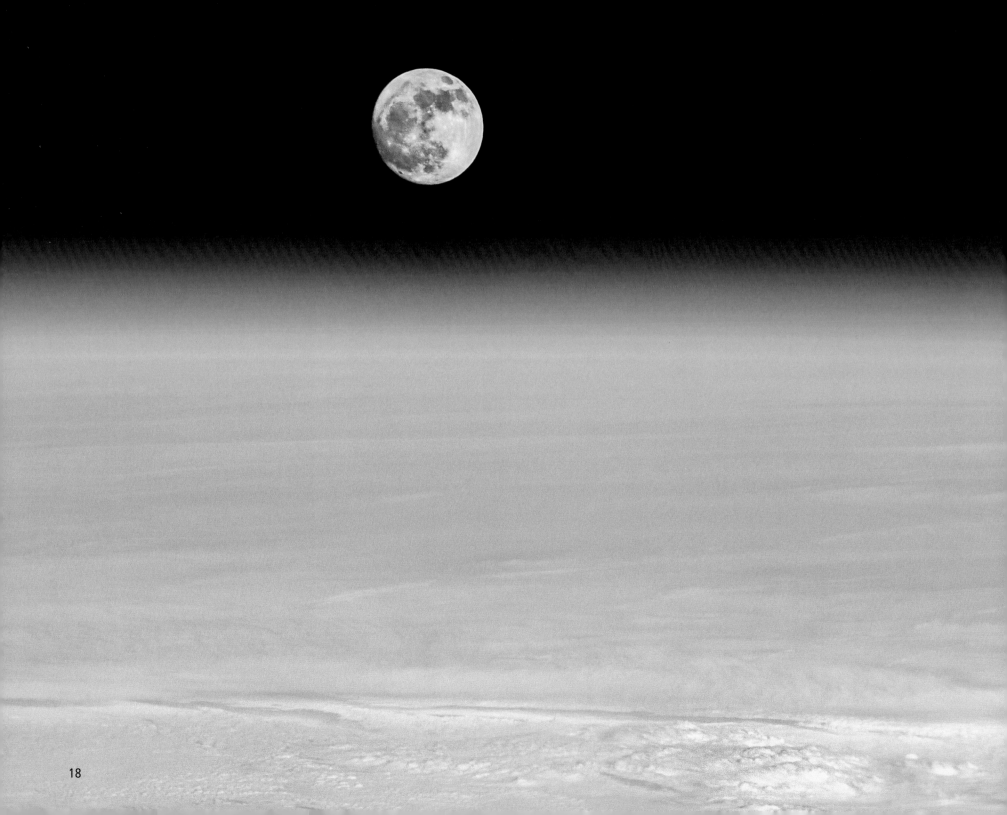

One person and one small step can be much more than just that.

Neil Armstrong, USA
Gemini 8, 1966
Apollo 11, July 1969

"Tonight's Finale: Our Moon, forever to be graced by the footprints of twelve brave men."
Chris Hadfield photo, © Government of Canada/NASA (January 26, 2013 – iss034-e-054858)

Apollo 11

This now legendary view of Earth rising over the moon's horizon was taken from the Apollo spacecraft. The lunar terrain pictured is in the area of Smyth's Sea on the near side. While astronaut Neil A. Armstrong, commander, and Edwin E. Aldrin, Jr., lunar module pilot, descended in the Lunar Module *Eagle* to explore the Sea of Tranquility region of the moon, astronaut Michael Collins remained with the Command and Service Modules *Columbia* in lunar orbit. And, as he is fond of saying; "*250,000 miles and I had to stay in the car.*"

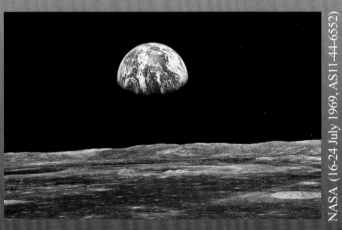

NASA (16-24 July 1969, AS11-44-6552)

Suddenly from behind the rim of the moon, in long, slow-motion moments of immense majesty, there emerges a sparkling blue and white jewel, a light, delicate sky-blue sphere laced with slowly swirling veils of white, rising gradually like a small pearl in a thick sea of black mystery. It takes more than a moment to fully realize this is Earth . . . home.

Edgar Mitchell, USA
Apollo 14, January, 1971
(The Home Planet)

19

We orbit and float in our space gondola and watch the oceans and islands and green hills of the continents pass by at five miles per second. We move silently and effortlessly past the ground. I want to say "over the ground" as I write this, but remember that in space your sense of up or down is completely gone and my description must reflect this fact. In addition, the breathtaking speed of the ship is in odd and confusing contrast to the feeling of perpetually floating within the spaceship. You do not sit before the window to view the passing scene, but rather you float there and look out on the scene, certainly not down upon it. Are you speeding past oceans and continents, or are you just hovering and watching them move beside you?

Virgil "Gus" Grissom, USA
Mercury 4, July 1961
Gemi 3, March 1965
(The Home Planet)

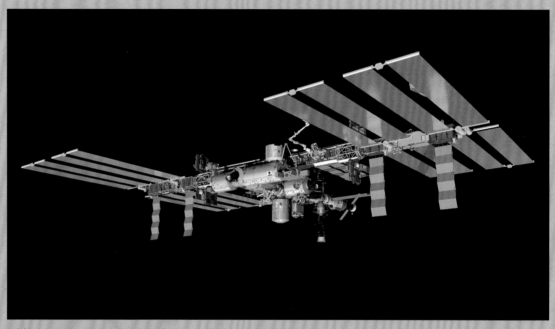

This computer-generated artist's rendering of the International Space Station reflects its external appearance as of May 13, 2013. *Soyuz* 33 (TMA-07M) undocks from *Rassvet*. *Soyuz* 34 (TMA-08M) is docked to *Poisk*. *Progress* 50 is docked to *Pirs*. *Progress* 51 docks to *Zvezda* aft.

NASA (JSC2013-E-023955)

The station's first resident crew, Expedition 1, marked the beginning of a permanent international human presence in space, arriving at the station in a Russian *Soyuz* capsule in November 2000. For more than a decade, station crews have provided a continuous human presence in space, with crews averaging six months at a time through the current 36th expedition.

The space station also is a vital precursor for future human exploration, where humans are learning how to combat the psychological and physiological effects of being in space for long periods, conducting both fundamental and applied research, testing technologies and decision-making processes.

The Florida tourism organizations must have got word they were on the astronauts' shoot list this day
and made special arrangements with the weather people to part the clouds for the occasion.
"Cuba, the Bahamas, Florida, the Universe." Chris Hadfield photo, © Government of Canada/NASA (March 27, 2013 – iss034-e-012160)

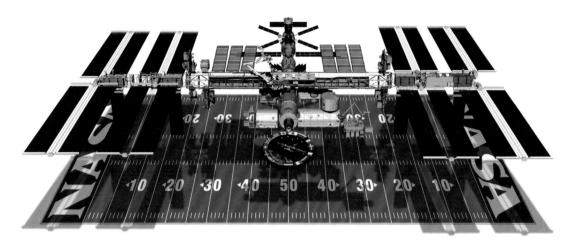

This diagram really puts the Station's size in perspective. NASA (jsc2012e219094)

The International Space Station is an unprecedented achievement in global human endeavors to conceive, plan, build, operate and use a research platform in space.

Almost as soon as the space station was habitable, researchers began using it to study the impact of microgravity and other space effects on several aspects of our daily lives. With almost 1,500 experiments completed on the station to date, the unique scientific platform continues to enable researchers from all over the world to put their talents to work on innovative experiments that could not be performed anywhere else. The space station represents the culmination of more than two decades of dedicated effort by a multinational team of agencies spanning Canada, Europe, Japan, Russia and the United States. While the various space agency partners may emphasize different aspects of research to achieve their goals in the use of the space station, they are unified in using the space station to its full potential as a research platform for the betterment of humanity.

The space station provides the first laboratory complex where gravity, a fundamental force on Earth, is virtually eliminated for extended periods. This ability to control the variable of gravity in experiments opens up unimaginable research possibilities. As a research outpost, the station is a test bed for future technologies and a laboratory for new, advanced industrial materials, communications technology, medical research, and more.

In the areas of human health, telemedicine, education and observations from space, the station has already provided numerous benefits to human life on Earth. Vaccine development research, station-generated images that assist with disaster relief and farming, and education programs that inspire future scientists, engineers and space explorers are just some examples of research benefits that are strengthening economies and enhancing the quality of life on Earth.

Clearly visible by the naked eye in the night sky, the expansive International Space Station is a working laboratory orbiting 386 kilometers (240 miles) above the Earth traveling at 28,000 kilometers per hour (17,500 miles per hour) and is home to an international crew.

On the most complex scientific and technological endeavor ever undertaken, the five supporting agencies represent 15 nations: the USA, Canada, Japan, Russia, Belgium, Denmark, France, Germany, Italy, the Netherlands, Norway, Spain, Sweden, Switzerland, and the United Kingdom.

In-orbit assembly began in November 1998 with the launch of its first module, *Zarya*, and was completed with the departure of the Space Shuttle *Atlantis* on the program's final flight in June 2011. The station is as large as a five-bedroom home with two bathrooms, a gymnasium and a 360° bay window, and provides crew members with more than 33,000 cubic feet (935 cubic meters) of habitable volume.

The station weighs 860,000 lbs (390,600 kg) and measures 361 feet (110 meters) end to end, which is equivalent to a U.S. football field, including the end zones. The station's solar panels exceed the wingspan of a Boeing 777 jetliner and harness enough energy from the sun to provide electrical power to all station components and scientific experiments.

Flying hundreds of kilometers above the Earth, the International Space Station and other orbiting satellites provide a unique perspective on our planet.

I set out into the unknown and nobody on Earth could tell me what I would encounter. There were no textbooks. This is the first time ever. But I knew for certain that it had to be done. It was clear that I had to be very careful. Take it easy, take it easy, I told myself, do not move too quickly.

Aleksei Leonov, Russia
Voskhod 2, March 1965
Soyuz 19-Epas, July 1975
(The Home Planet)

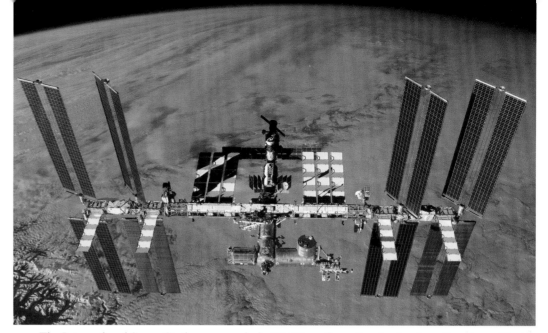

The International Space Station as seen in its ULF3 configuration by the departing Space Shuttle *Atlantis*, following the departure of STS-129. NASA (November 29, 2009 – ISS_ULF3_STS-129)

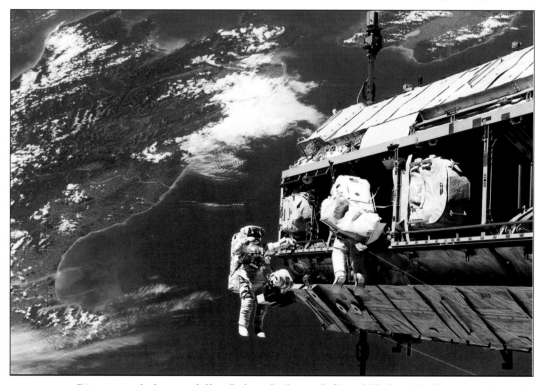

Discovery mission specialists Robert Curbeam (left) and Christer Fuglesang work on ISS construction during a spacewalk in 2006. NASA (cb1341247758)

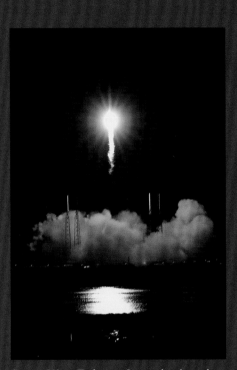

SpaceX's *Falcon* 9 rocket's nine engines ignite during launch from Cape Canaveral Air Force Station, May 22, 2012. NASA

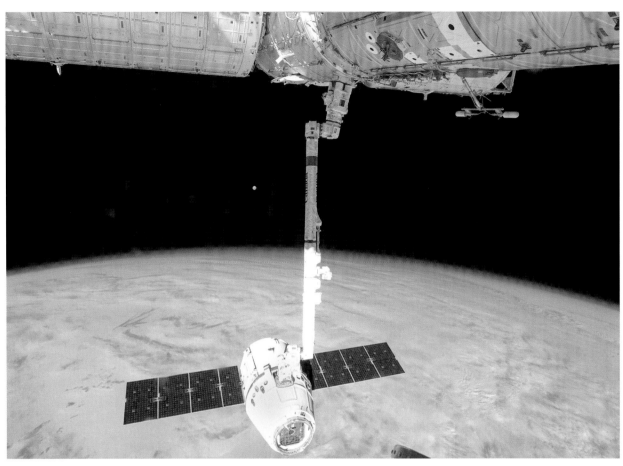

View from the International Space Station of the SpaceX *Dragon* spacecraft as the station's robotic arm moves *Dragon* into place for attachment to the station. NASA (March 26, 2013 – iss035-e-008930)

SpaceX *Falcon* and *Dragon*

Dragon is a free-flying, reusable spacecraft developed by SpaceX under NASA's Commercial Orbital Transportation Services (COTS) program. Initiated internally by SpaceX in 2005, the *Dragon* spacecraft is made up of a pressurized capsule and unpressurized trunk used for Earth to Low Earth Orbit (LEO) transport of pressurized cargo, unpressurized cargo, and/or crew members.

In May 2012, SpaceX made history when its *Dragon* spacecraft became the first commercial vehicle in history to successfully attach to the International Space Station. Previously only four governments—the United States, Russia, Japan and the European Space Agency—had achieved this challenging technical feat. SpaceX has now begun regular missions to the Space Station, completing its first official resupply mission in October 2012, 50 years after John Glenn became the first American to orbit the Earth.

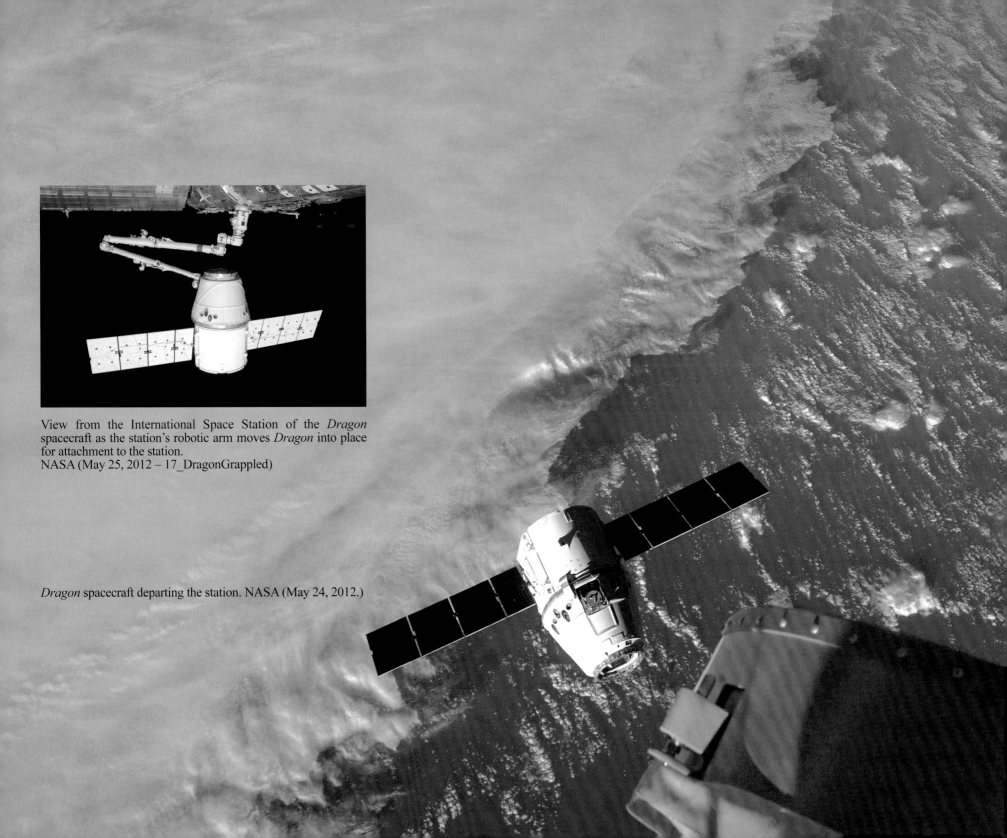

View from the International Space Station of the *Dragon* spacecraft as the station's robotic arm moves *Dragon* into place for attachment to the station.
NASA (May 25, 2012 – 17_DragonGrappled)

Dragon spacecraft departing the station. NASA (May 24, 2012.)

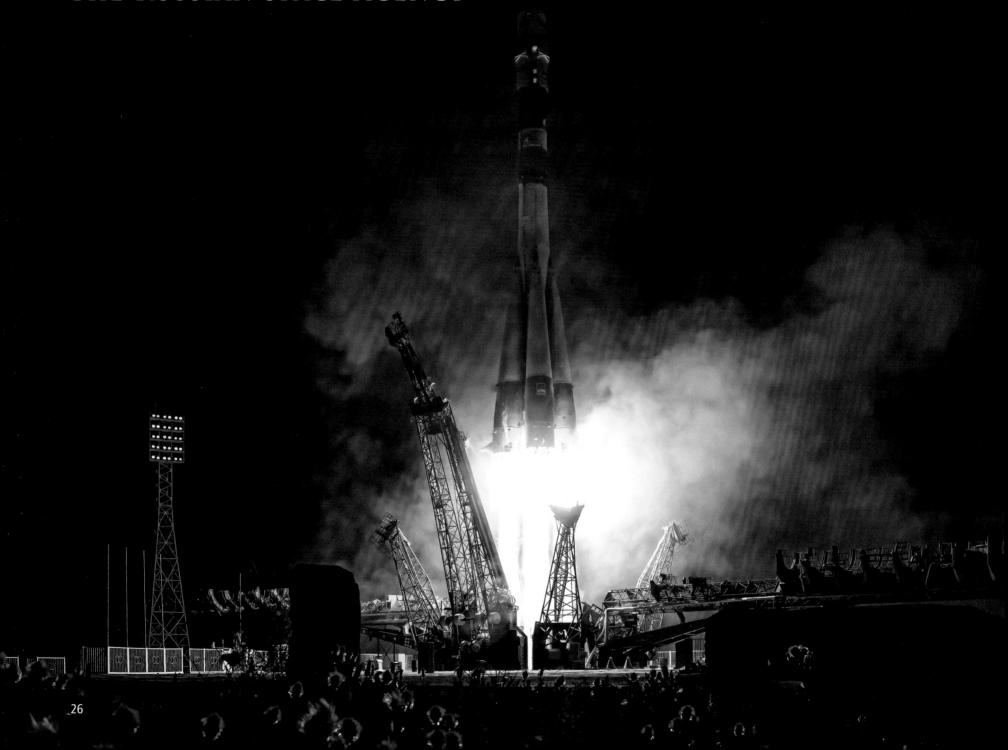

The Soviet space program did not have central executive agencies in the beginning. Instead, its organizational architecture was multi-centered; it was the design bureaus and the council of designers that had the most say, not the political leadership. The creation of a central agency after the separation of Russia from the Soviet Union was therefore a new development. The Russian Space Agency was formed on February 25, 1992, by a decree of President Yeltsin. Yuri Koptev, who had previously worked designing Mars landers at NPO Lavochkin, became the agency's first director.

The 1990s saw serious financial problems because of decreased cash flow, which encouraged the agency to improvise and seek other ways to keep space programs running. This resulted in it taking a leading role in commercial satellite launches and space tourism. While scientific missions, such as interplanetary probes or astronomy missions during these years played a very small role, they managed to operate the space station *Mir* well past its planned lifespan, contribute to the International Space Station, and continue to fly additional *Soyuz* and *Progress* missions.

The Russian economy boomed throughout 2005 from high prices for exports such as oil and gas, and the outlook for future funding in 2006 appeared more favorable. This resulted in the Russian Duma approving a budget of 305 billion rubles (about 11 billion USD) for the the Space Agency from 2006 to 2015. The budget for 2006 was as high as 25 billion rubles (about 900 million USD), which is a 33% increase from the 2005 budget. It was at this time that a 10-year budget was approved, giving the Space Agency increases of 5–10% per year, virtually guaranteeing a constant influx of money. In addition to its budget, the agency planned to have over 130 billion rubles flowing into its coffers by other means, such as industry investments and commercial space launches.

A *Soyuz* rocket with ISS Expedition 36/37 *Soyuz* Commander Fyodor Yurchikhin of the Russian Federal Space Agency (Roscosmos) and Flight Engineers Luca Parmitano of the European Space Agency and Karen Nyberg of NASA, onboard launches from the Baikonur Cosmodrome in Kazakhstan.
NASA/Bill Ingalls, (May 29, 2013 – 2013090003hq)

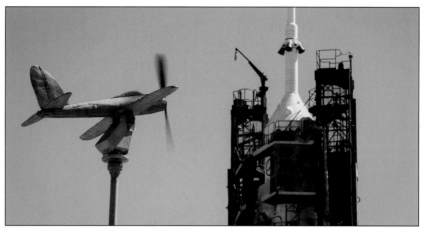

An aircraft-shaped wind vane, crafted in the style of a series of Second World War era Yak fighter aircraft, keeps vigil on the launch pad of the Baikonur Cosmodrome in Kazakhstan. NASA/Bill Ingalls, (May 29, 2013 – 2013090003hq)

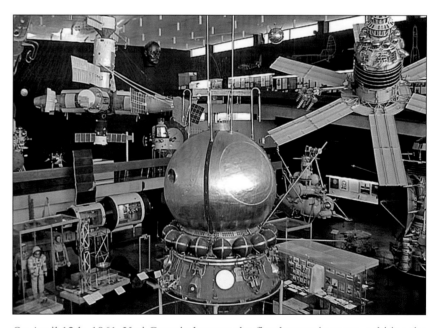

On April 12th, 1961, Yuri Gagarin became the first human in space, orbiting the planet once in a 108-minute flight aboard the Vostok 1 capsule, shown here in the Hall of Rocket Machinery at Tsiolkovsky State Museum of the History of Cosmonautics in Kaluga.

Vladimir Birukov, Russian Wikipedia project

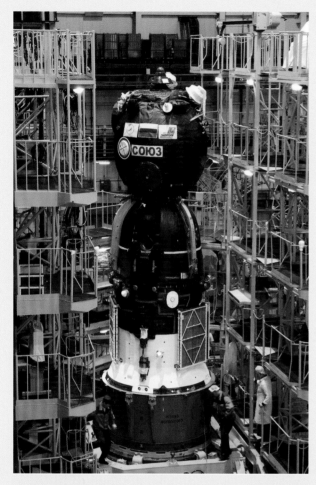

At the Integration Facility at the Baikonur Cosmodrome in Kazakhstan, the *Soyuz TMA-08M* spacecraft stands ready to be moved into place for its encapsulation into the third stage of a *Soyuz* booster rocket.
NASA/Victor Zelentsov (JSC2013-E-018015)

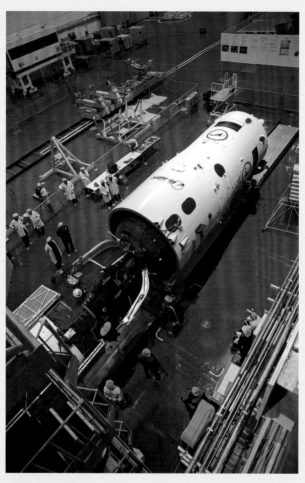

The *Soyuz TMA-08M* spacecraft is encapsulated into the third stage of a *Soyuz* booster rocket.
NASA/Victor Zelentsov (JSC2013-E-018019)

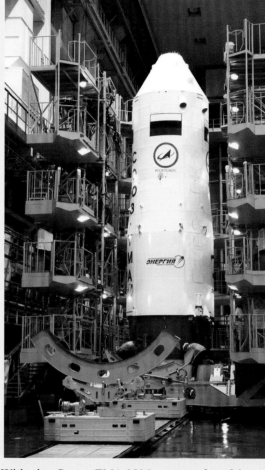

With the *Soyuz TMA-08M* spacecraft safely nestled inside, the upper stage of a *Soyuz* booster rocket stands at the ready.
NASA/Victor Zelentsov (JSC2023e018021)

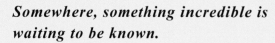

Somewhere, something incredible is waiting to be known.

Carl Sagan
American astronomer,
astrophysicist and author

Soyuz **Rocket and Spacecraft**

A *Soyuz* space capsule took the first crew to the International Space Station in November 2000. Since that time, at least one *Soyuz* has always been at the Station, generally to serve as a lifeboat should the crew have to return to Earth unexpectedly. After the *Columbia* accident in February 2003, the *Soyuz TMA* became the means of transportation for crew members going to or returning from the orbiting laboratory.

Large gantry mechanisms on either side of the *Soyuz TMA-08M* spacecraft are raised into position to secure the rocket at the launch pad.
NASA/Carla Cioffi (201303260025hq)

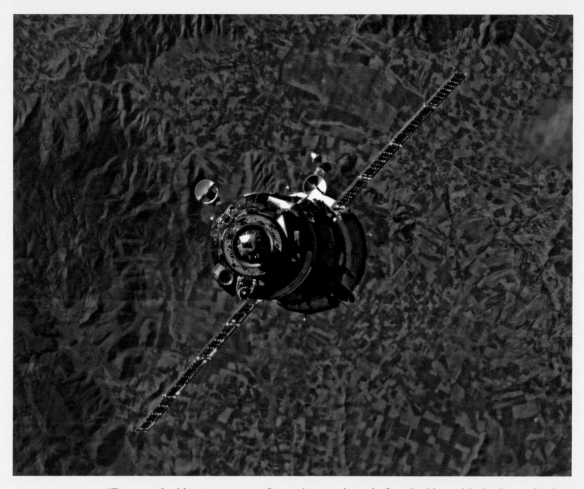

"Festooned with antennae, our *Soyuz*, just a minute before docking with the Space Station. Just beautiful!" Chris Hadfield photo,
© Government of Canada/NASA (December 21, 2012 – iss034-e-009927)

When the *Soyuz* rendezvouses with the Station, the crew performs systems checks and keeps in touch with controllers at the Russian Mission Control Center. The rendezvous and docking are both automated, but the *Soyuz* crew has the capability to manually intervene or execute these operations.

Before the final rendezvous phase, the crewmembers put on pressurized suits and then monitor the automated docking sequence. Once docking is complete, the crew members equalize the air pressure of the *Soyuz* with the Station before opening the hatches. Up to three crew members can launch and return to Earth from the Station aboard a *Soyuz TMA* spacecraft. The vehicle lands on the flat steppes of Kazakhstan in central Asia. A *Soyuz* trip to the station used to take two days from launch to docking, but in March of 2013 Russian engineers found a "shorter" route, reducing the transit time to just six hours. The return to Earth takes less than four hours.

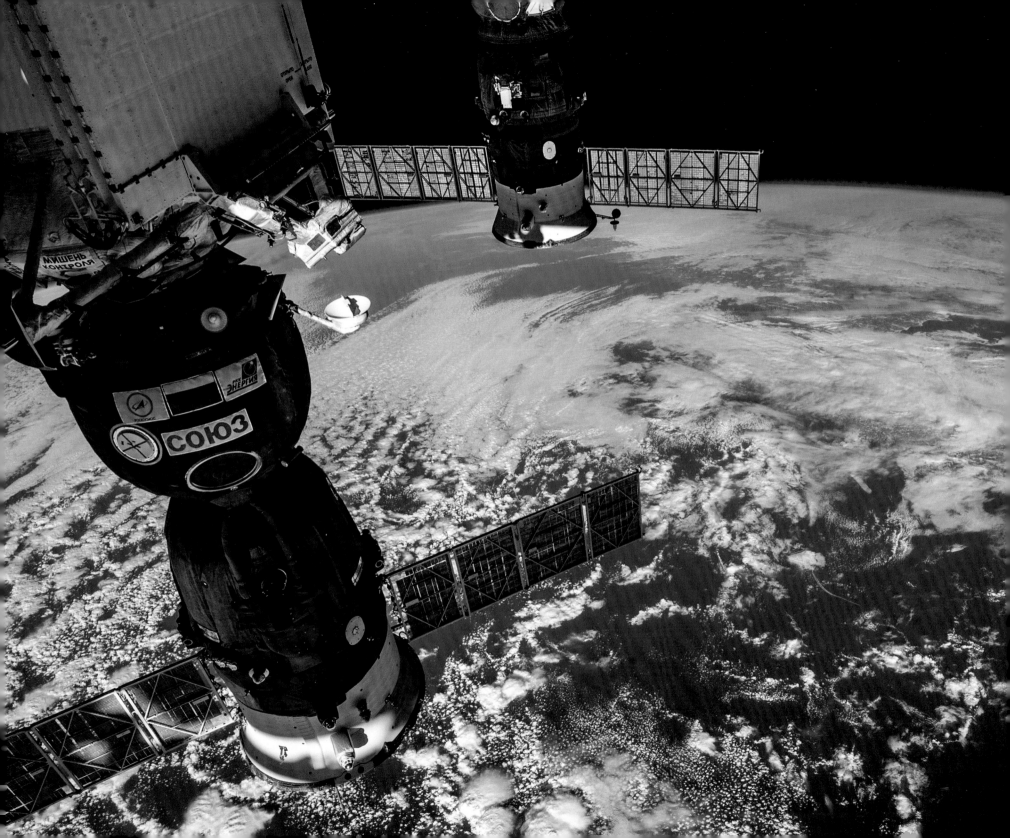

The docking mechanism is used to dock with the space station, and the hatch allows entry into the station. The rendezvous antennae are used by the automated docking system—a radar-based system—to maneuver towards the station for docking. There is also a window in the module. The opposite end of the Orbital Module connects to the Descent Module via a pressurized hatch. Before returning to Earth, the Orbital Module separates from the Descent Module—after the deorbit maneuver—and burns up upon re-entry into the atmosphere.

The Descent Module (right) is where the cosmonauts and astronauts sit for launch, re-entry and landing. All the necessary controls and displays of the Soyuz are located here. The module also contains life support supplies and batteries used during descent, as well as the primary and backup parachutes and landing rockets. It also contains custom-fitted seat liners for each crewmember's couch/seat, which are custom molded to fit each person's body – this ensures a tight, comfortable fit when the module lands on the Earth. When crewmembers are brought to the station aboard the space shuttle, their seat liners are brought with them and transferred to the existing *Soyuz* spacecraft as part of crew handover activities.

"Soyuz, Progress, Earth.
This is what we see when we glance out the window."
Chris Hadfield photo, © Government of Canada/NASA
(March 24, 2013 – iss035-e-009738)

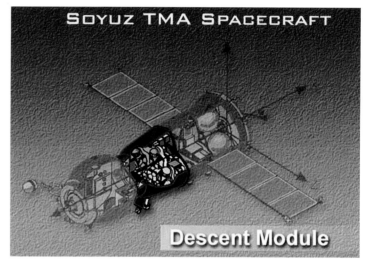

SOYUZ TMA SPACECRAFT

Descent Module

This graphic highlights the crew compartment of the *Soyuz* spacecraft's Descent Module. NASA (112585_soyuz))

The module has a periscope, which allows the crew to view the docking target on the station or the Earth below. The eight hydrogen peroxide thrusters located on the module are used to control the spacecraft's orientation, or attitude, during the descent until parachute deployment. It also has a guidance, navigation and control system to maneuver the vehicle during the descent phase of the mission. This module weighs 6,393 pounds, with a habitable volume of 141 cubic feet. Approximately 110 pounds of payload can be returned to Earth in this module and up to 331 pounds if only two crewmembers are present. The Descent Module is the only portion of the *Soyuz* that survives the return to Earth.

The earth was small, light blue, and so touchingly alone, our home that must be defended like a holy relic. The Earth was absolutely round. I believe I never knew what the word round meant until I saw Earth from space.

Aleksei Leonov, Russia
Columbia 5, November 1982
(*The Home Planet*)

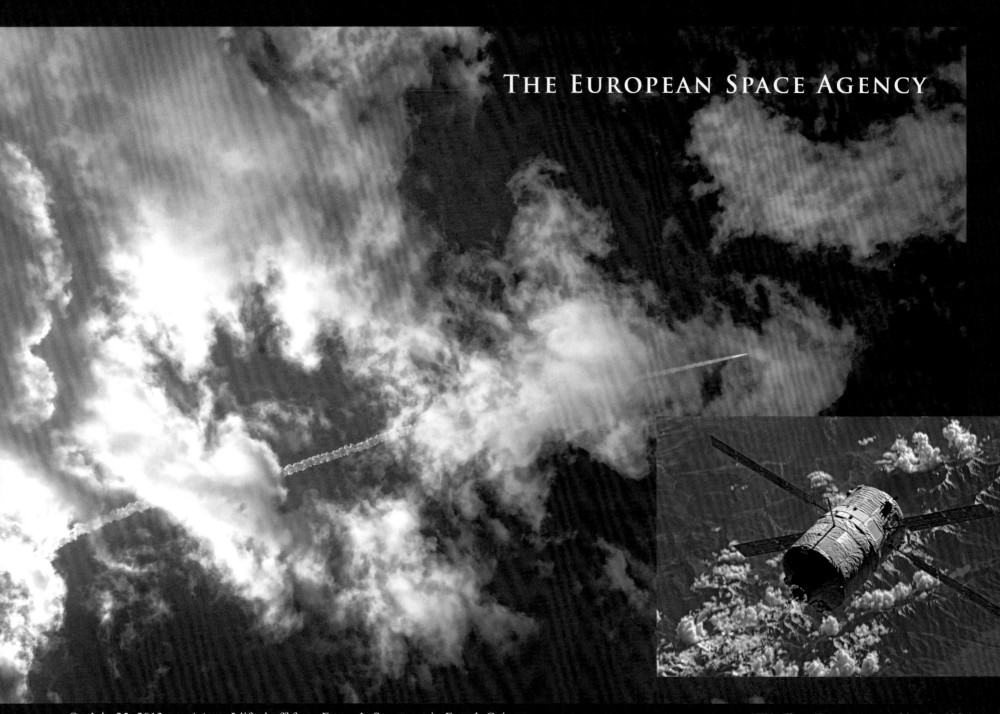

THE EUROPEAN SPACE AGENCY

On July 25, 2013, an *Ariane 5* lifted off from Europe's Spaceport in French Guiana carrying Europe's largest telecom satellite, *Alphasat*.
ESA-CNES-ARIANESPACE – Optique Photo Video du CSG, L. Boyer, 2013

ATV *Albert Einstein* approaching the ISS.
ESA-NASA (June 15, 2013)

The European Space Agency (ESA) is Europe's gateway to space. Its mission is to shape the development of Europe's space capability and ensure that investment in space continues to deliver benefits to the citizens of Europe and the world.

ESA is an international organization with 20 member states. By co-ordinating the financial and intellectual resources of its members, it can undertake programes and activities far beyond the scope of any single European country.

ESA's job is to draw up the European space programme and carry it through. ESA's programmes are designed to find out more about Earth, its immediate space environment, our solar system and the universe, as well as to develop satellite-based technologies and services, and to promote European industries. ESA also works closely with space organizations outside Europe.

Austria, Belgium, the Czech Republic, Denmark, Finland, France, Germany, Greece, Ireland, Italy, Luxembourg, the Netherlands, Norway, Portugal, Romania, Spain, Sweden, Switzerland and the United Kingdom. Canada takes part in some projects under a Co-operation agreement. Poland exchanged accession agreements with ESA in September 2012 to become our 20th member state. Hungary, Estonia and Slovenia are European co-operating states. Other countries have signed co-operation agreements with ESA.

ESA's headquarters are in Paris, which is where policies and programmes are decided. ESA also has sites in a number of European countries, each of which has different responsibilities:

- EAC, the European Astronauts Center in Cologne, Germany;
- ESAC, the European Space Astronomy Center, in Villanueva de la Cañada, Madrid, Spain;
- ESOC, the European Space Operations Center in Darmstadt, Germany;
- ESRIN, the European Space Research Institute, the ESA center for Earth Observation, in Frascati, Italy;
- ESTEC, the European Space Research and Technology Center, Noordwijk, the Netherlands.

ATV *Albert Einstein* successfully docked on the ISS. ESA-NASA (June 15, 2013)

ATV *Albert Einstein*, (Automated Transfer Vehicle) Europe's supply and support ferry, docked with the International Space Station on June 15 2013, some ten days after its launch from Europe's Spaceport in French Guiana.

In this image you can see ATV's four solar panel arrays along with the vertical antenna on top. This antenna is the 'proximity boom' that is used to communicate with the Station.

ATV *Albert Einstein* brought 7 tonnes of supplies, propellants and experiments to the complex. ESA astronaut Luca Parmitano oversees the unloading and cataloguing of the cargo of over 1400 individual items.

'Vehicle traffic' is the term used for every spaceship that arrives or departs from the International Space Station. Every couple of weeks on the ISS sees one of those vehicles coming or going.

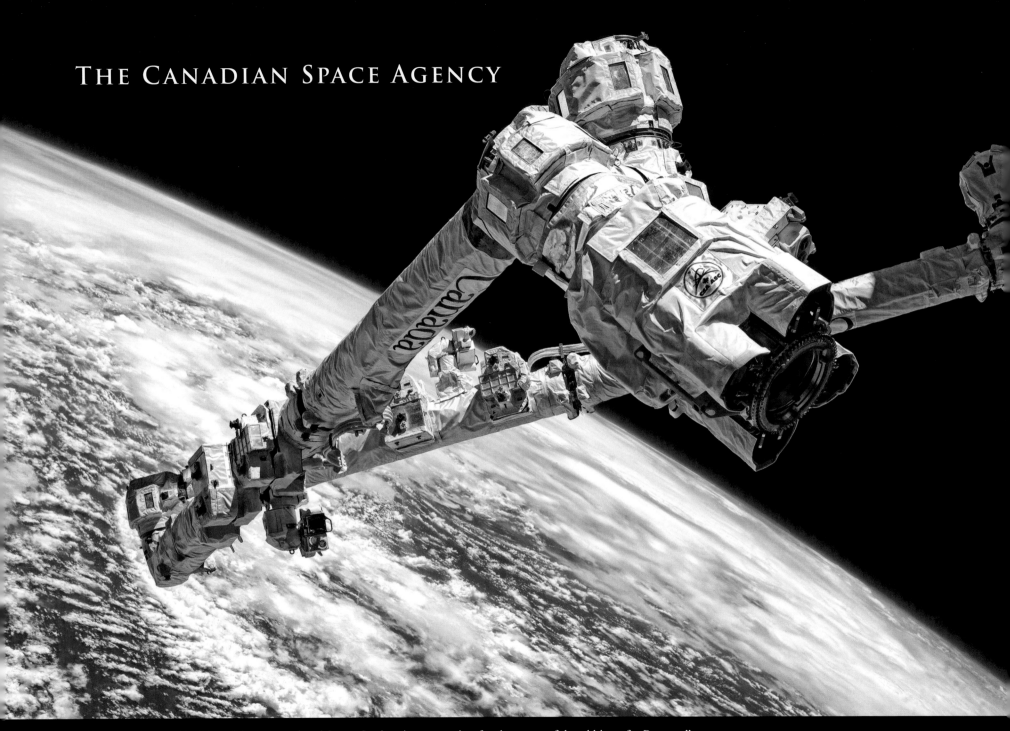

THE CANADIAN SPACE AGENCY

"Canadarm2, proud builder of the International Space Station, in preparation for the successful grabbing of a *Dragon*."
Chris Hadfield photo, © Government of Canada/NASA (February 16, 2013 – iss034-e-050045)

Along with the United States, Russia, Europe and Japan, Canada is a partner in the International Space Station (ISS). Since the first module of the Station was launched in 1998, the Station has circled the globe 16 times per day at 28,000 km/h (17,500 mph) at an altitude of about 386 kilometers (230 miles), covering a distance equivalent to the Moon and back daily.

On September 29, 2012, Canada celebrated 50 years of space activities, which have propelled it into the ranks of world aerospace leaders. When it launched its first scientific satellite, *Alouette I*, on September 29, 1962, Canada became the first nation after the Soviet and American superpowers, to design and manufacture its own satellite. The launch marked Canada's entry into the Space Age, and Canada was recognized by the scientific community as having the most advanced space program at that time.

Its technical and technological success in those early days earned Canada considerable scientific credibility, which served as the foundation for developing the international partnerships in which all Canadians take pride.

In the wake of the Alouette's success, the government decided to support space communications and the growth of a Canadian space industry. This led to Canada becoming the first country to develop the following:

- A geostationary communications satellite system (Anik satellites);
- Earth observation satellites (RADARSAT);
- Satellite-aided search and rescue (SARSAT); and
- Space robotics technology (the Canadarms) supplied for NASA Space Shuttles and the International Space Station.

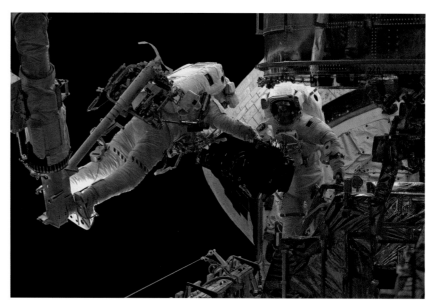

The Canadarm guides NASA astronaut Michael Massimino towards the cargo bay of Space Shuttle *Columbia* during STS-109.
© Government of Canada/NASA (March 5, 2002)

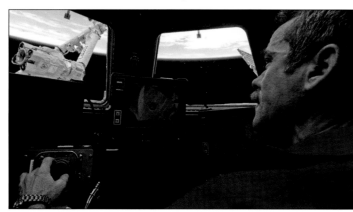

"Flying Canadarm2, keeping proficient at this very particular and exacting skill. Good job for a Canadian!"
© Government of Canada/NASA (February 25, 2013 – Iss034-e-055894)

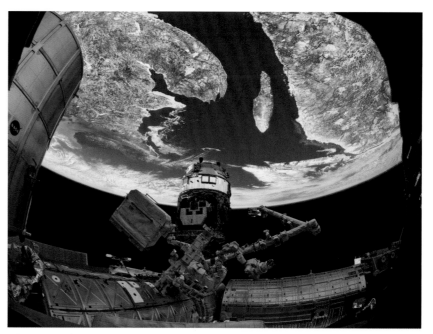

The International Space Station flies over Atlantic Canada as Canadarm2 is poised to release *Kounotori2*. © Government of Canada/NASA (March 20, 2011)

CHRIS HADFIELD

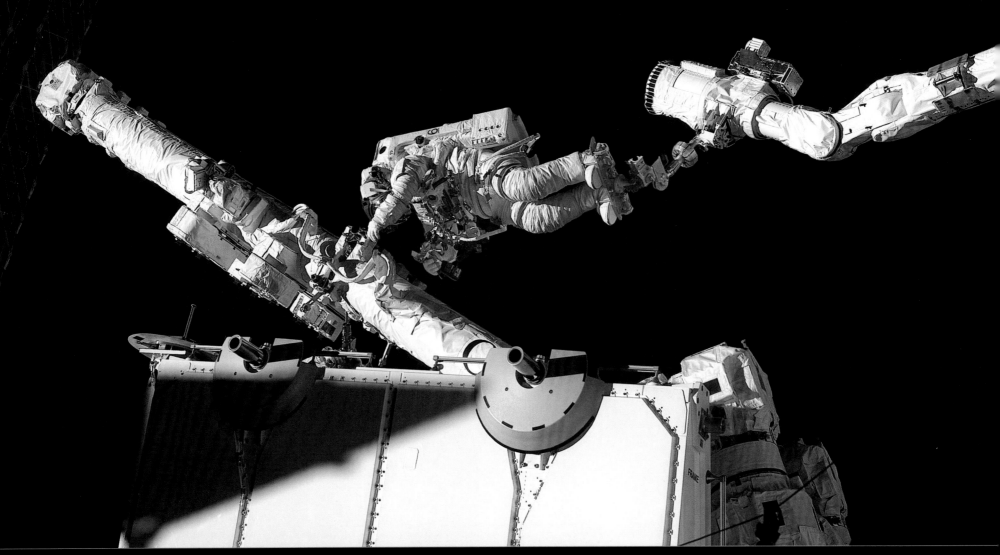

April 22, 2001 – History is being made here. Canadian Space Agency Astronaut Chris Hadfield, attached to the original Canadarm, installs the next-generation Canadarm2 to the International Space Station during Shuttle Mission STS-100. © Government of Canada/NASA

Chris Hadfield performing one of his favourite duties, photographing Earth In the Station's viewing cupola that he has immortalized in his legendary twitter feeds.
© Government of Canada/NASA (January 1, 2013 – iss034-e-024093)

Biography

Raised on a corn farm in southern Ontario, Chris Hadfield became interested in flying at an early age. As an Air Cadet, he won a glider pilot scholarship at age 15 and a powered pilot scholarship at age 16. He also taught skiing and ski racing part- and full-time for 10 years.

Hadfield joined the Canadian Armed Forces in May 1978. He spent two years at Royal Roads Military College, in Victoria, British Columbia, followed by two years at the Royal Military College in Kingston, Ontario, where he received a bachelor's degree in Mechanical Engineering (with honours) in 1982. Hadfield underwent basic flight training in Portage la Prairie, Manitoba, for which he was named top pilot in 1980. In 1983, he took honours as the overall top graduate from Basic Jet Training in Moose Jaw, Saskatchewan, and in 1984-1985, he trained as a fighter pilot in Cold Lake, Alberta on CF-5s and CF-18s.

For the next three years Hadfield flew CF-18s for the North American Aerospace Defence Command (NORAD) with 425 Squadron, during which time he flew the first CF-18 intercept of a Soviet Bear aircraft. He attended the United States Air Force (USAF) Test Pilot School at Edwards Air Force Base in California, and upon graduation, served as an exchange officer with the U. S. Navy at Strike Test Directorate at the Patuxent River Naval Air Station.

His accomplishments from 1989 to 1992 included testing the F/A-18 and A-7 aircraft; performing research work with NASA on pitch control margin simulation and flight; completing the first military flight of F/A-18 enhanced performance engines; piloting the first flight test of the National Aerospace Plane external burning hydrogen propulsion engine; developing a new handling qualities rating scale for high-angle-of-attack tests; and participating in the F/A-18 out-of-control-recovery test program. In total, Hadfield has flown over 70 different types of aircraft.

In June 1992, Chris Hadfield was selected to become one of four new Canadian astronauts from a field of 5330 applicants. He was assigned by the Canadian Space Agency (CSA) to the NASA Johnson Space Center in Houston, Texas in August of the same year, where he addressed technical and safety issues for Shuttle Operations Development, contributed to the development of the glass shuttle cockpit, and supported shuttle launches at the Kennedy Space Center in Florida. In addition, Hadfield was NASA's Chief CapCom, the voice of mission control to astronauts in orbit, for 25 space shuttle missions. From 1996 to 2000, he represented CSA astronauts and co-ordinated their activities as the Chief Astronaut for the CSA.

From 2000 to 2003, Hadfield was the Director of Operations for NASA at the Yuri Gagarin Cosmonaut Training Center (GCTC) in Star City, Russia. His work included co-ordination and direction of all International Space Station crew activities in Russia, oversight of training and crew support staff, as well as policy negotiation with the Russian Space Program and other International Partners. He also trained and became fully qualified to be a flight engineer cosmonaut in the *Soyuz* TMA spacecraft, and to perform spacewalks in the Russian Orlan spacesuit.

Hadfield is a civilian CSA astronaut, having retired as a Colonel from the Canadian Air Force in 2003 after 25 years of military service. He was Chief of Robotics for the NASA Astronaut Office at the Johnson Space Center in Houston, Texas from 2003 to 2006, and was Chief of International Space Station Operations there from 2006 to 2008.

(continued overleaf)

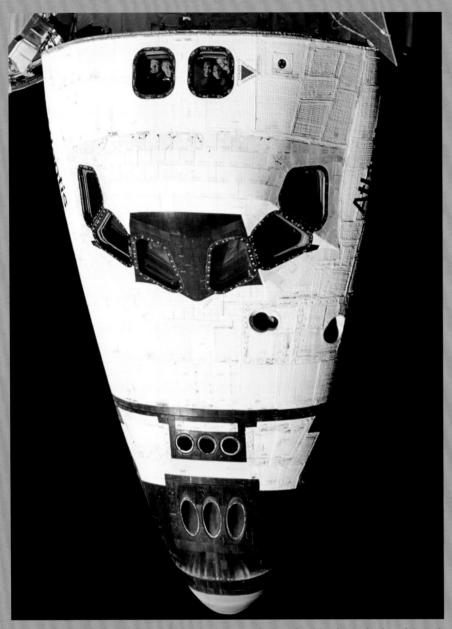

Astronaut Chris Hadfield (seen in the upper window beside the red triangle) and NASA astronauts on Space Shuttle *Atlantis* look up through the overhead windows at their counterparts on Russia's *Mir* Space Station. Mission STS-74 was launched November 12, 1995, from Kennedy Space Center (KSC) and ended at KSC on November 20, 1995. On November 15, 1995, *Atlantis* docked with *Mir*, and the Canadian and American astronauts joined the *Mir* 20 crew for a short time
© Government of Canada/NASA (November, 1995)

Space Flights

In November 1995, Hadfield served as Mission Specialist 1 on STS-74, NASA's second space shuttle mission to rendezvous and dock with the Russian Space Station *Mir*. During the flight, the crew of Space Shuttle *Atlantis* attached a five-tonne docking module to *Mir* and transferred over 1,000 kg of food, water, and scientific supplies to the cosmonauts. Hadfield flew as the first Canadian mission specialist, the first Canadian to operate the Canadarm in orbit, and the only Canadian to ever board *Mir*.

In April 2001 Hadfield served as Mission Specialist 1 on STS-100 International Space Station (ISS) assembly Flight 6A. The crew of Space Shuttle *Endeavor* delivered and installed Canadarm2, the new Canadian-built robotic arm, as well as the Italian-made resupply module *Raffaello*. During the 11-day flight, Hadfield performed two spacewalks, which made him the first Canadian to ever leave a spacecraft and float freely in space. In total, Hadfield spent 14 hours, 54 minutes outside, travelling 10 times around the world.

From May 10 to 23, 2010 Hadfield was the Commander of NEEMO 14, a NASA undersea mission to test exploration concepts living in an underwater facility off the Florida coast. NEEMO 14 used the ocean floor to simulate exploration missions to the surface of asteroids, moons and Mars in order to gain a better understanding of how astronaut crews interact with equipment including advanced spacesuits, a lander, a rover and robotic arms.

In September 2010, he was assigned to Expedition 34/35. On December 19, 2012 he launched aboard the Russian *Soyuz*, en route to becoming the second Canadian to take part in a long-duration spaceflight aboard the ISS. On March 13, 2013 he became the first Canadian to command a spaceship as Commander of the ISS during the second portion of his five-month stay in space. On May 13, Hadfield, Tom Marshburn and Roman Romanenko landed in Kazakhstan after travelling almost 99.8 million kilometers (45.6 million miles) while completing 2,336 orbits of Earth. The trio spent 146 days in space, 144 of which were aboard the station.

In July of 2013 he announced his retirement, capping a 35-year career as a military pilot and astronaut.

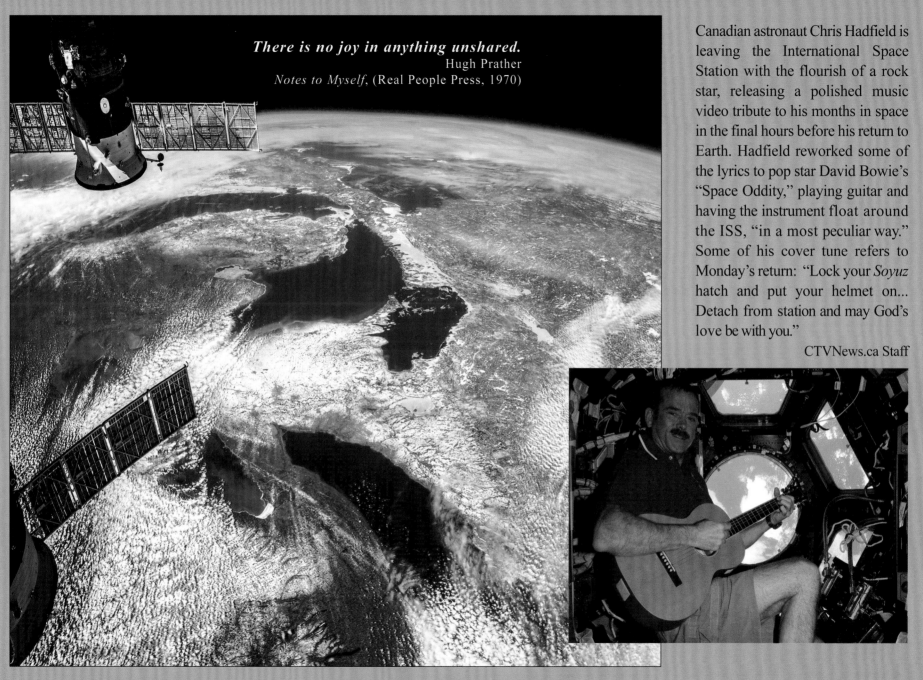

There is no joy in anything unshared.
Hugh Prather
Notes to Myself, (Real People Press, 1970)

Canadian astronaut Chris Hadfield is leaving the International Space Station with the flourish of a rock star, releasing a polished music video tribute to his months in space in the final hours before his return to Earth. Hadfield reworked some of the lyrics to pop star David Bowie's "Space Oddity," playing guitar and having the instrument float around the ISS, "in a most peculiar way." Some of his cover tune refers to Monday's return: "Lock your *Soyuz* hatch and put your helmet on... Detach from station and may God's love be with you."

CTVNews.ca Staff

"From Ontario to Superior, the Great Lakes in mid-March, as seen from Earth orbit." Chris Hadfield photo,
© Government of Canada /NASA (March 14, 2013 – iss034-e-068631)
The city of Toronto is visible at the north west end of Lake Ontario (lake at bottom right).
Chris's hometown of Milton, Ontario lies just west of Canada's largest city.

"Music on High—playing Christmas carols while floating over the eastern Mediterranean. Miraculous."
© Government of Canada /NASA
(March 14, 2013 – iss034-e-068631)

Chris Hadfield and Dr. Tom Marshburn, colleagues, fellow astronaut photographers and good friends, strike a pose.
© Government of Canada/NASA (2013 – ISS 034/035)

This experience is way too rich to keep to myself, I am planning to record and share this experience as many ways as I can. Take pictures, write music, write e-mails, use the phone on board, call people I know, talk to the media, but also send a tweet as often as I can. I think as many people should see what is going on as is humanly possible.

Chris Hadfield, Canada

John McQuarrie Photo (July 1, 2013)

Chris Hadfield's passion for space is evident here as he and fellow astronaut Tom Marshburn take turns responding in a Q&A during the 2013 Canada Day celebrations in Ottawa.

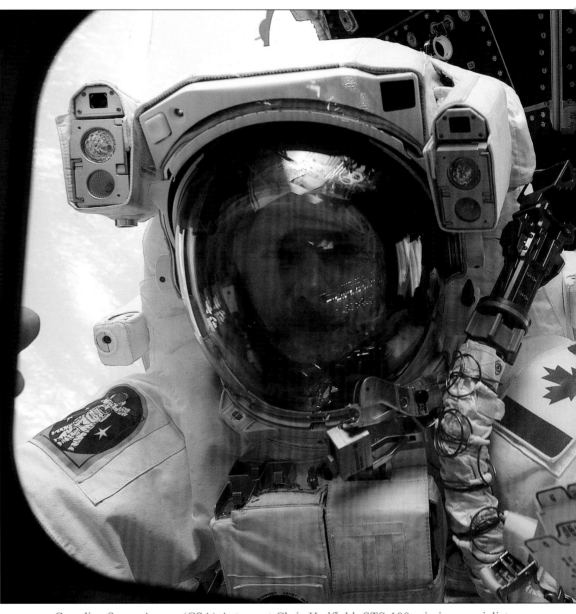

Canadian Space Agency(CSA) Astronaut Chris Hadfield, STS-100 mission specialist, peers through a window into the crew cabin of the Space Shuttle *Endeavor* during a lengthy spacewalk to install Canadarm2 on the International Space Station (ISS). The Pressurized Mating Adapter, which temporarily anchors the orbital outpost to the Shuttle, can be seen behind him.
Scott Parazynski photo, © Government of Canada/NASA (April 22, 2001 – S100E5262)

Chris Hadfield says NASA's job is not to 'titillate'
Pallab Ghosh, science correspondent, BBC News

Space station commander Chris Hadfield has told BBC News that those calling for a quick return of manned missions to the Moon are seeking "titillation". His comments were in response to suggestions that the International Space Station (ISS) served little purpose.

Commander Hadfield has been a Twitter sensation with his feed of comments, photos and videos showing what life is like in space. "We will go to the Moon and we will go to Mars; we will go and see what asteroids and comets are made of," he told BBC News. "But we're not going to do it tomorrow and we're not going to do it because it titillates the nerve endings. We're going to do it because it's a natural human progression. It's a process—we're not trying to make a front page every day and we're not planning on planting a flag every time we launch. That's just a false expectation of low-attention-span consumerism."

Those growing up in the 1960s were inspired by views of the Earth from space and the Moon landing. A new generation has become enthralled by commander Hadfield's frequent tweets on what it is like to live in space. He has shown his 1,000,000 plus followers how astronauts brush their teeth and how to eat a tortilla in zero gravity. Commander Hadfield has also sung along with schoolchildren from space and chatted with William Shatner, who played Captain Kirk in the original series of Star Trek.

He has probably become the most famous astronaut since the days of Neil Armstrong and Yuri Gagarin.

Pallab Ghosh, BBC News

How Chris Hadfield turned earthlings on to Space
Janet Davison, CBC News, Posted: May 13, 2013

When Chris Hadfield and his family began talking three years ago about how to give Canadians a behind-the-scenes look at his next spaceflight, they came up with some ideas that would forge an unprecedented everyman link between life on Earth and his stint on the International Space Station.

That bond, which resulted in, among other things, more than 1,000,000 followers all over the globe keeping up with Hadfield on Twitter, ended—in some ways—on Monday. Hadfield, the first Canadian to command the ISS, and two other astronauts (NASA astronaut Tom Marshburn and cosmonaut Roman Romanenko) strapped tightly inside a *Soyuz* spacecraft landed on the flat steppes of Kazakhstan.

But for Hadfield and the Canadian Space Agency, there is hope that the unique way the charismatic 53-year-old was able to connect with people on Earth will be more than a curiosity that lingers on through the tweets, videos and pictures, which showed him doing everything from playing his guitar to testing his blood. Instead, they hope, the interest that Hadfield has roused over the past five months will help forge a stronger role for Canada in space at a time when that future is anything but certain.

Hadfield's son Evan, 27, who is currently serving as his father's unpaid social media manager, says several factors went into wanting to find a way to make a connection with Canadians during the ISS mission. "Its many things, but it all boils down to generating interest," Evan Hadfield said in an interview.

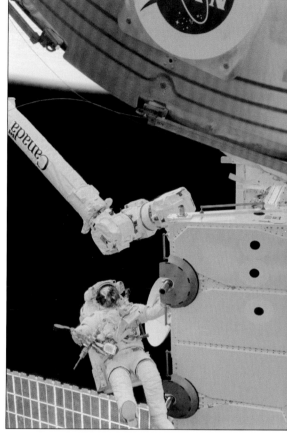

Astronaut Chris Hadfield is near Canadarm2 as the new robotic arm for the International Space Station grasps the Spacelab pallet on mission STS-100.
Scott Parazynski photo
© Government of Canada/NASA
(April 22, 2001 – STS-100-112)

"You want people to be interested in the space program. And in a democracy like Canada, if you want a program to continue, the best way … is to get people interested in it."

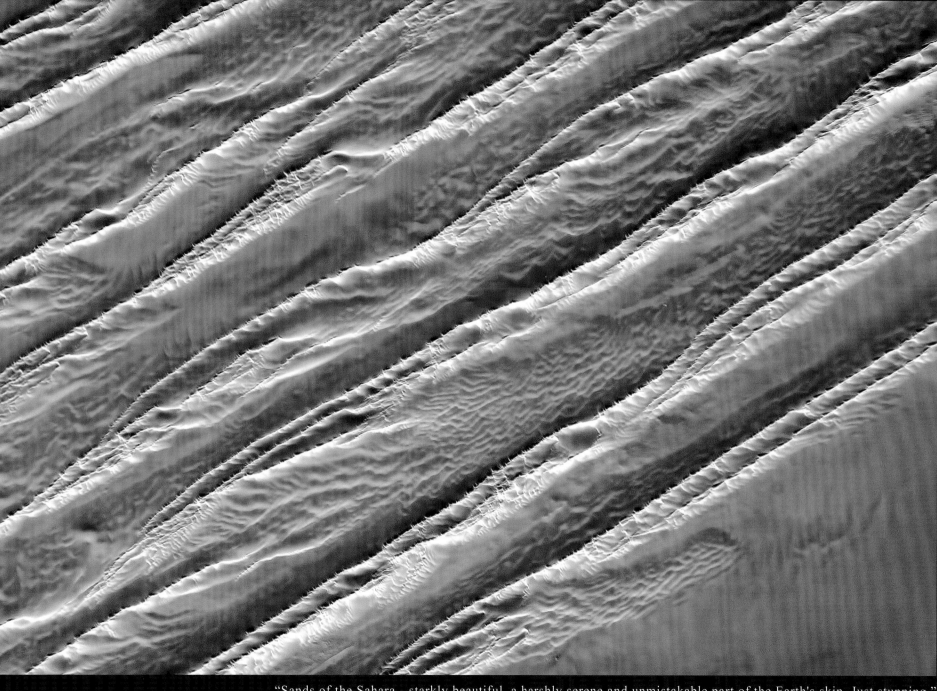

"Sands of the Sahara - starkly beautiful, a harshly serene and unmistakable part of the Earth's skin. Just stunning."
Chris Hadfield photo, © Government of Canada/NASA (January 2, 2013 – iss034-e-014129)

EARTH AS ART

In many of these remarkable photographs, we are treated to what seems for all the world to be Earth's deliberate and ordered sense of pattern and color that rivals that of all the artists who have ever inhabited her.

A traveler walking or driving across the Earth or even in an airplane was like a fly walking across the Mona Lisa at the Louvre in Paris. It would be difficult to appreciate the beauty and the genius of da Vinci that way. You have to back off ten feet to appreciate the masterpiece. The same is true in space. You have to back off a hundred or more miles to see what a masterpiece our home planet is.

Richard W. Underwood, NASA

This prominent circular feature, known as the Richat Structure, in the Sahara desert of Mauritania has long been a favorite of astronauts because it forms a conspicuous 50-kilometer (30-mile) wide bull's-eye on this otherwise rather featureless expanse of the desert. Initially mistaken for a possible impact crater, it is now known to be an eroded circular anticline (structural dome) of layered sedimentary rocks. This snail-shell-like formation was created when a volcanic dome hardened and gradually eroded, exposing onion-like layers of rock.

"One of the coolest space sights on Earth. Like a well-licked all-day sucker, it's called the Richat Structure of Mauritania"
Chris Hadfield photo, © Government of Canada/NASA
(January 16, 2013 – iss034-e-030503)

It's so important to communicate the leading-edge, work that's been done on the frontier, and bring it into the mainstream fabric of the public.

Chris Hadfield, Canada
Atlantis STS/74, November 1995
Endeavor, STS 100, April 2001
Soyuz ISS 34/35, December 2012

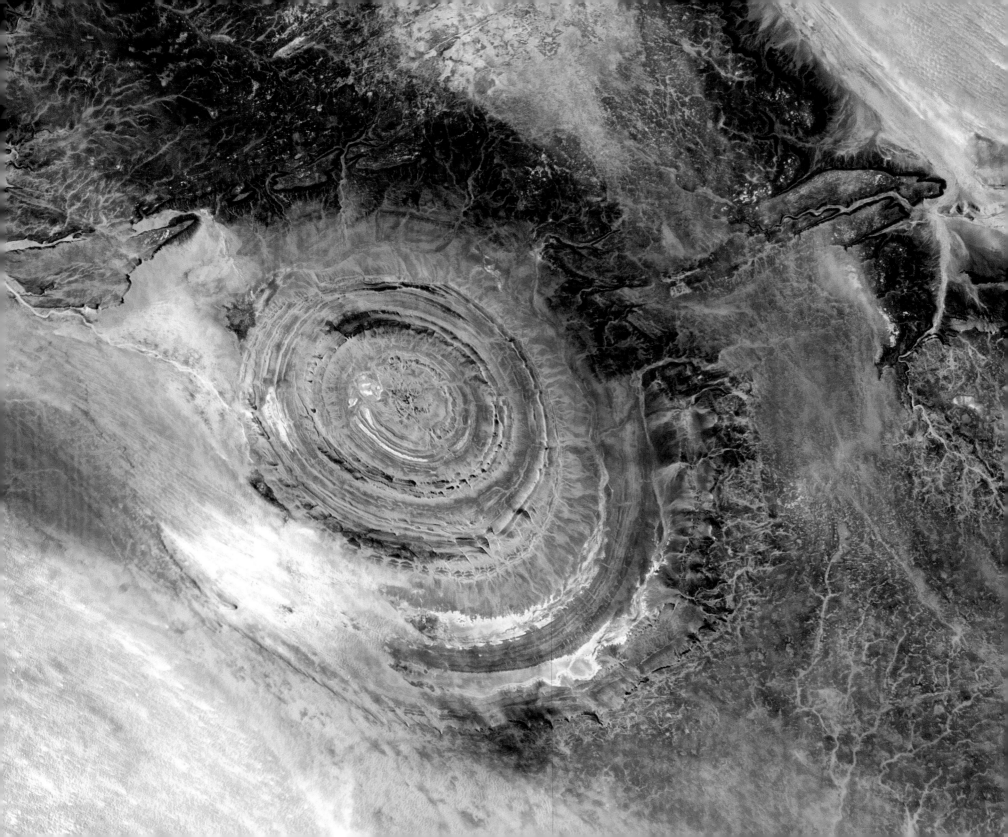

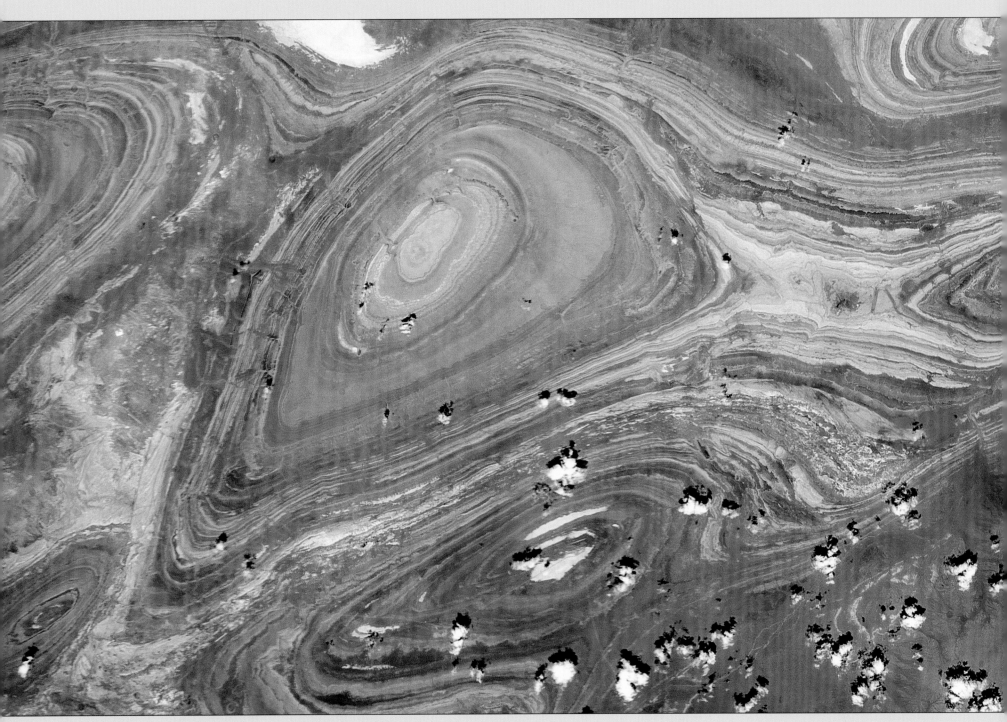

"Ancient Saharan stone, burnished by eternal sand and wind."
Chris Hadfield photo, © Government of Canada/NASA (April 24, 2013 – iss035-e-028546) Location: central Algeria, about 60 kilometers south of I-n-Salah

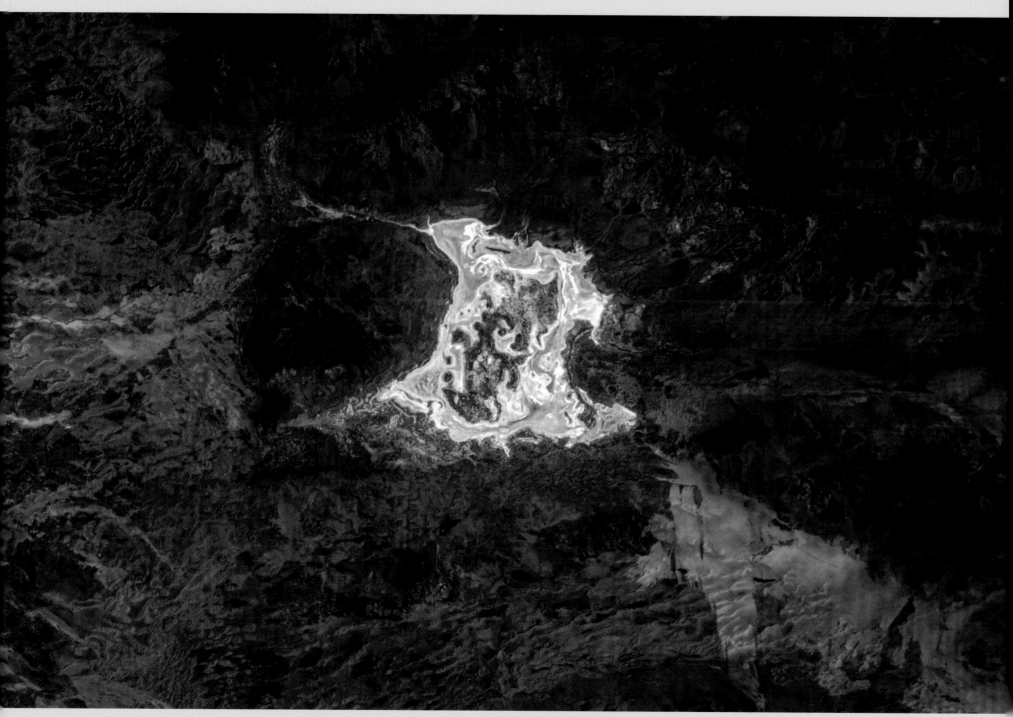

"A splash of dry salt white on seared red in Australia's agonizingly beautiful Outback."
Chris Hadfield photo, © Government of Canada/NASA (April 10, 2013 – iss035-e-017937) Location: Baker Lake, Western Australia

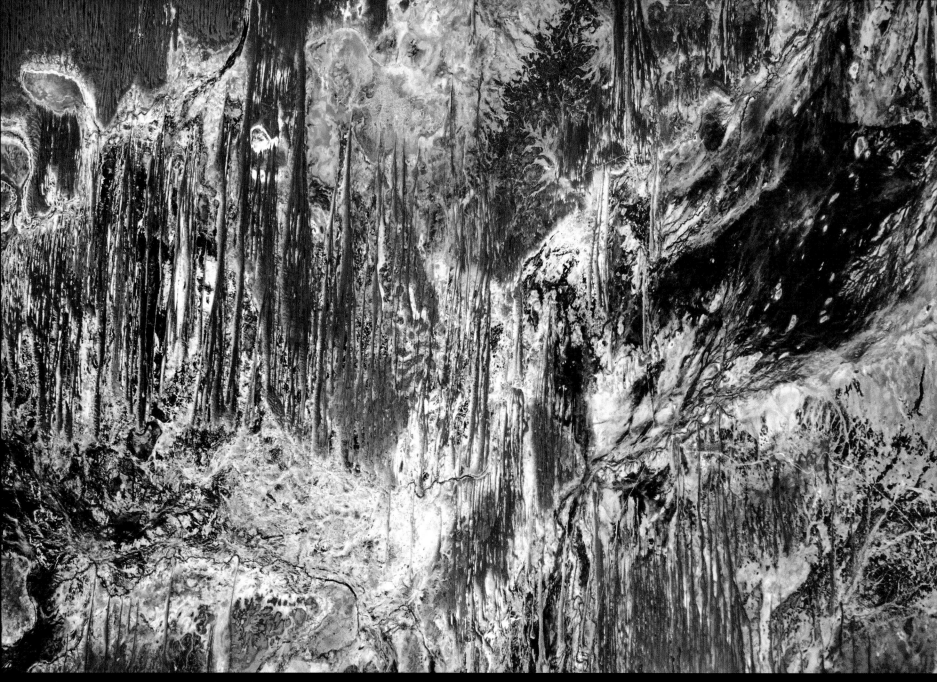

"Jackson Pollock would have been even further inspired by seeing the Outback of the Great Artesian Basin of Queensland from orbit."
Chris Hadfield photo, © Government of Canada/NASA (January 15, 2013 – iss034-e-029127) Location: about 20 kilometers west of Cluny

48

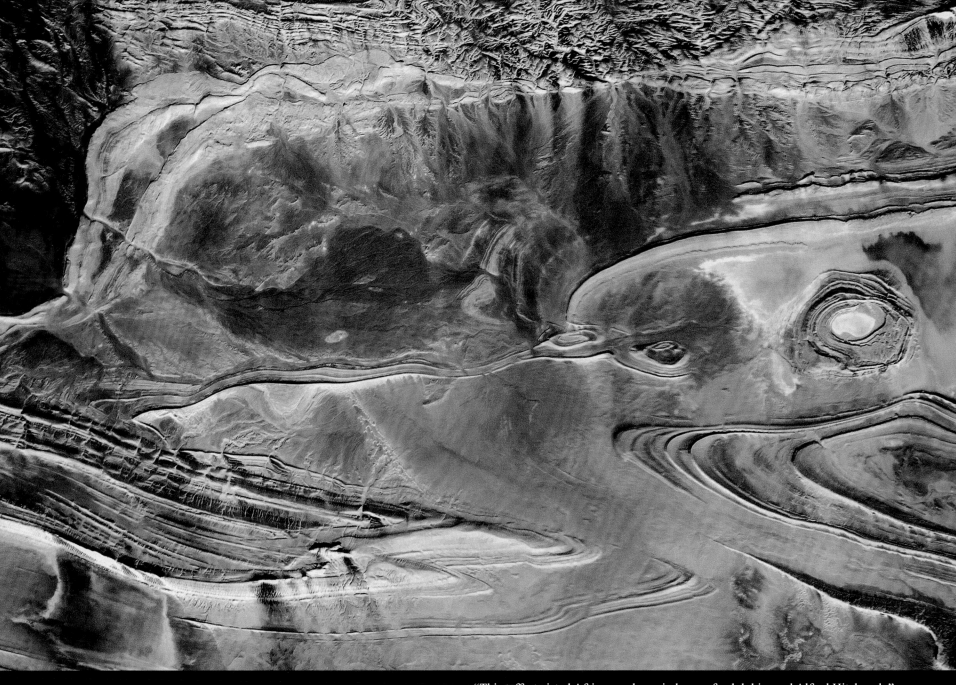

"This taffy-twisted African rock reminds me of a dolphin, and Alfred Hitchcock."
Chris Hadfield photo, © Government of Canada/NASA (February 13, 2013 – iss034-e-047108) Location: about 30 kilometers east of Reggane in central Algeria

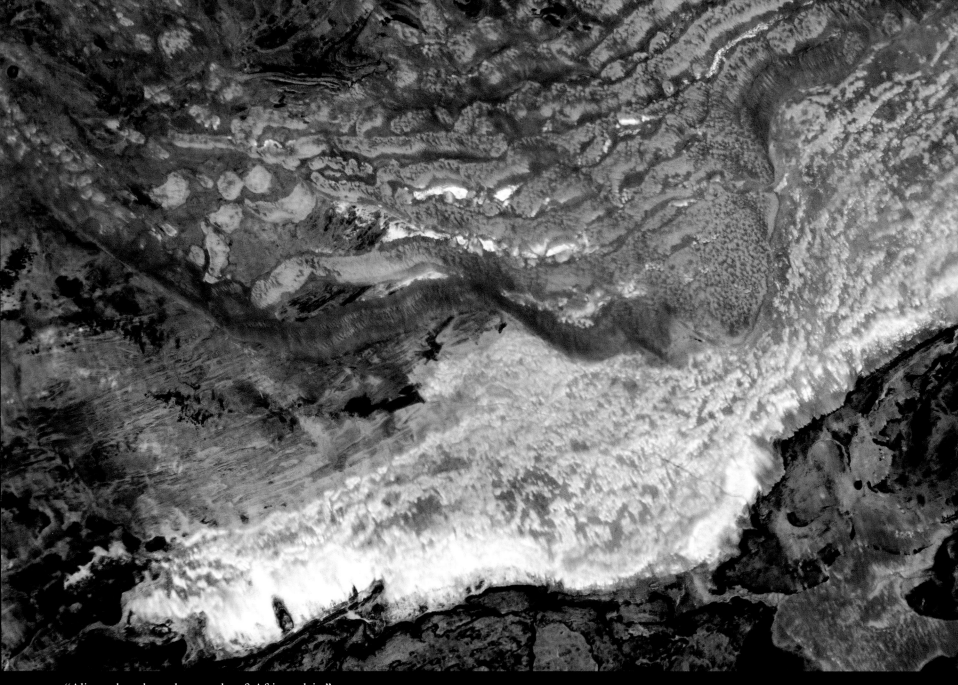

"Alien red sand crawls over a bereft African plain."
Chris Hadfield photo, © Government of Canada/NASA (March 19, 2013 – iss035-e-006339) Location: Moudjéria, Mauritania is in lower right.

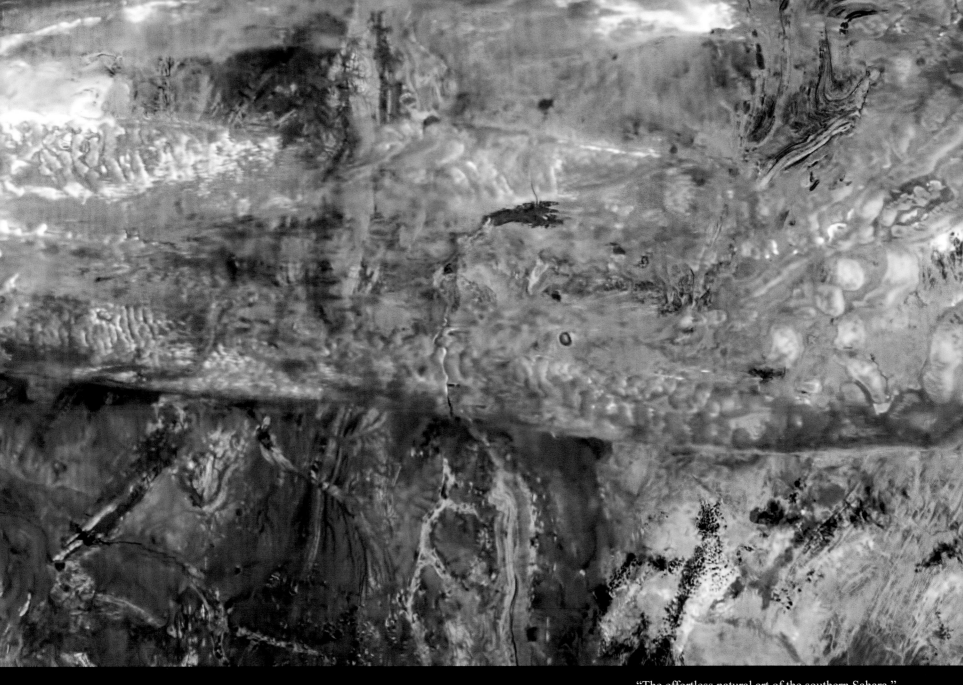

"The effortless natural art of the southern Sahara."

Chris Hadfield photo, © Government of Canada/NASA (March 19, 2013 – iss035-e-006340) Location: 40 kilometers west of Moudjéria, Mauritania

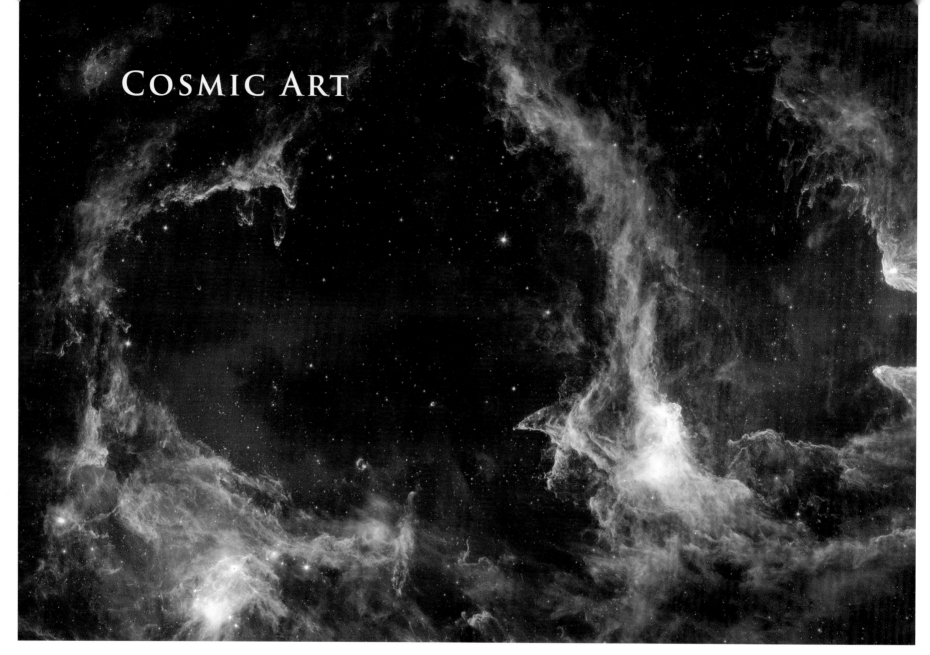

COSMIC ART

Celestial Valentine

Generations of stars can be seen in this infrared portrait from NASA's Spitzer Space Telescope. In this wispy star-forming region, called W5, the oldest stars can be seen as blue dots in the centers of the two hollow cavities (other blue dots are background and foreground stars not associated with the region).

Younger stars line the rims of the cavities, and some can be seen as pink dots at the tips of the elephant-trunk-like pillars. The white knotty areas are where the youngest stars are forming. Red shows heated dust that pervades the region's cavities, while green highlights dense clouds.

NASA/JPL-Caltech/Harvard-Smithsonian (727311)

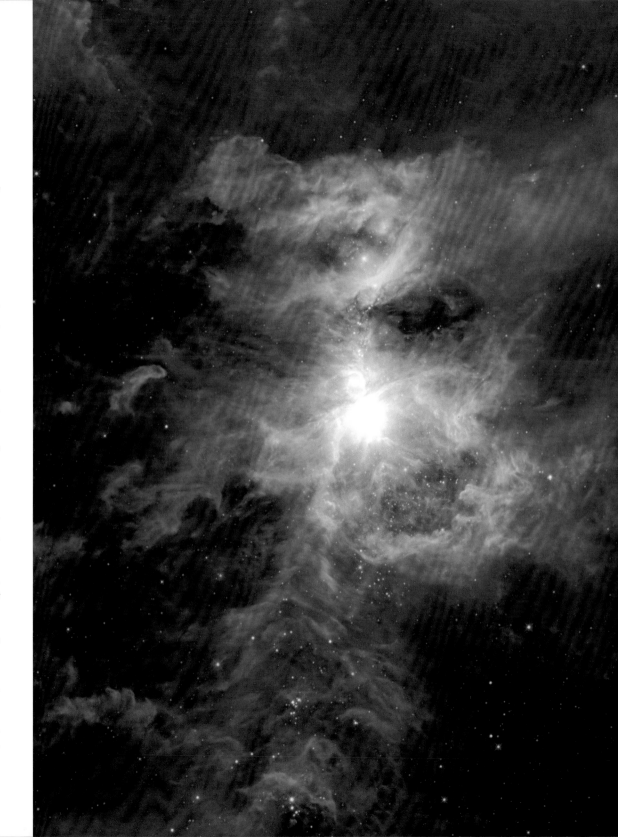

The Cosmic Hearth

The Orion nebula is featured in this sweeping image from NASA's Wide-field Infrared Survey Explorer, or WISE. The constellation of Orion is prominent in the evening sky throughout the world from about December through April of each year. The nebula (also catalogued as Messier 42) is located in the sword of Orion, hanging from his famous belt of three stars. The star cluster embedded in the nebula is visible to the unaided human eye as a single star, with some fuzziness apparent to the most keen-eyed observers. Because of its prominence, cultures all around the world have given special significance to Orion. The Maya of Mesoamerica envision the lower portion of Orion, his belt and feet (the stars Saiph and Rigel), as being the hearthstones of creation, similar to the triangular three-stone hearth that is at the center of all traditional Mayan homes. The Orion nebula, lying at the center of the triangle, is interpreted by the Maya as the cosmic fire of creation surrounded by smoke.

This metaphor of a cosmic fire of creation is apt. The Orion nebula is an enormous cloud of dust and gas where vast numbers of new stars are being forged. It is one of the closest sites of star formation to Earth and therefore provides astronomers with the best view of stellar birth in action. Many other telescopes have been used to study the nebula in detail, finding wonders such as planet-forming disks coalescing around newly forming stars. NASA/JPL-Caltech/UCLA (724739)

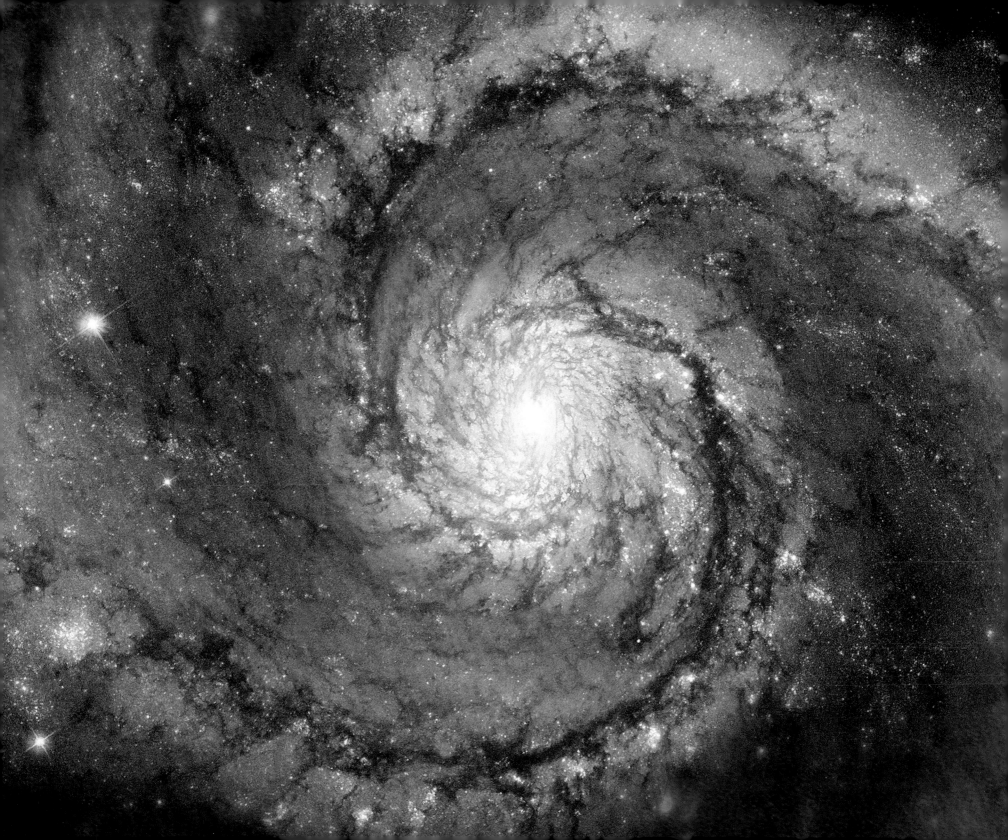

Light Echoes from V838 Mon (right)

What caused this outburst in V838 Mon? For reasons unknown, star V838 Mon's outer surface suddenly greatly expanded with the result that it became the brightest star in the entire Milky Way Galaxy in January 2002. Then, just as suddenly, it faded. A stellar flash like this had never been seen before. Supernovas and novas expel matter out into space. Although the V838 Mon flash appears to expel material into space, what is seen in the image at right, from the Hubble Space Telescope is actually an outwardly moving light echo of the bright flash.

In a light echo, light from the flash is reflected by successively more distant rings in the complex array of ambient interstellar dust that already surrounded the star. V838 Mon lies about 20,000 light years away toward the constellation of the unicorn (Monoceros), while the light echo here spans about six light years in diameter.

NASA, ESA (734502)

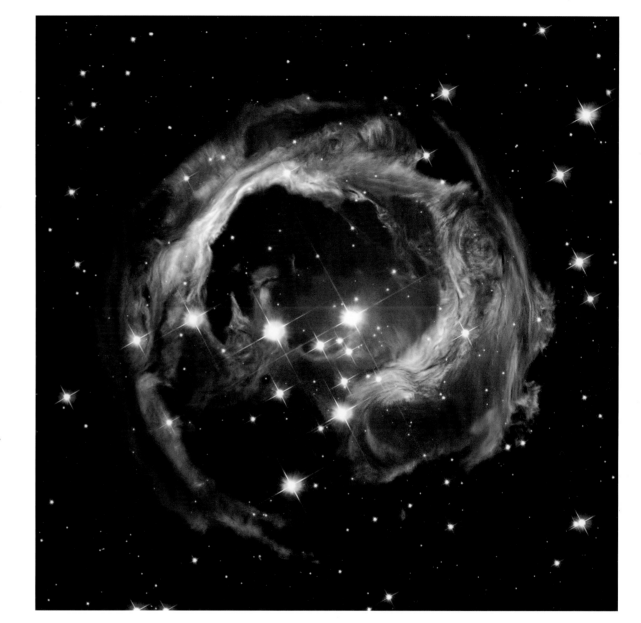

The Whirlpool Galaxy (left)

The Whirlpool Galaxy is a classic spiral galaxy. At only 30 million light years distant and fully 60 thousand light years across, M51, also known as NGC 5194, is one of the brightest and most picturesque galaxies in the sky. This image is a digital combination of a ground-based image from the 0.9-meter telescope at Kitt Peak National Observatory and a space-based image from the Hubble Space Telescope highlighting sharp features normally too red to be seen.

NASA/Hubble (729779)

Hubble Sees a Horsehead of a Different Color

Astronomers have used NASA's Hubble Space Telescope to photograph the iconic Horsehead Nebula in a new, infrared light to mark the 23rd anniversary of the famous observatory's launch aboard the space shuttle Discovery on April 24, 1990.

Looking like an apparition rising from whitecaps of interstellar foam, the iconic Horsehead Nebula has graced astronomy books ever since its discovery more than a century ago. The nebula is a favorite target for amateur and professional astronomers. It is shadowy in optical light. It appears transparent and ethereal when seen at infrared wavelengths. The rich tapestry of the Horsehead Nebula pops out against the backdrop of Milky Way stars and distant galaxies that easily are visible in infrared light.

Hubble has been producing ground-breaking science for two decades. During that time, it has benefited from a slew of upgrades from space shuttle missions, including the 2009 addition of a new imaging workhorse, the high-resolution Wide Field Camera 3 that took the new portrait of the Horsehead.

NASA/ESA/Hubble Heritage Team (742882)

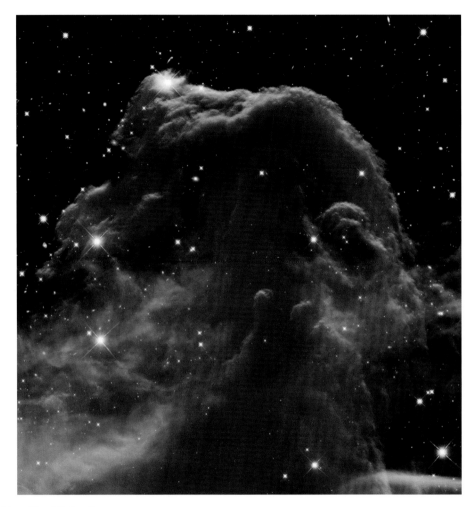

The Butterfly Nebula

The bright clusters and nebulae of planet Earth's night sky are often named for flowers or insects. Though its wingspan covers over three light-years, NGC 6302 is no exception. With an estimated surface temperature of about 250,000° C, the dying central star of this particular planetary nebula has become exceptionally hot, shining brightly with ultraviolet light but hidden from direct view by a dense torus of dust.

This colorful close-up of the dying star's nebula was recorded in 2009 by the Hubble Space Telescope's Wide Field Camera 3. NGC 6302 lies about 4,000 light years away in the arachnologically correct constellation of the Scorpion (Scorpius).

NASA/ESA/Hubble (754349)

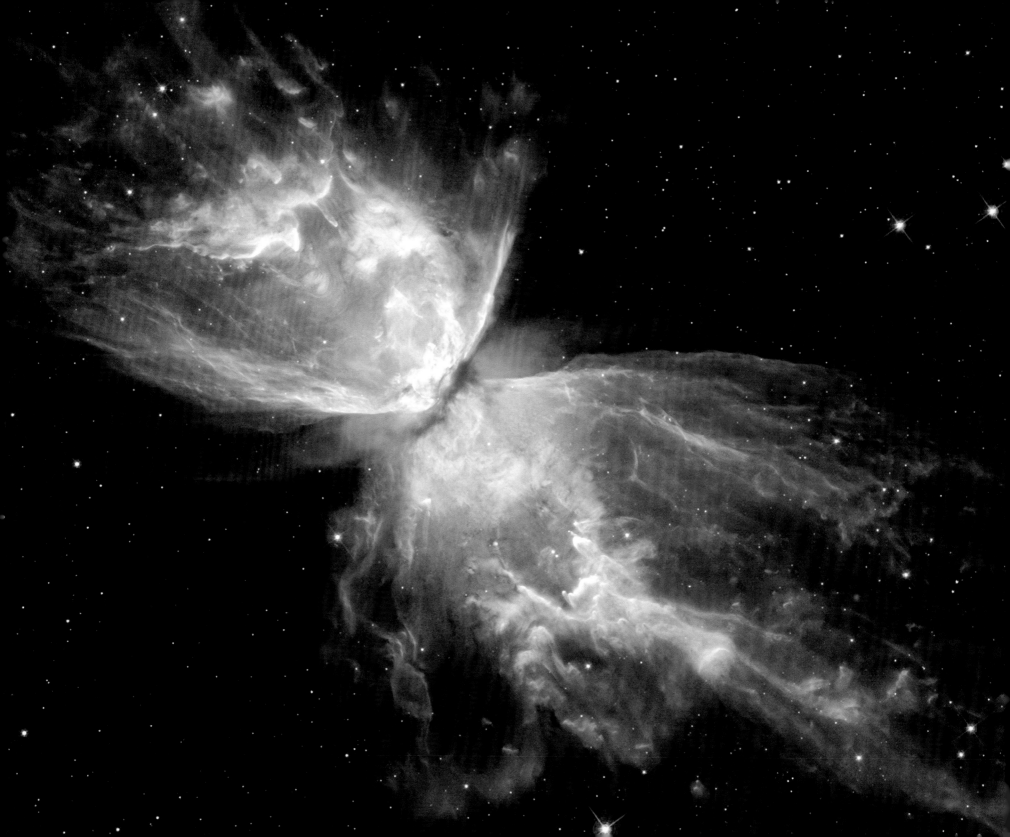

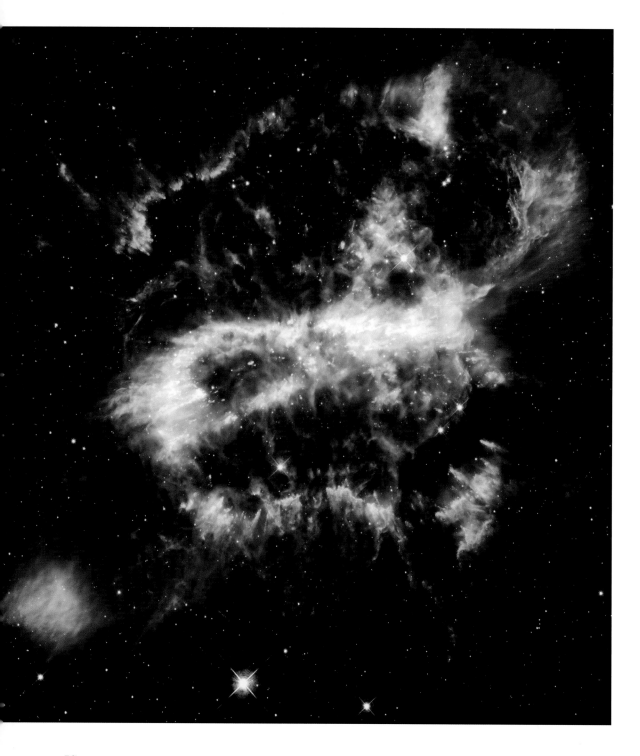

A Cosmic Holiday Ornament, Hubble-Style

'Tis the season for holiday decorating and tree-trimming. Not to be left out, astronomers using NASA's Hubble Space Telescope have photographed a festive-looking nearby planetary nebula called NGC 5189.

The intricate structure of this bright gaseous nebula resembles a glass-blown holiday ornament with a glowing ribbon entwined. Planetary nebulae represent the final brief stage in the life of a medium-sized star like our sun. While consuming the last of the fuel in its core, the dying star expels a large portion of its outer envelope. This material then becomes heated by the radiation from the stellar remnant and radiates, producing glowing clouds of gas that can show complex structures, as the ejection of mass from the star is uneven in both time and direction. A spectacular example of this beautiful complexity is seen in the bluish lobes of NGC 5189. Most of the nebula is knotty and filamentary in its structure. As a result of the mass-loss process, the planetary nebula has been created with two nested structures, tilted with respect to each other, that expand away from the center in different directions. NASA/Hubble (715715)

The Day the Earth Smiled

In this rare image taken on July 19, 2013, the wide-angle camera on NASA's *Cassini* spacecraft has captured Saturn's rings and our planet Earth in the same frame. Earth, which is 1.44 billion kilometers (898 million miles) away in this image, appears as a blue dot at center right (above "those men" in the Irwin quotation). The other bright dots nearby are stars.

This is only the third time ever that Earth has been imaged from the outer solar system. The acquisition of this image marked the first time that inhabitants of Earth knew in advance that their planet was being imaged. That opportunity allowed people around the world to join together in social events to celebrate the occasion.

The Cassini-Huygens mission is a co-operative project of NASA, the European Space Agency and the Italian Space Agency. The Jet Propulsion Laboratory, a division of the California Institute of Technology in Pasadena, manages the mission for NASA's Science Mission Directorate, Washington, D.C. The Cassini orbiter and its two onboard cameras were designed, developed and assembled at JPL. The imaging operations center is based at the Space Science Institute in Boulder, Colorado.

NASA/JPL-Caltech/Space Science Institute (PIA17171)

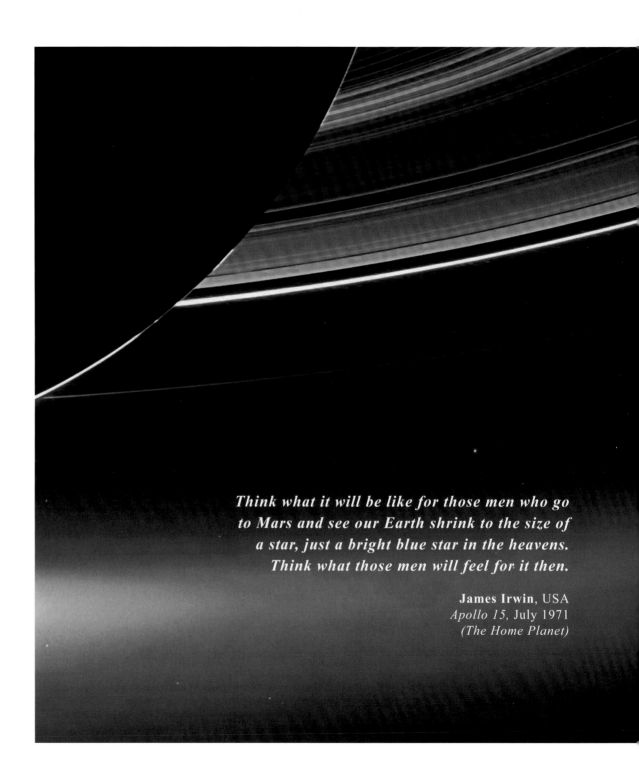

Think what it will be like for those men who go to Mars and see our Earth shrink to the size of a star, just a bright blue star in the heavens. Think what those men will feel for it then.

James Irwin, USA
Apollo 15, July 1971
(The Home Planet)

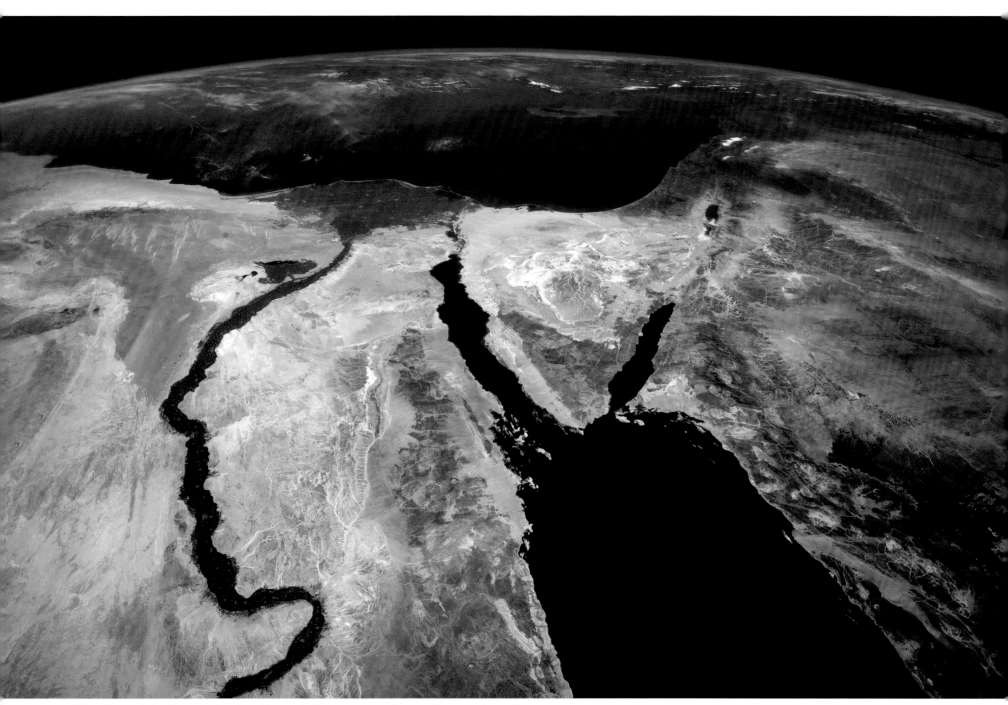

"The Nile and the Sinai, to Israel and beyond. One sweeping glance of human history."
Chris Hadfield photo, © Government of Canada/NASA (March 20, 2013 – iss035-e-007148)

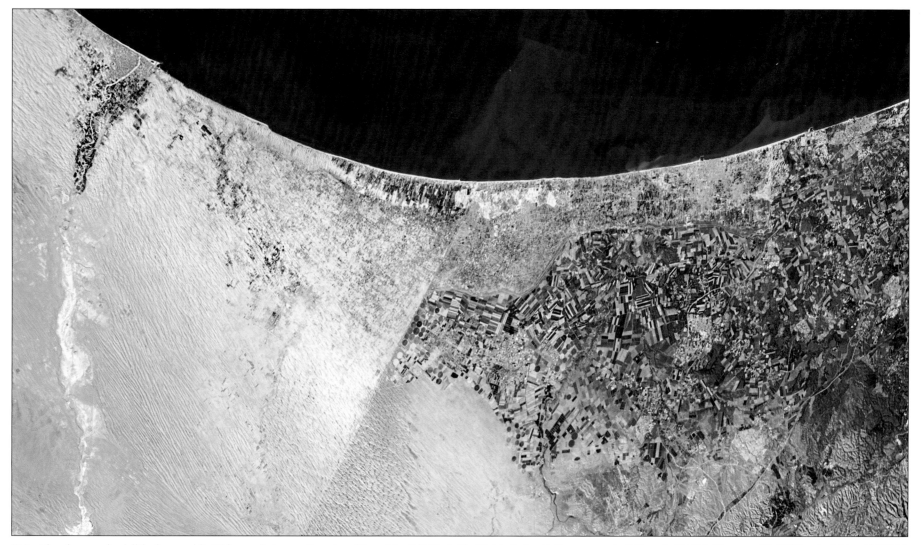

"Most borders are invisible from orbit. This one between Egypt and Israel isn't." Chris Hadfield photo, © Government of Canada/NASA (January 13, 2013 – iss034-e-0288723

A clearly visible line marks about 80 kilometers (50 miles) of the international border between Egypt and Israel. The reason for the color difference is likely a higher level of grazing by the Bedouin-tended animal herds on the Egyptian side of the border (left). Israel has mastered the artful use of water in the desert, as evidenced dramatically here by the deep shades of green.

The densely populated Gaza Strip, home to about 1.7 million Palestinians, is the blue tinted sliver of land extending along the southern Mediterranean from the Egyptian border. It is 41 kilometers (25 miles) long, and from 6 to 12 kilometers (3.7 to 7.5 miles) wide, with a total area of 365 square kilometers (141 square miles).

Just north of the border between Egypt and Sudan lies the Aswan High Dam, a huge rockfill dam that captures the world's longest river, the Nile, in the world's third largest reservoir, Lake Nasser. The dam, known as Saad el Aali in Arabic, was completed in 1970 after ten years of work.

Egypt has always depended on the water of the Nile River. The Nile River has a total length of 6,695 kilometers (4,160 miles) from source to sea.

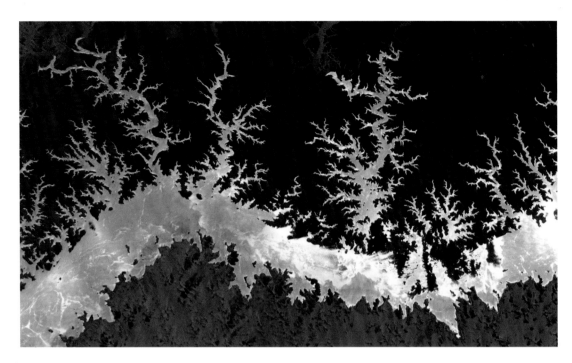

Sunglint (light reflected off the water surface) on the lake makes Lake Nasser easily visible from space.
NASA (January 23, 2005 – iss010-e-014618)

"You know you're a big dam when you a) have your own airport and b) are visible from space." Chris Hadfield photo
© Government of Canada/NASA (January 23, 2013 – iss034-e-033662)

(Opposite) "Taming the Nile—the Aswan Dam's reservoir, Lake Nasser, highlighted in sun glint"
Chris Hadfield photo, © Government of Canada/NASA (January 23, 2013 – iss034-e-033660)

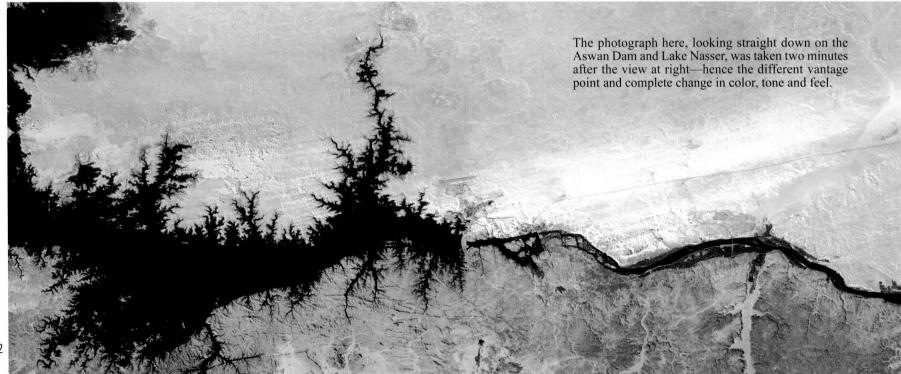

The photograph here, looking straight down on the Aswan Dam and Lake Nasser, was taken two minutes after the view at right—hence the different vantage point and complete change in color, tone and feel.

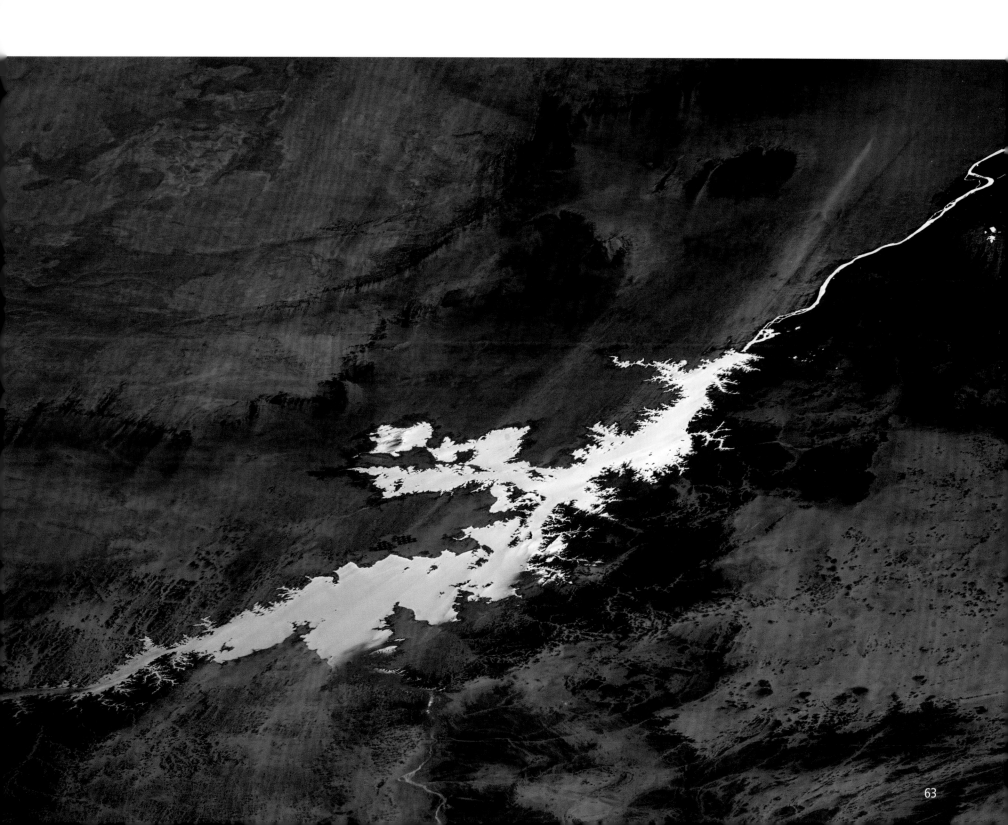

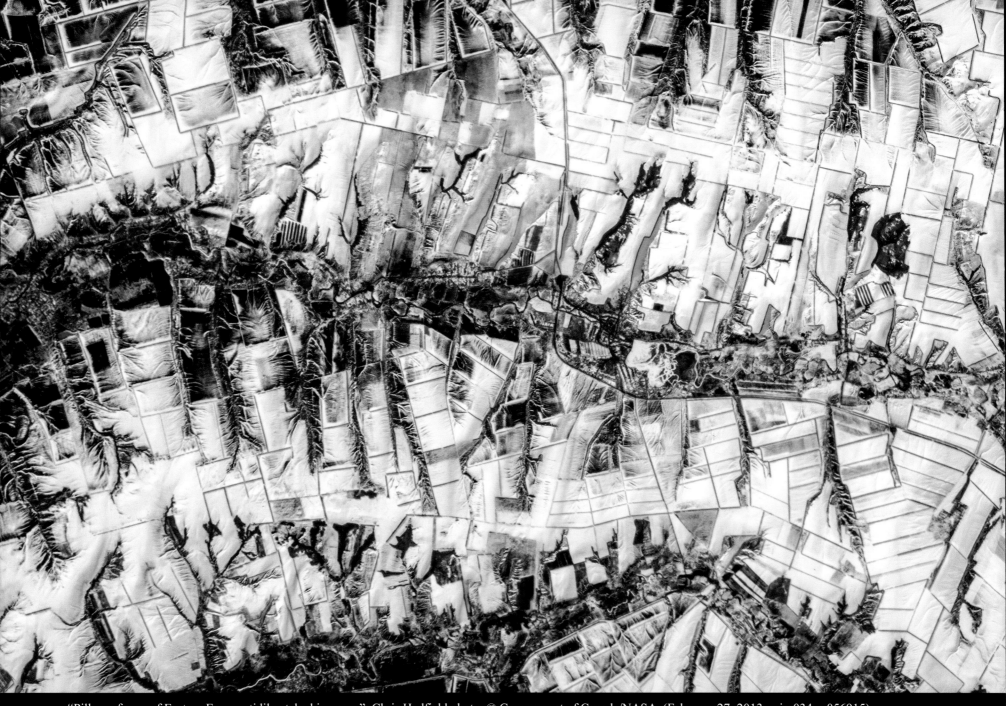

"Pillowy farms of Eastern Europe, tidily etched in snow." Chris Hadfield photo, © Government of Canada/NASA (February 27, 2013 – iss034-e-056915)
Location: Kashary, Russia

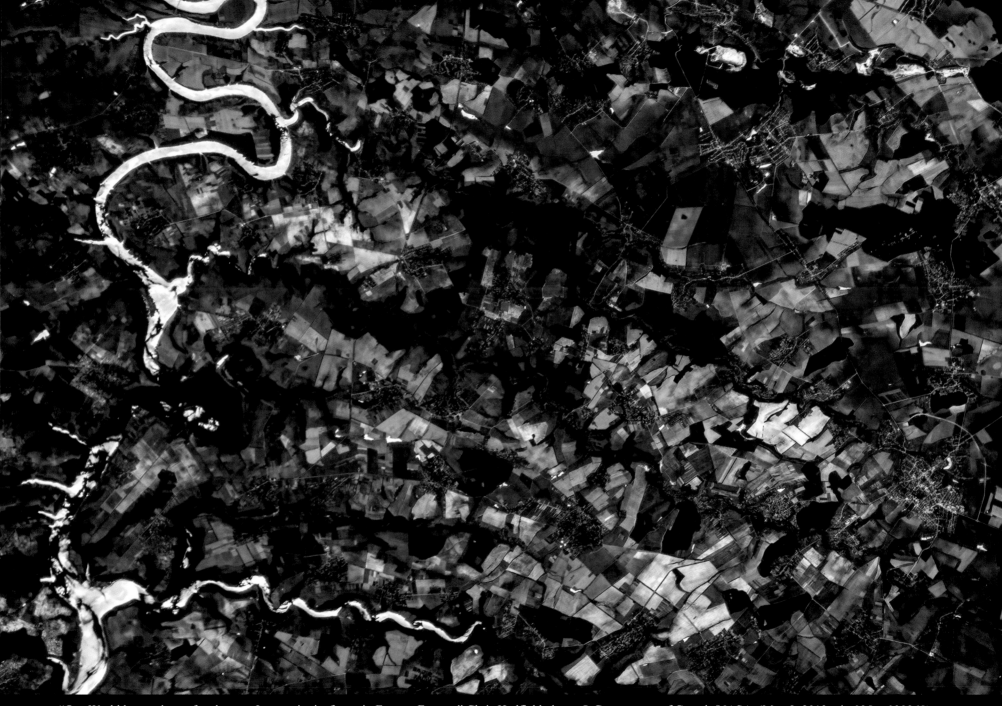

"Our World has such carefree beauty. Impressionist farms in Eastern Europe." Chris Hadfield photo, © Government of Canada/NASA (May 9, 2013 – iss035-e-039268)
Location: the Dniester River; center left lake is Dnistrovs'ke Reservoir in Ukraine.

Seasonal Change

The Zambezi River forms part of the border between Zambia (top) and Namibia. Flowing down a gentle gradient in this region, the Zambezi often spills onto floodplains during the rainy season, with water levels peaking between February and April.

Water levels were high when the Advanced Land Imager (ALI) on NASA's Earth Observing-1 (EO-1) satellite recorded this stretch of the river on March 31, 2013 (top image). For comparison, the bottom image shows the river on August 25, 2012, during the dry season. Both the river and the surrounding floodplain show sharp differences.

The Zambezi River flows through braided channels, and the main channel appears swollen in March 2013; its bluer color indicates greater water depth. But the differences in the floodplain dwarf changes in the channels. Where browns and tans of dried vegetation and burn scars prevail in the dry season, green plant life is revived in the wet season. The water-loving floodplain grasses surrounding the Zambezi River depend on annual floods and seasonal rainfall that is relatively abundant compared to much drier areas to the west.

NASA Earth Observatory images created by Jesse Allen and Robert Simmon.
Caption by Michon Scott and Robert Simmon
(NASA, top 2013090, bottom 2012238)

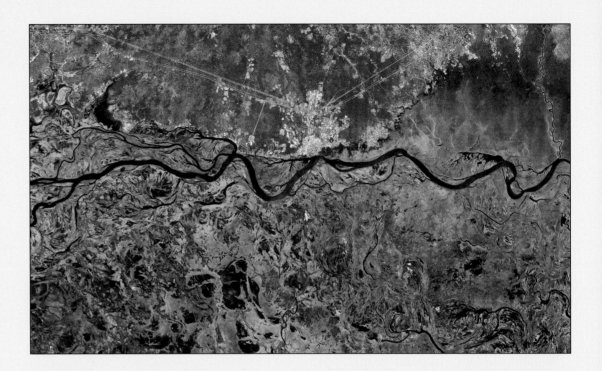

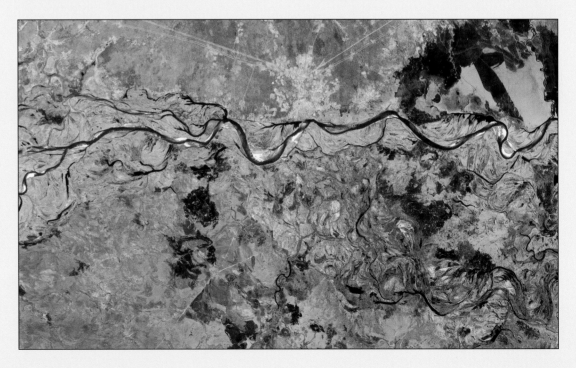

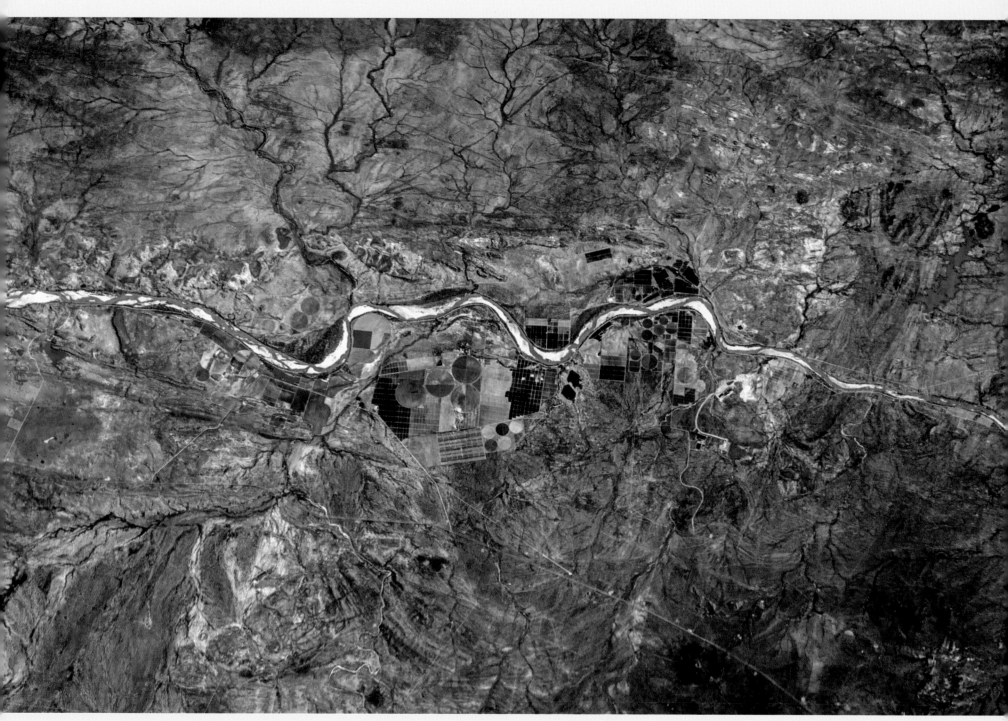

"Intensive agriculture in a forbidding place, southern Africa. Like terraforming on Mars one day?" Chris Hadfield photo, © Government of Canada/NASA (February 23, 2013 – iss034-e-053087) Location: about 40 kilometers west of Beitbridge, South Africa. Zimbabwe lies north of the river.

NASA (June 6, 2009, 20100609)

NASA (June 10, 2010, 20100606)

Flowing southward through Pakistan and emptying into the Arabian Sea, the Indus River has supported agriculture for millennia. Fed by glaciers in the Himalaya and Karakoram mountain ranges—and by Asian monsoon rains—the river experiences substantial fluctuations every year.

Flow is typically highest from mid-July to mid-August, as snow melt and rains spike around the same time. Water flow is lowest from December to February. Because the Indus irrigates an estimated 18 million hectares (44 million acres) of farmland, the landscape changes along with the river.The Thematic Mapper on the Landsat 5 satellite observed these seasonal changes in the Indus River and surrounding lands in Pakistan from June 6, 2009, to June 9, 2010. These natural-color images focus on the area around the Guddu (or Gudu) Barrage, just south of the border between Punjab and Sindh Provinces.

Working around the river's ups and downs, and using an extensive irrigation infrastructure, Pakistani farmers coax both summer and winter crops out of the land. According to Dath Mita of the U.S. Foreign Agricultural Service, Pakistan has two principal growing seasons, with cotton and rice grown from May to November (Kharif season) and wheat from November to May (Rabi season). Other crops also thrive in the area around the Guddu Barrage, including corn, rice, wheat, cotton, millet, and sugar cane.

Strong monsoons have likely occurred in southwest Asia for millions of years. Likewise, runoff down the Indus River has supported irrigation agriculture in Pakistan for 4,000 years. Even now, the majority of Pakistan's population lives in rural areas, with direct links to farming. Although the Indus River can cause catastrophic damage when flooded, the river and the irrigation infrastructure surrounding it sustain a population of millions where water is generally scarce.

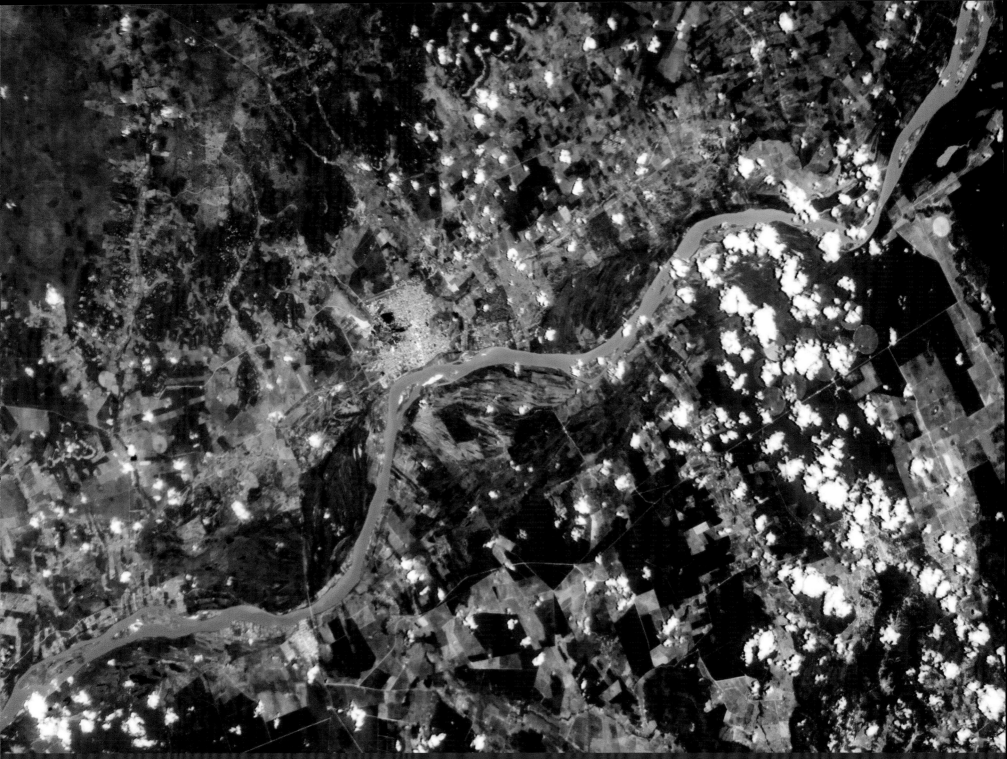

"Square Brazilian city on a red, red river?" Chris Hadfield photo, © Government of Canada/NASA (March 29, 2013 – iss035-e-011820)
Another continent, another hemisphere and water is less of a problem. Location: city of Januária on the São Francisco River in Brazil

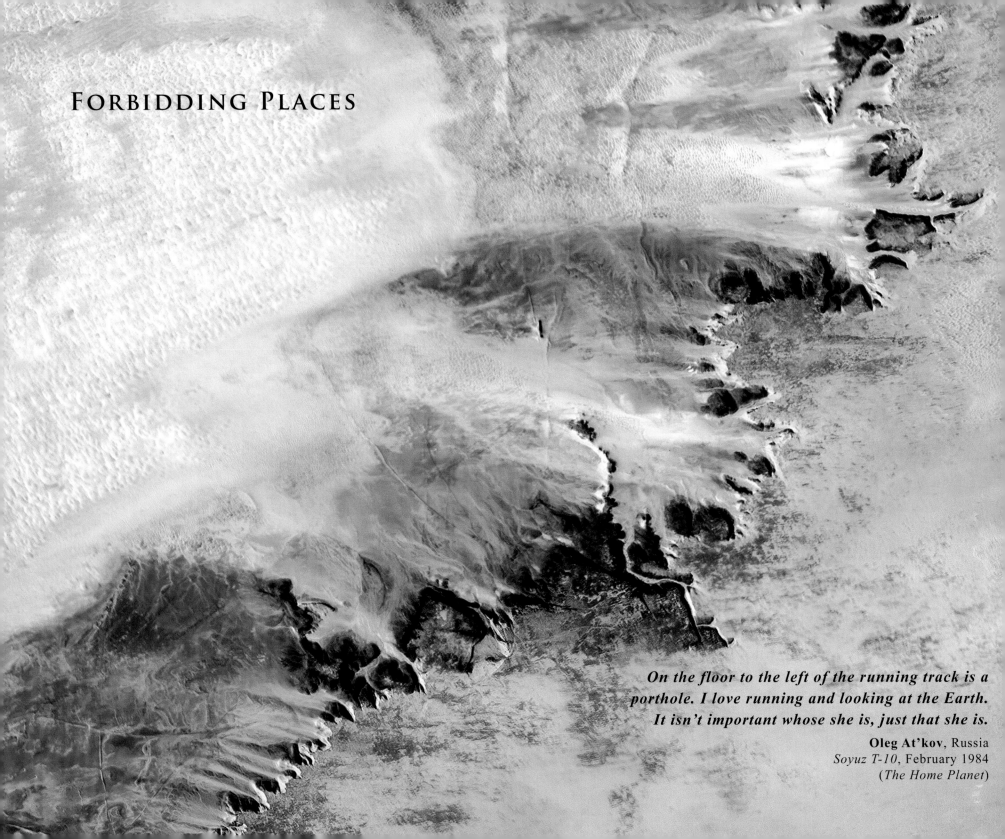

FORBIDDING PLACES

On the floor to the left of the running track is a porthole. I love running and looking at the Earth. It isn't important whose she is, just that she is.

Oleg At'kov, Russia
Soyuz T-10, February 1984
(*The Home Planet*)

"Tonight's Finale: There is an undeniable beauty in human imagination. What do you see in this Saharan cloud?"
Chris Hadfield photo, © Government of Canada/NASA (February 13, 2013 – iss034-e-047088) Location: northwest Mali, near Timbuktu

"Arid fingers of sand-blasted rock look like they're barely holding on against the hot Saharan wind."
Chris Hadfield photo, © Government of Canada/NASA (February 13, 2013 – iss034-e-047082)
Location: about 100 kilometers north of Néma, Mauritania

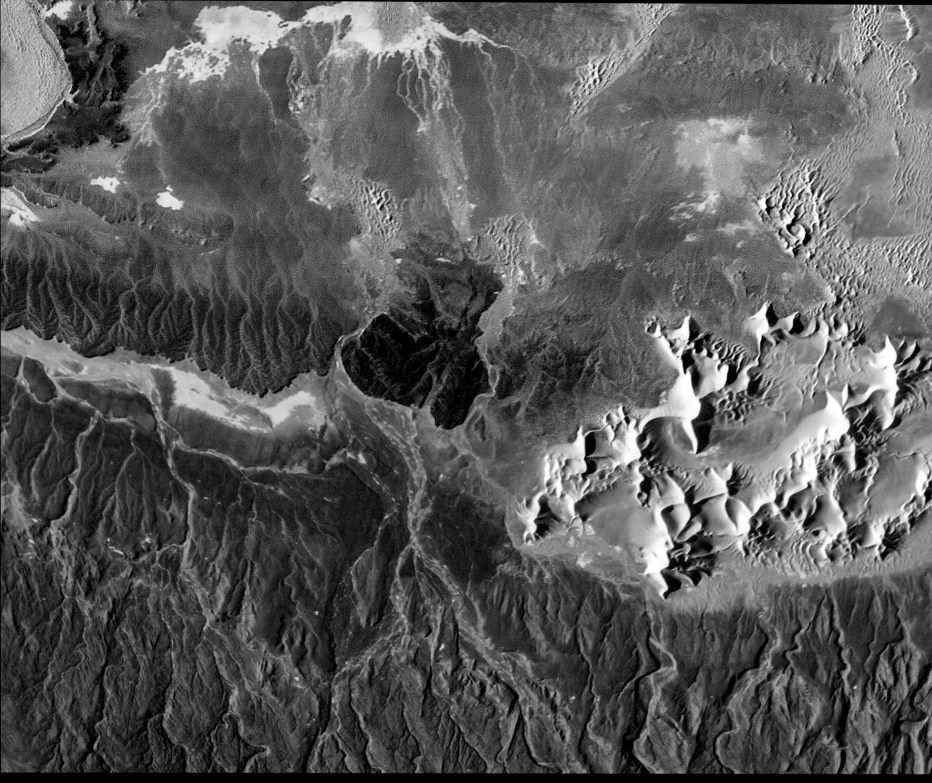

"I don't think that sand came from those rocks." Chris Hadfield photo, © Government of Canada/NASA (February 13, 2013 – iss034-e-047113)
Location: about 100 kilometers northeast of Arak, Algeria

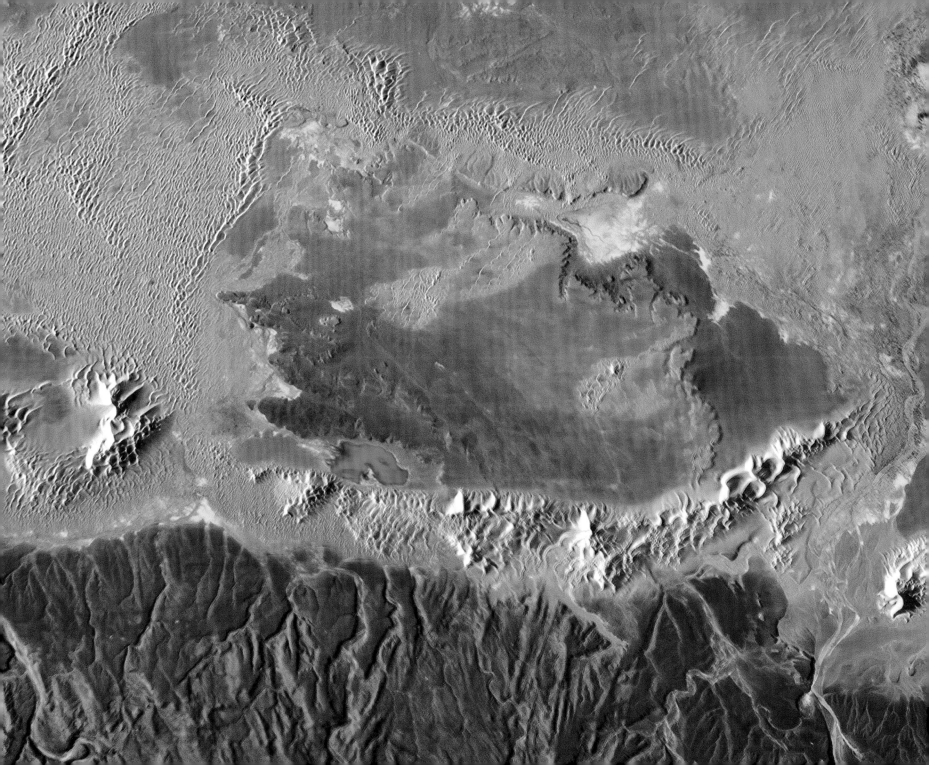

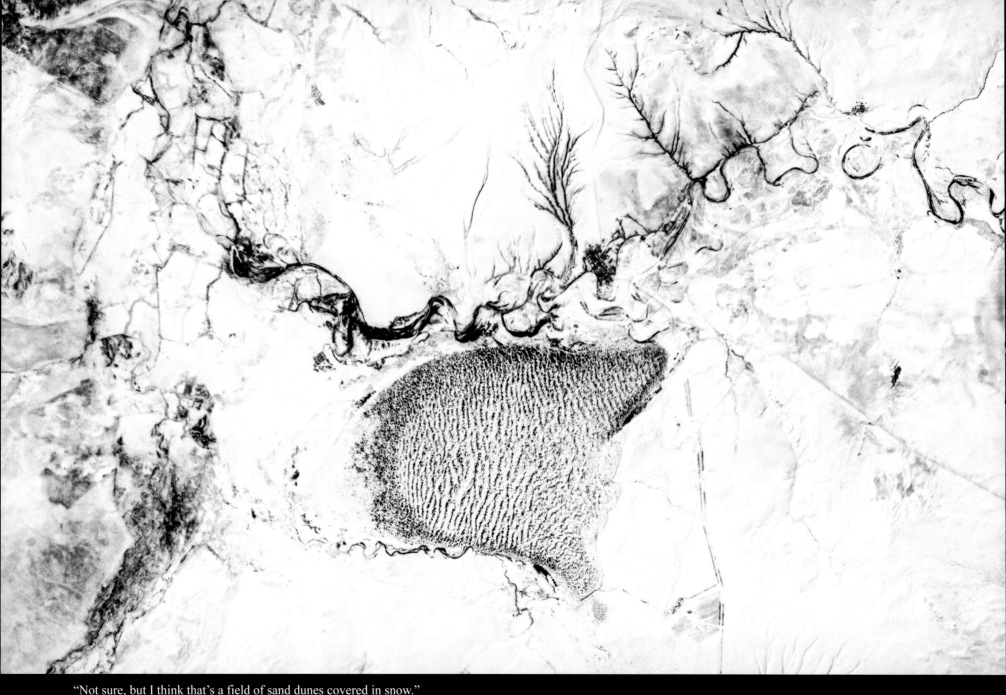

"Not sure, but I think that's a field of sand dunes covered in snow."

Chris Hadfield photo, © Government of Canada/NASA (February 26, 2013 – iss034-e-054924) Location: Ooyl River, Kazakhstan

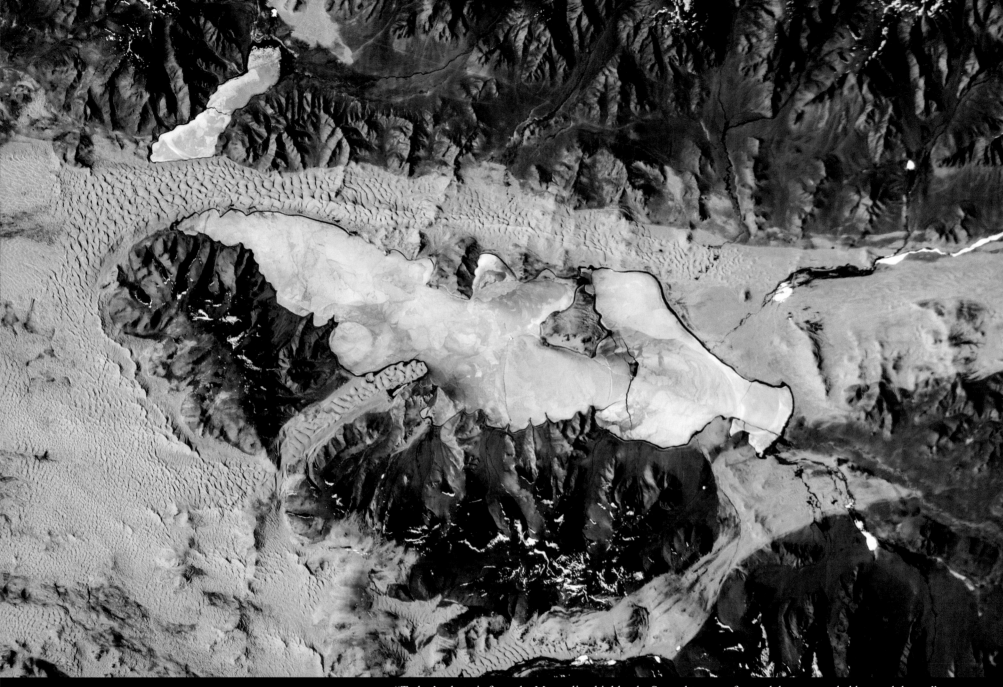

"Today's photo is from the Mongolian highlands. Surreal to see a frozen lake surrounded by sand dunes."
Chris Hadfield photo, © Government of Canada/NASA (May 2, 2013 – iss035-e-033739 Location: Khar Lake in the Zavkhan aimag province in western Mongolia.

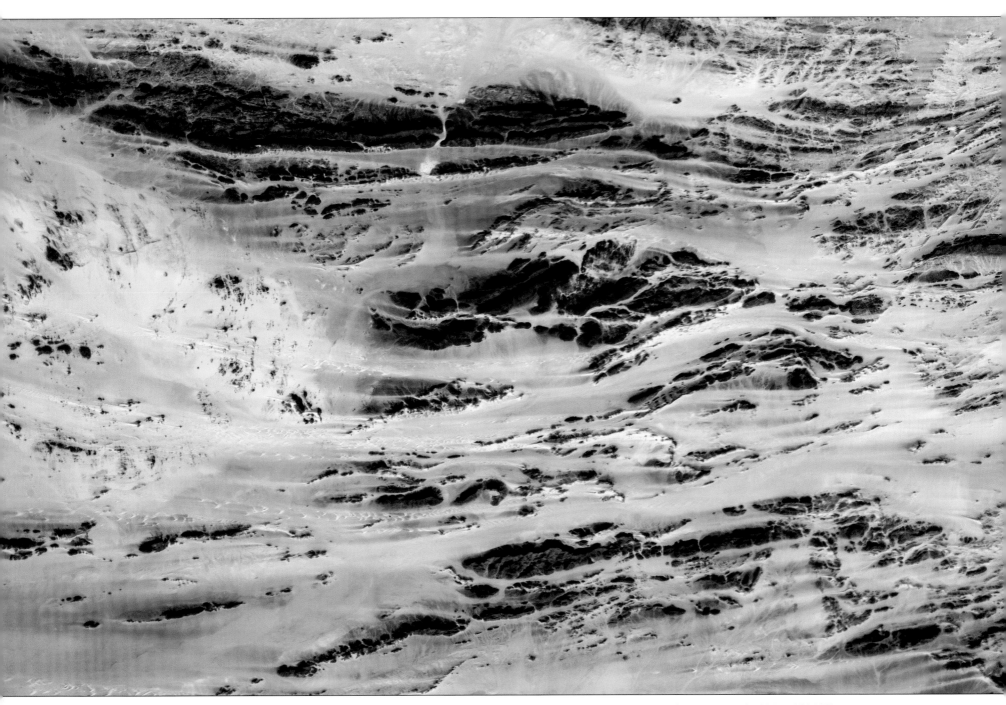

"Like the sand came crashing over the shore of rock." Chris Hadfield photo, © Government of Canada/NASA (March 25, 2013 – iss035-e-009649)
Location: 375 kilometers west of Ad Dabbah, Sudan

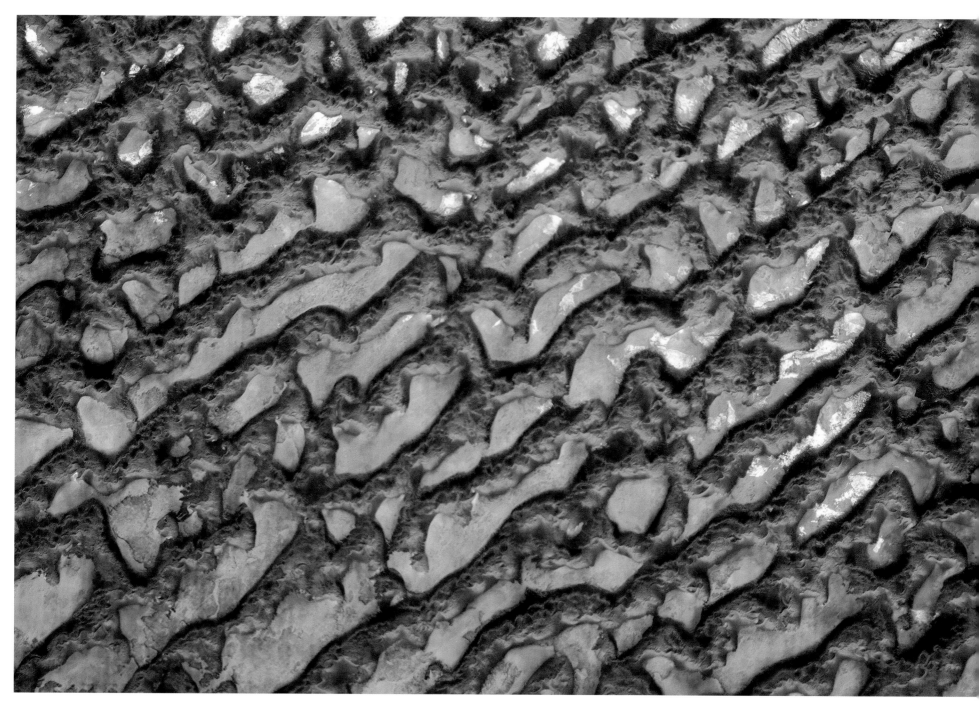

"These mouthwatering generous folds of icing are actually Saudi sand." Chris Hadfield photo, © Government of Canada/NASA (March 22, 2013 – iss035-e-007370)
Location: dunes straddling the Saudi-Omani border

"Tonight's finale: Angry-looking smoke cloud in western Australia. Good night, Earth!"
Chris Hadfield photo, © Government of Canada/NASA (January 26, 2013 – iss034-e-030648)
Location: near Warburton, Western Australia

The Australian Outback

The Outback is a vast, remote, arid area of Australia. The term "the outback" is generally used to refer to locations that are comparatively more remote than those areas named "the bush" which, colloquially, can refer to any lands outside the main urban areas. The Outback is home to a diverse set of animal species, such as the red kangaroo, emu and dingo. The Dingo Fence was built to restrict dingo movements into agricultural areas in the southeast of the continent. The marginally fertile parts are primarily used as rangelands and have been traditionally used for sheep or cattle grazing, on cattle stations that are leased from the Federal Government.

(Opposite) "If Picasso painted lakes..." Chris Hadfield photo, © Government of Canada/NASA (January 15, 2013 – iss034-e-029151) Kinchega National Park, 75 kilometers. southeast of Broken Hill, Australia

(Overleaf) "The Australian Outback is effortlessly, crazily beautiful."
Chris Hadfield photo, © Government of Canada/NASA (April 3, 2013 – iss035-e-014024)
Location: Davenport Range of Australia's Northern Territory, 250 kilometers northeast of Alice Springs

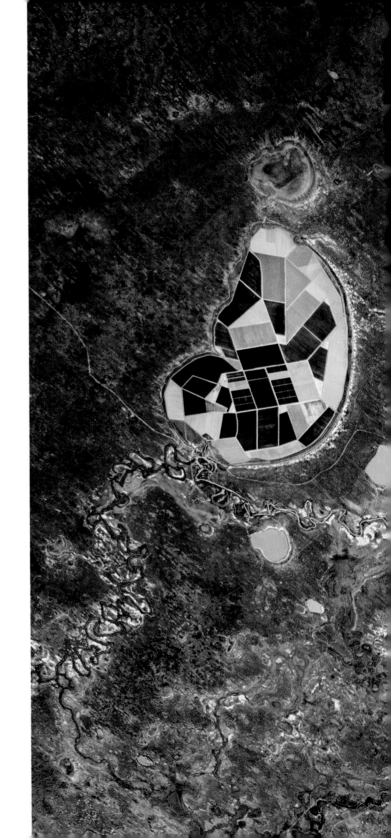

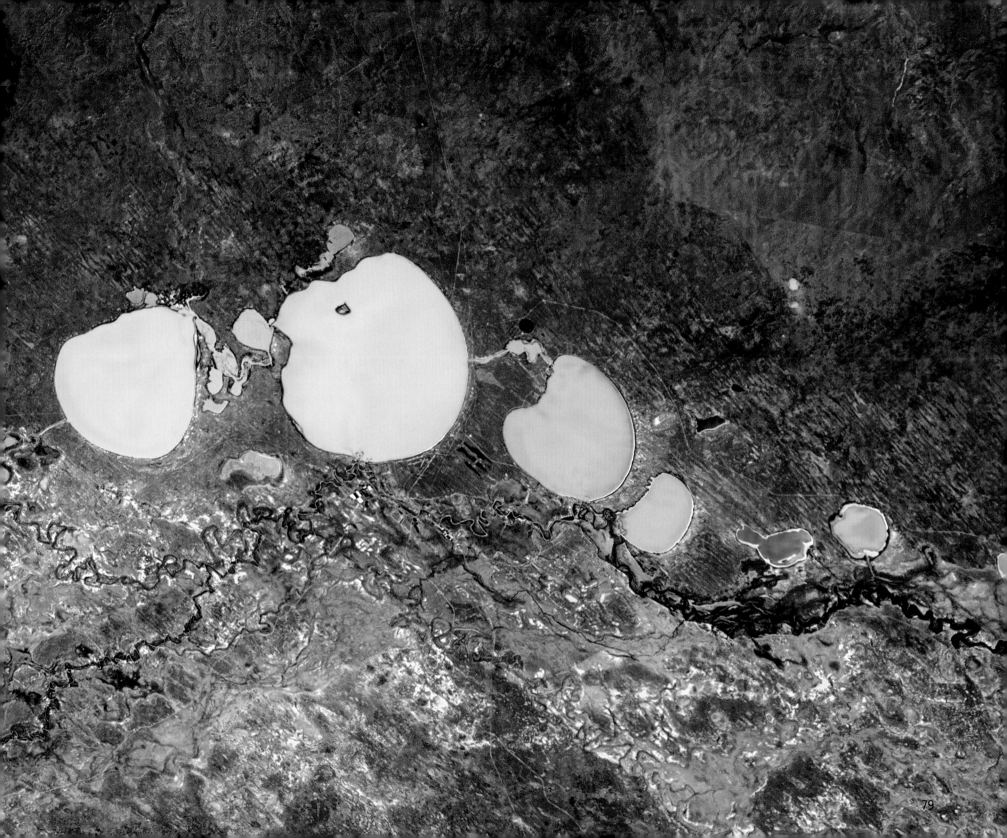

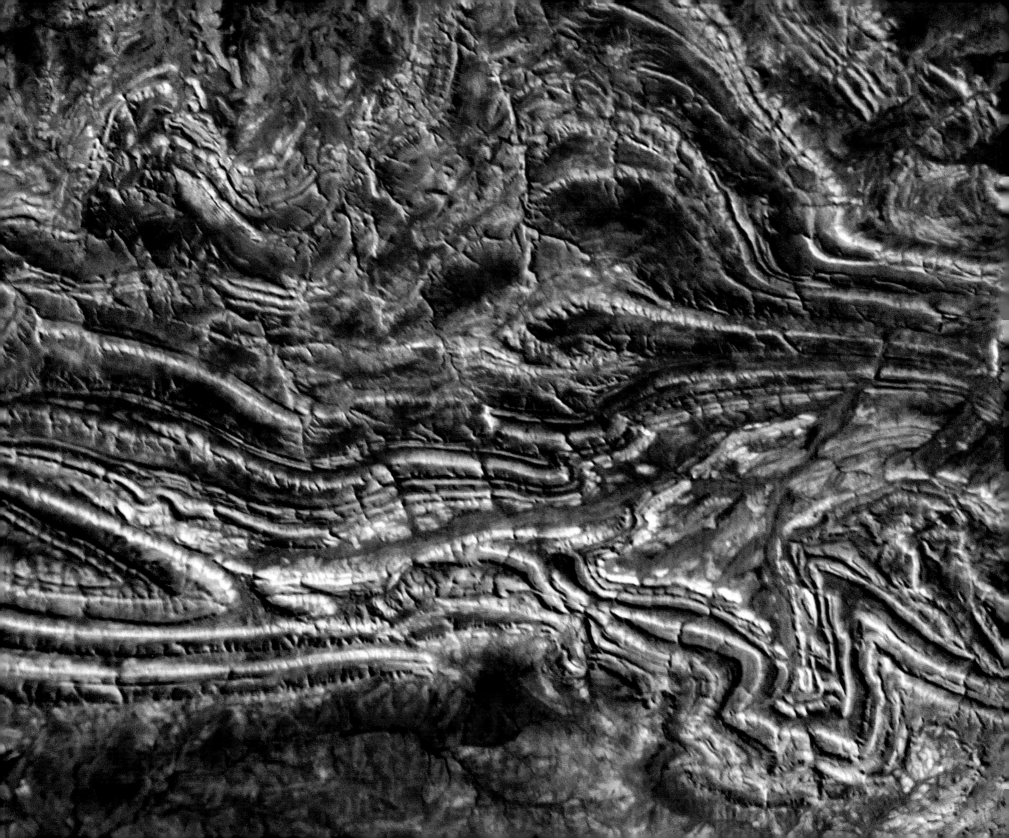

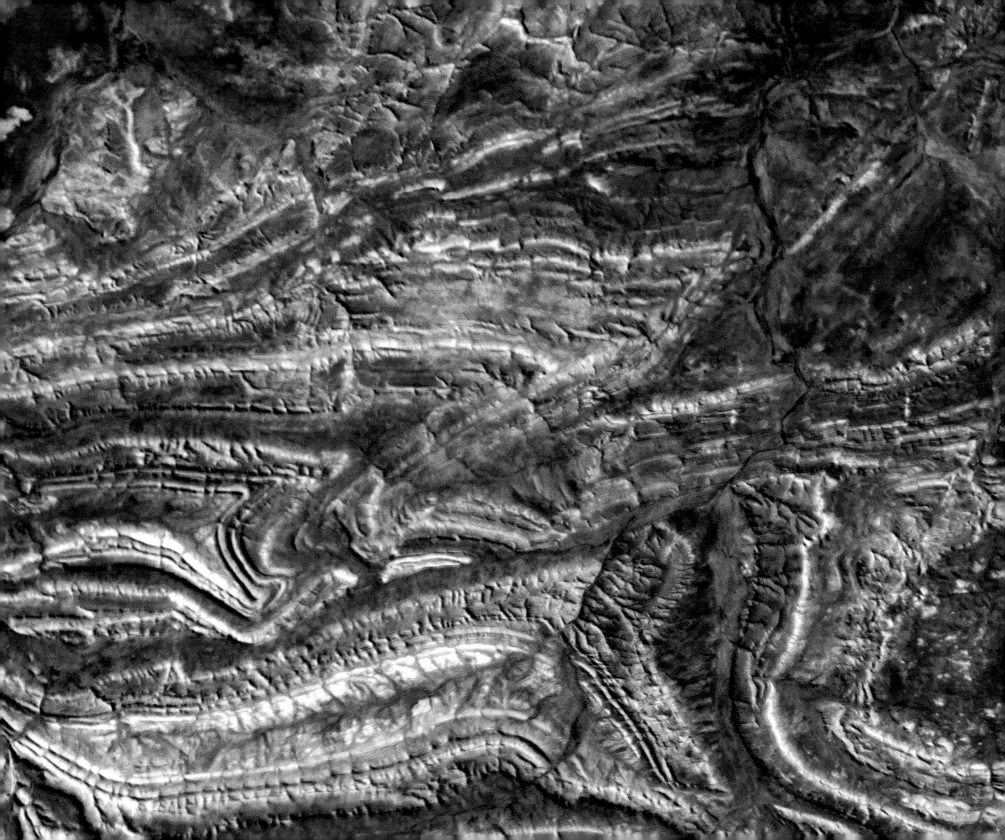

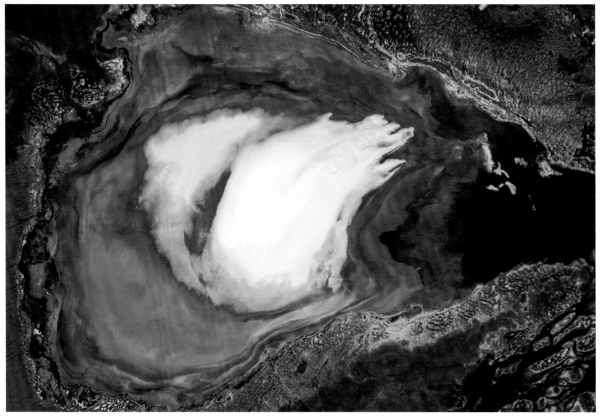

"Winged white puffball on an oyster half-shell (actually a dry lake in Australia)!"
Chris Hadfield photo, © Government of Canada/NASA (January 17, 2013 – iss034-e-042950)
Location: Lake Yamma Yamma, 20 kilometers west of Tanbar, Australia

"The Outback is full of scary faces, staring up in forbidding horror."
Chris Hadfield photo, © Government of Canada/NASA (January 15, 2013 – iss034-e-042958)
Location: the Bulloo River, 15 kilometers west of Thargomindah, Australia

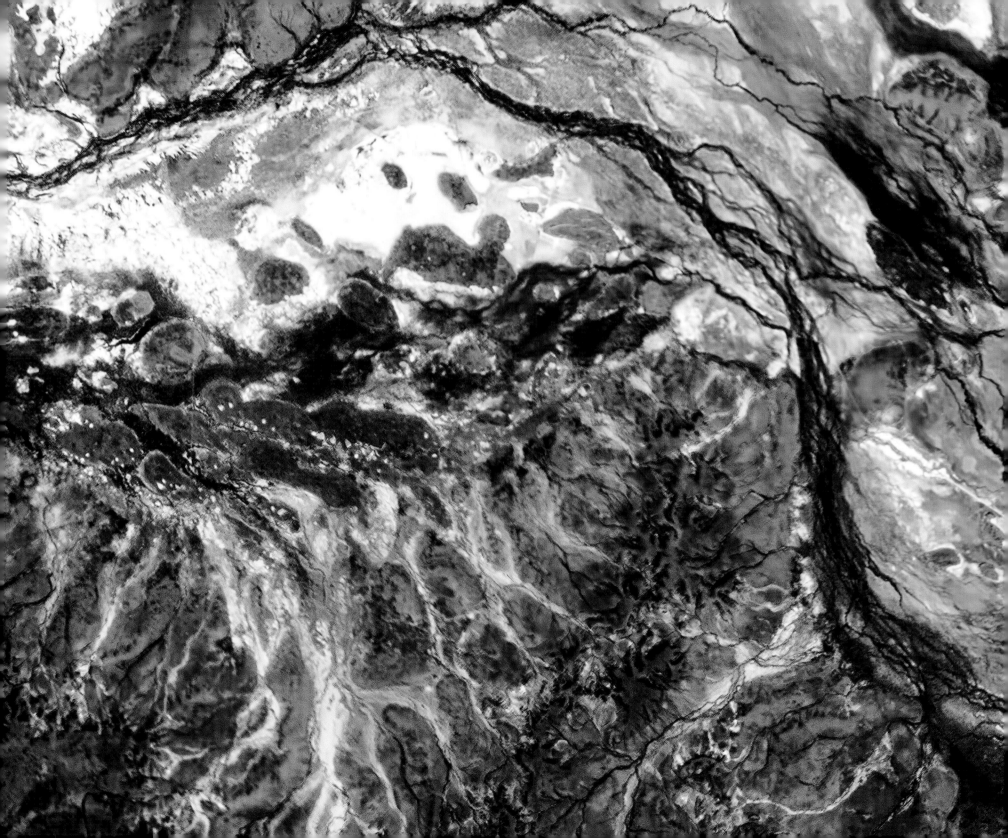

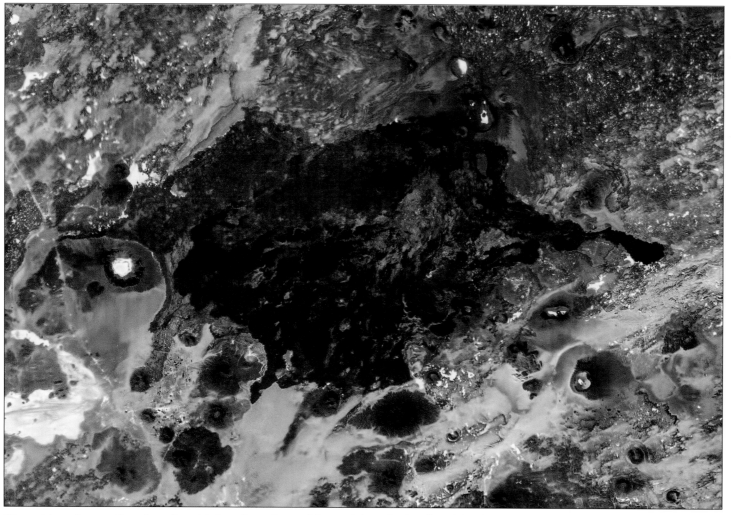

"It must have been quite a day when this lava flowed out of the earth into the Saudi Arabian desert.."
Chris Hadfield photo, © Government of Canada/NASA (January 10, 2013 – iss034-e-027738)

"Death Valley looking every inch its name."
Chris Hadfield photo, © Government of Canada/NASA
(March 10, 2013– iss034-e-066109)

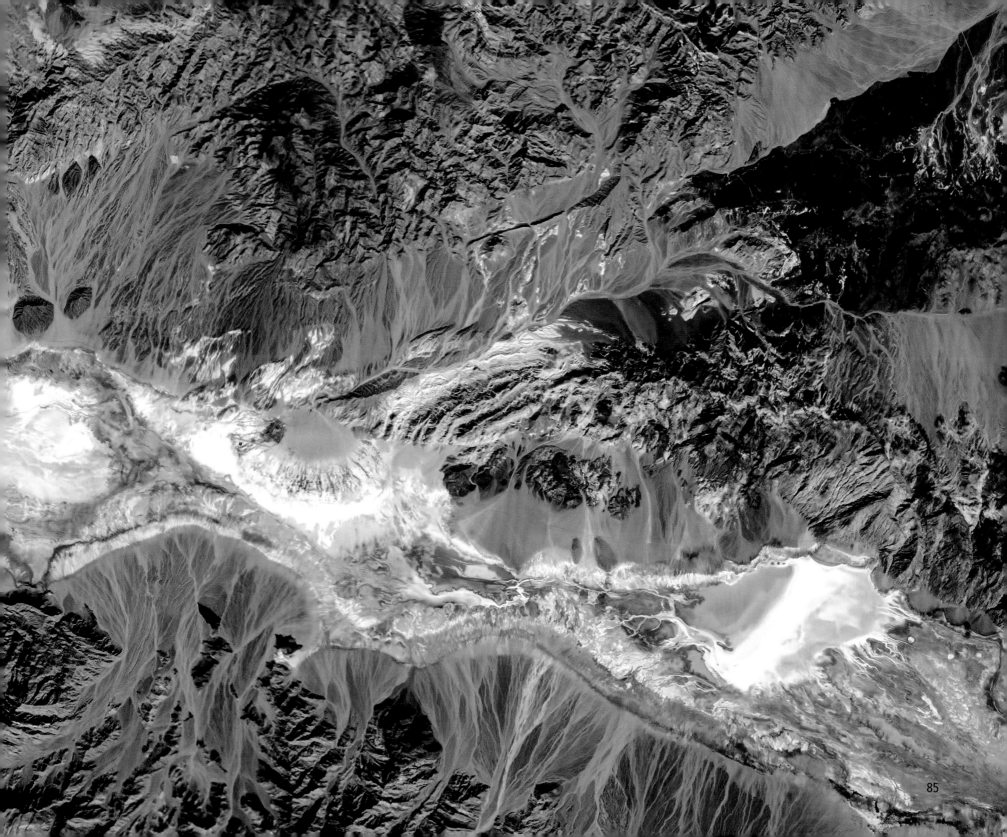

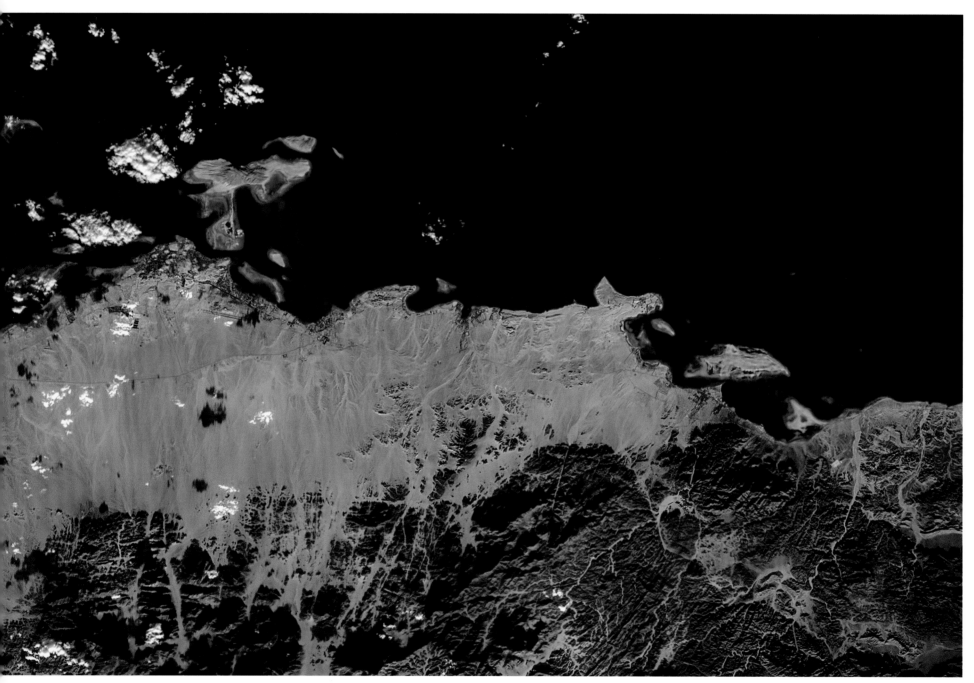

"Hurghada, Egypt, a popular tourism and diving site on the Red Sea" Chris Hadfield photo, © Government of Canada/NASA (January 6, 2013 – iss034-e-023965)

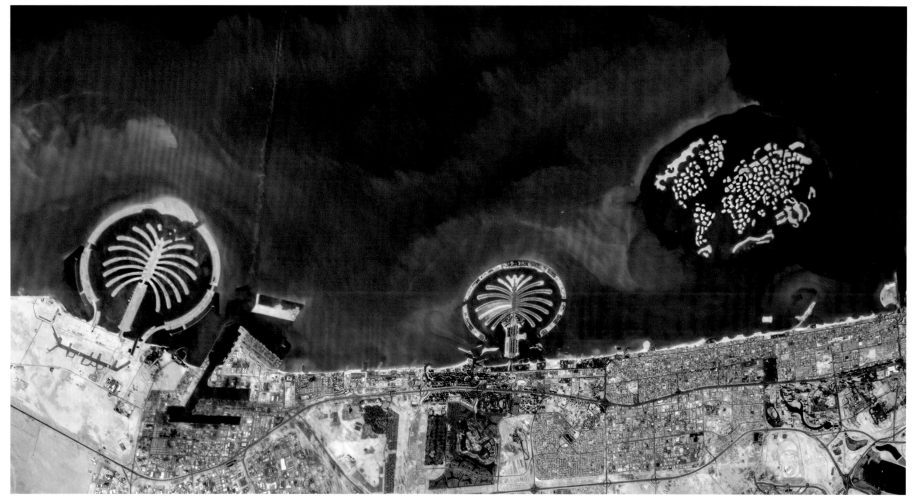

"Some of the things we build for ourselves are puzzlingly visible from space." Chris Hadfield photo, © Government of Canada/NASA (February 20, 2013 – iss034-e-067831)

Transformation

The Palm Jumeirah is an artificial archipelago created using land reclamation by Nakheel, a real estate developer in Dubai and creator of several land reclamation projects, including the Palm Islands and the Dubai Waterfront. Nakheel operates under the umbrella of Dubai World, which manages various businesses on behalf of the Dubai government. The executive chairman of Al Nakheel is Sheikh Ahmed bin Saeed Al Maktoum. Among the three islands, there will be over 100 luxury hotels, exclusive residential beachside villas and apartments, marinas, water theme parks, restaurants, shopping malls, sports facilities and health spas.

SWIRLS

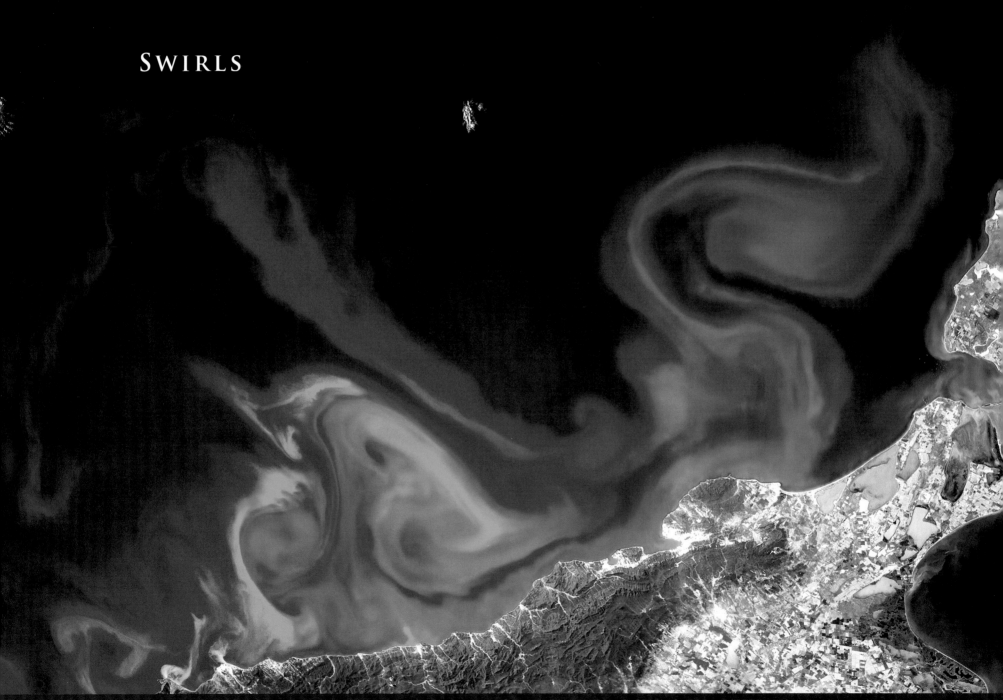

"Dr. Seuss-inspired swirls in the Black Sea." Chris Hadfield photo, © Government of Canada/NASA (May 2, 2013 – iss035-e-040034)
Location: Sochi, host city of the 2014 Winter Olympics, is just visible in the lower left corner of this photograph. The town (and strait) of Kirch are at center right.

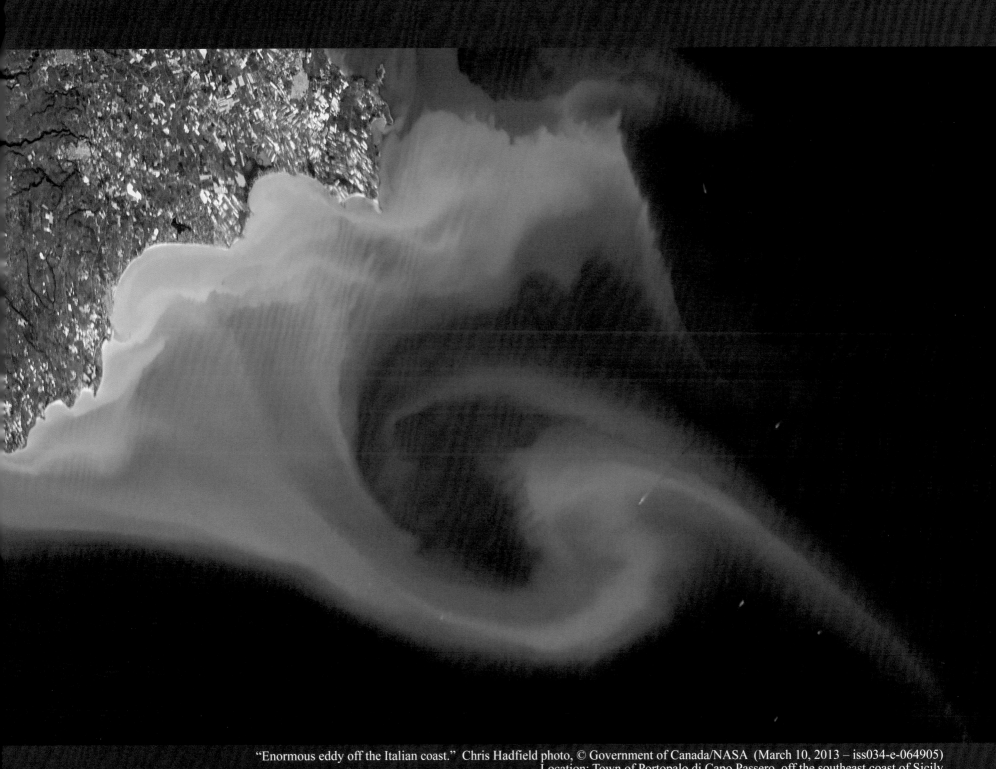

"Enormous eddy off the Italian coast." Chris Hadfield photo, © Government of Canada/NASA (March 10, 2013 – iss034-e-064905)
Location: Town of Portopalo di Capo Passero, off the southeast coast of Sicily

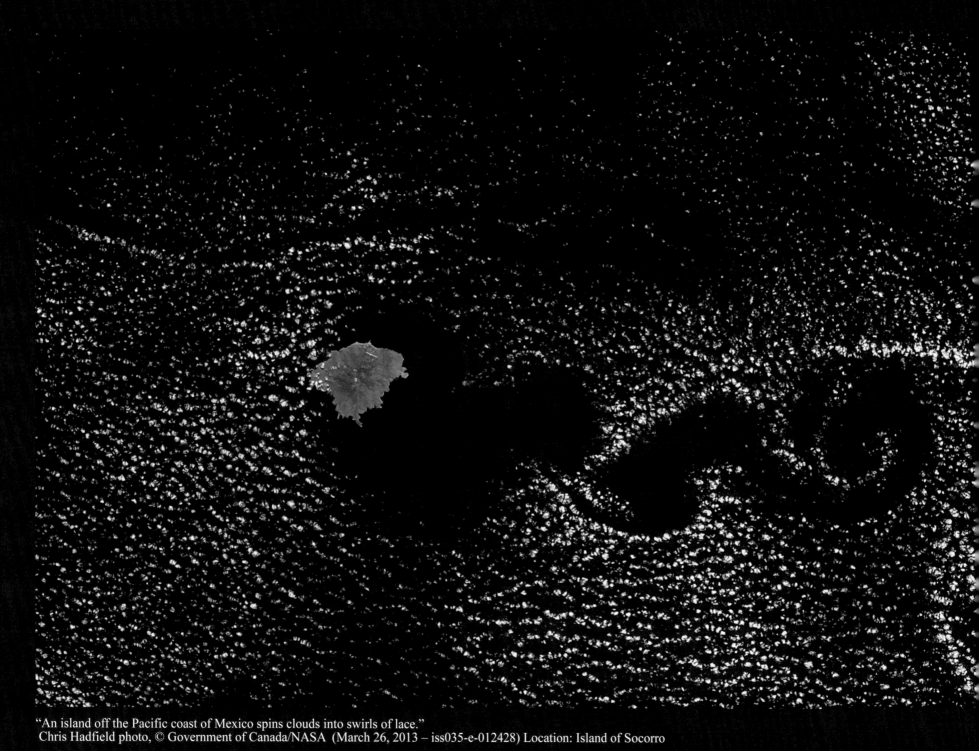

"An island off the Pacific coast of Mexico spins clouds into swirls of lace."
Chris Hadfield photo, © Government of Canada/NASA (March 26, 2013 – iss035-e-012428) Location: Island of Socorro

The Pacific. You don't comprehend it by looking at a globe, but when you're traveling at four miles a second and it still takes you twenty-five minutes to cross it, you know it's big.

Paul Weitz, USA
Skylab-2 (SL-2), 1973
STS-6, 1983

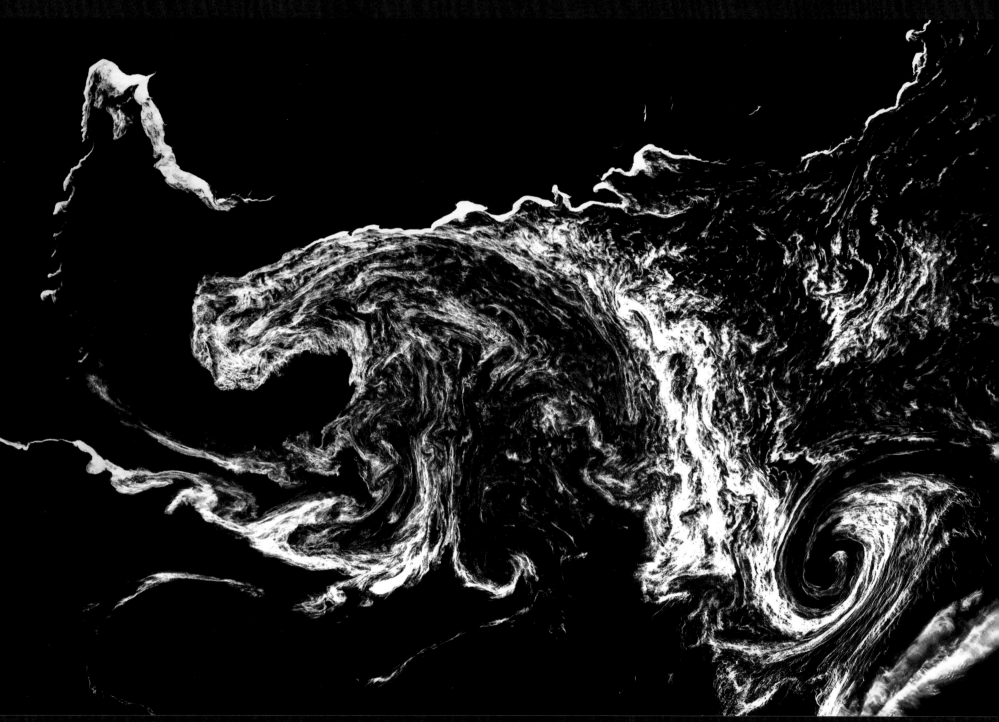

"Psychedelic ice swirls off the northern coast of Japan." Chris Hadfield photo, © Government of Canada/NASA (April 16, 2013 – iss035-e-022796)

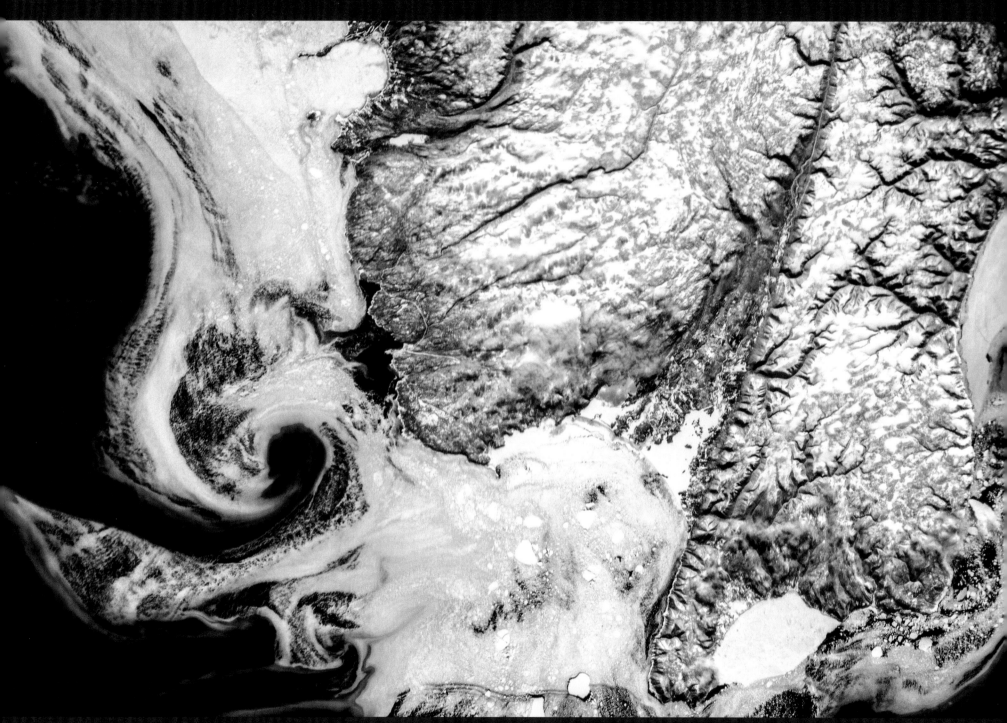

"Rock and water churning it up in Newfoundland." Chris Hadfield photo, © Government of Canada/NASA (February 24, 2013 – iss034-e-054829)

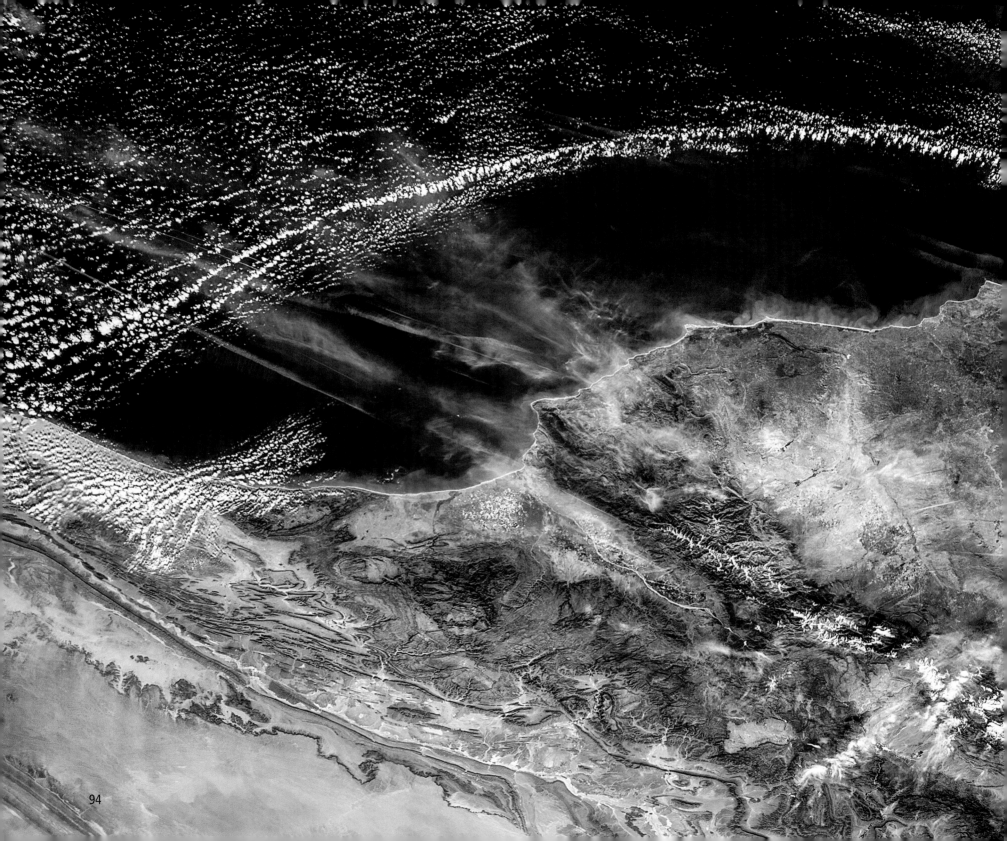

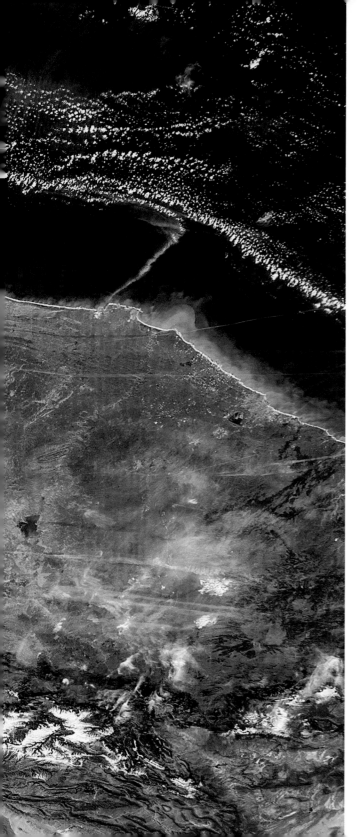

"Sable Island like a snake slithering smoothly through the cloud."
Chris Hadfield photo, © Government of Canada/NASA (March 10, 2013 – iss034-e-066379)
Location: off the Atlantic coast of Nova Scotia

"Like a red tide, a wave of rock in the Chinese highlands."
Chris Hadfield photo, © Government of Canada/NASA (May 9, 2013 – iss035-e-009578)

"Very strange cloud pattern off Morocco's coast. Like Marrakesh has a force field."
Chris Hadfield photo, © Government of Canada/NASA (March 28, 2013 – iss035-e-009758)

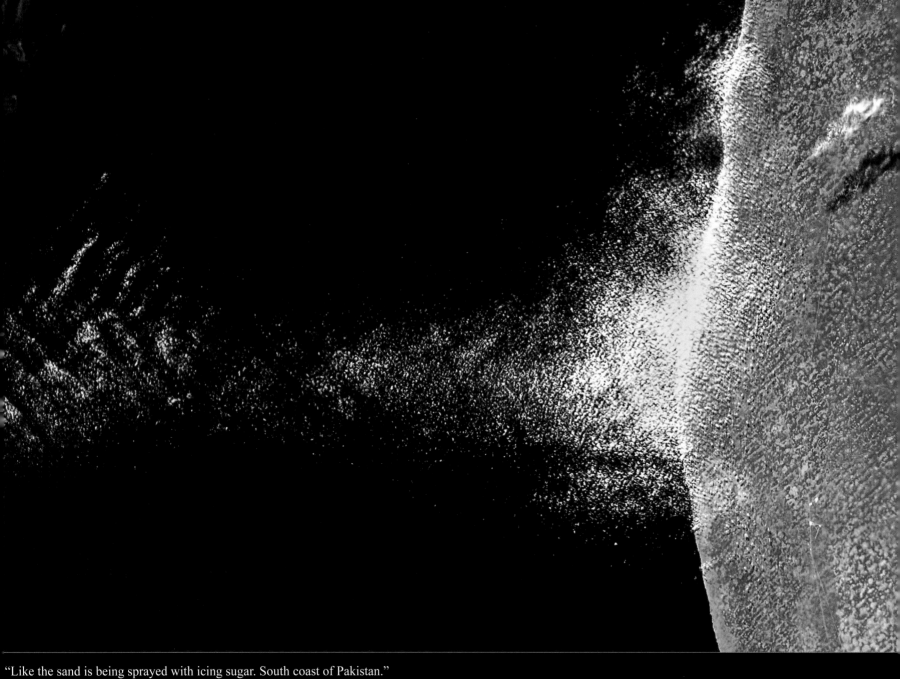

"Like the sand is being sprayed with icing sugar. South coast of Pakistan."

Chris Hadfield photo. © Government of Canada/NASA. (January 17, 2013 – iss034-e-030655) Location: 15 kilometers west of Pasni, Pakistan.

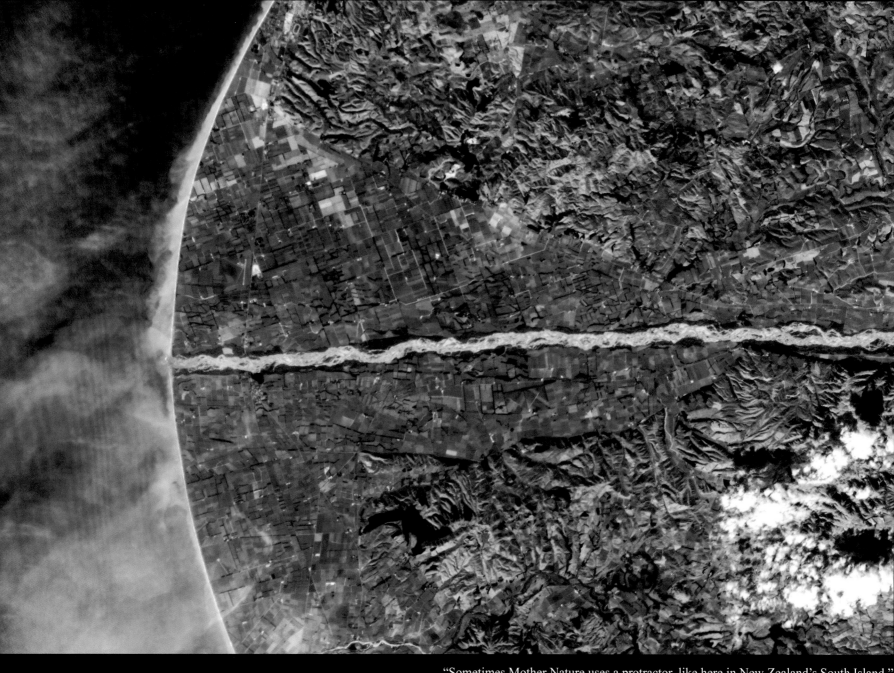

"Sometimes Mother Nature uses a protractor, like here in New Zealand's South Island."
Chris Hadfield photo, © Government of Canada/NASA (April 5, 2013 – iss035-e-017032) Location: Waitaki River, north of Oamaru

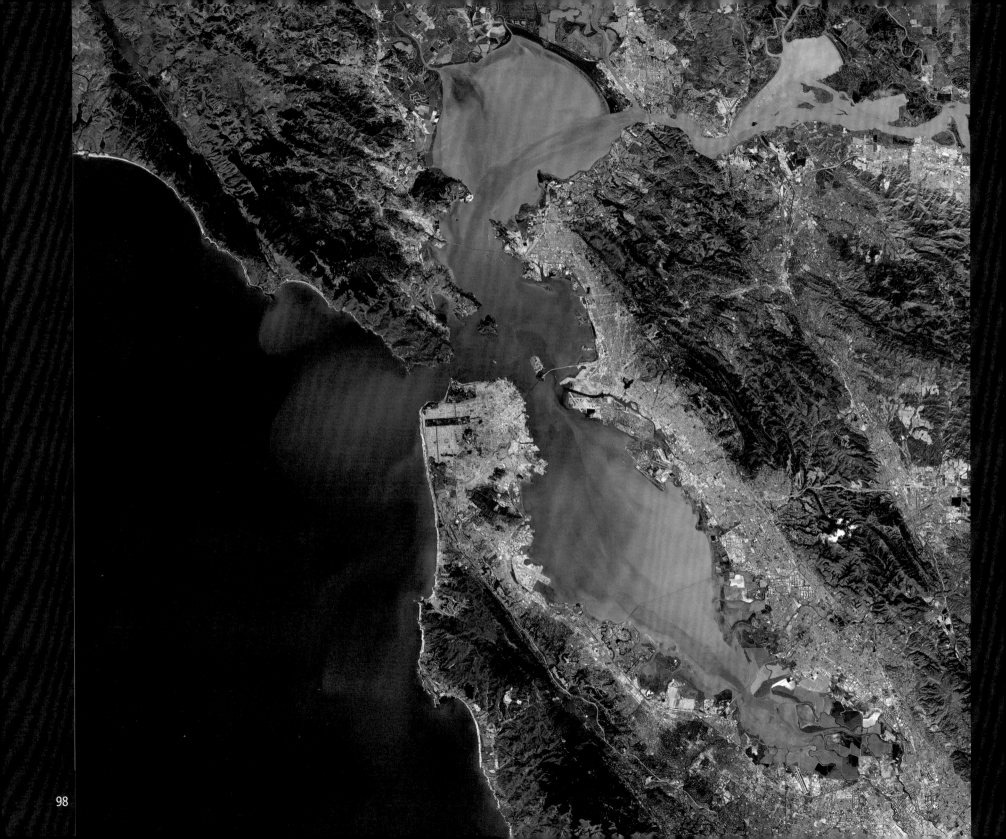

Satellite observations of Earth's land and ice surfaces and the open ocean have been incredibly valuable for understanding the processes and rhythms of our planet. But at the intersection of land and sea, many imaging techniques and analyses can get muddy.

For remote sensing scientists, coastal waters are a productive, murky, fascinating, and frustrating mess. Salt water meets fresh. Waters rise and fall and get mixed constantly by waves, winds, eddies, and other turbulence. The visible boundaries between ocean and land move on scales from hours to seasons to decades. Even the atmosphere gets murky, as moisture, pollution, and airborne particles are more abundant and dynamic than over open water.

The newest satellite in the Landsat series offers scientists a clearer view. The Landsat Data Continuity Mission—officially renamed Landsat 8 on May 30, 2013—has better spatial resolution than most ocean-sensing instruments and greater sensitivity to brightness and color than previous Landsats. Most significantly, it can observe the Earth in wavelengths that allows scientists to adjust for the distortions caused by the atmosphere near the coast.

"With the new coastal band, there is a good chance to estimate carbon exchange at the land-water interface—such as salt marshes, wetlands, harbors—where ocean color instruments fail due to coarse pixel size," said Nima Pahlevan, a researcher at the University of Massachusetts–Boston. "That said, the retrieval of chlorophyll and dissolved colored organic matter in turbid coastal waters is an ongoing challenge."

Schott and Pahlevan also note that Landsat 8 should expand and improve upon their ability to map some underwater features, such as kelp and other vegetation, coral reefs, and the bathymetry (the measurement of the depth of large bodies of water) of shallow waters.

Images by Jesse Allen and Robert Simmon, using data provided by the U.S. Geological Survey and NASA.
(france_tmo_2013224_geo)
Caption by Michael Carlowicz.

In the Landsat 8 image at left, we see the extent of the plankton bloom in the **San Francisco** Bay area.
(May 29 2013, sfbay_oli_2013106_geo)

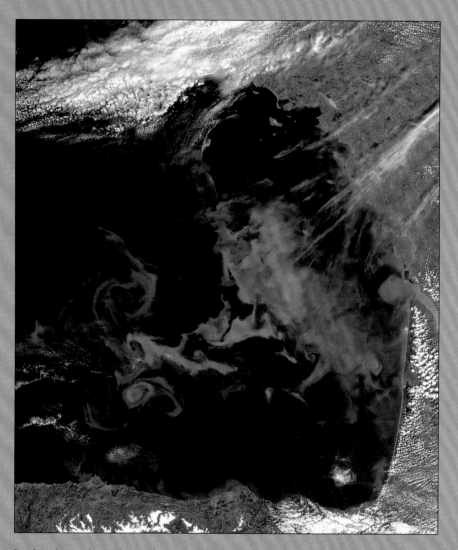

Springtime has brought a substantial and long-lasting bloom of phytoplankton to the **Bay of Biscay**, off the western coast of France. Swirls of green, turquoise, and cyan on the water surface show the location of these microscopic, plant-like organisms, while also tracing the currents and eddies that mix them. Such blooms tend to occur every March and April in the area, diminishing in May as ocean conditions change and surface nutrients run out.

Trailing the Canaries

The play of light on water can reveal overlooked details and nuances to photographers and artists on Earth. The same thing can happen when looking from space.

The Moderate Resolution Imaging Spectroradiometer (MODIS) on NASA's Terra satellite looked down on the Canary Islands on June 15, 2013. The Atlantic Ocean has a silvery or milky color in much of the image, the result of sunglint. Sunlight is being reflected off of the ocean surface directly back at the satellite imager, revealing details about the water surface or circulation that are otherwise invisible.

Wavy, windsock-like tails stretch to the southwest from each of the islands. The patterns are likely the result of winds roughening or smoothing the water surface in different places. Prevailing winds in the area come from the northeast, and the rocky, volcanic islands create a sort of wind shadow—blocking, slowing, and redirecting the air flow. That wind, or lack of it, piles up waves and choppy water in some places and calms the surface in others, changing how light is reflected. The swirling nature of the leeward wind field is shown in a long, helical trail of clouds stretching southwest from Tenerife (the second island from the right).

NASA image Jeff Schmaltz LANCE/EOSDIS MODIS Rapid Response Team, GSFC. Caption by Mike Carlowicz, with assistance from Jeff Schmaltz and Will Stefanov.

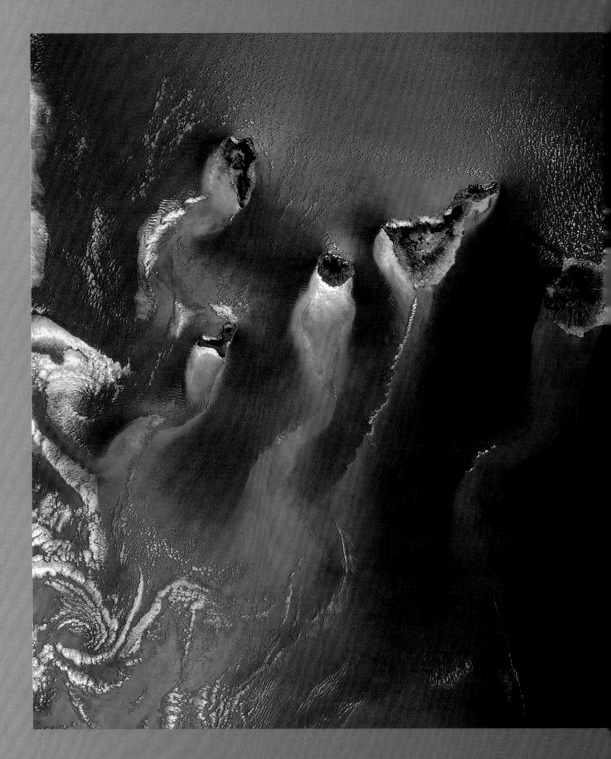

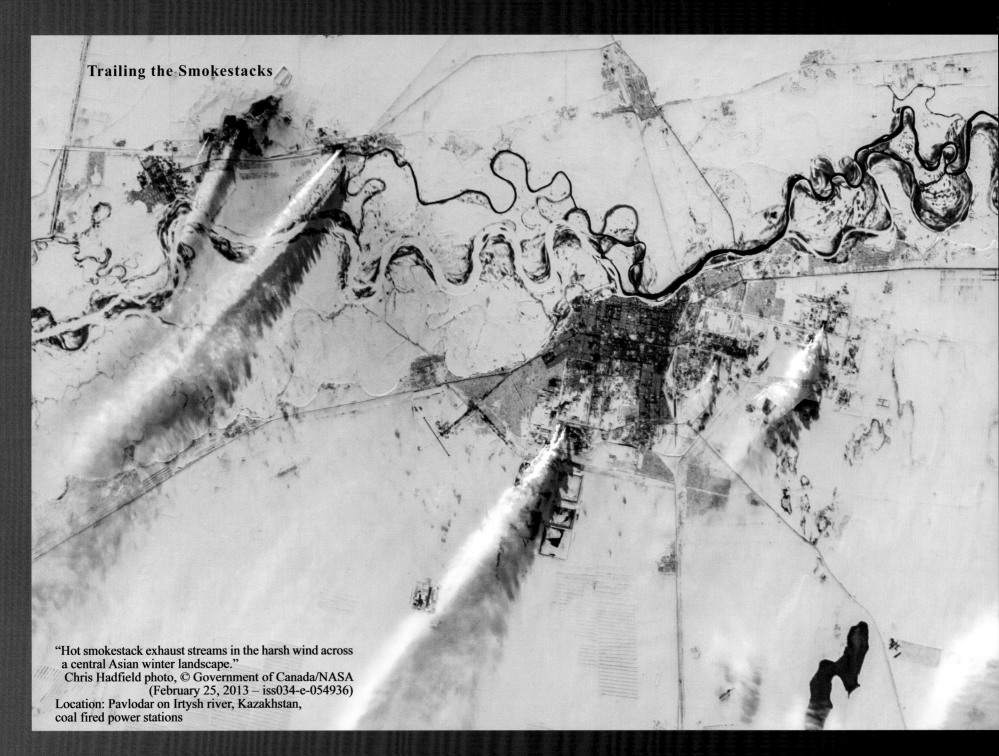

Trailing the Smokestacks

"Hot smokestack exhaust streams in the harsh wind across
a central Asian winter landscape."
Chris Hadfield photo, © Government of Canada/NASA
(February 25, 2013 – iss034-e-054936)
Location: Pavlodar on Irtysh river, Kazakhstan,
coal fired power stations

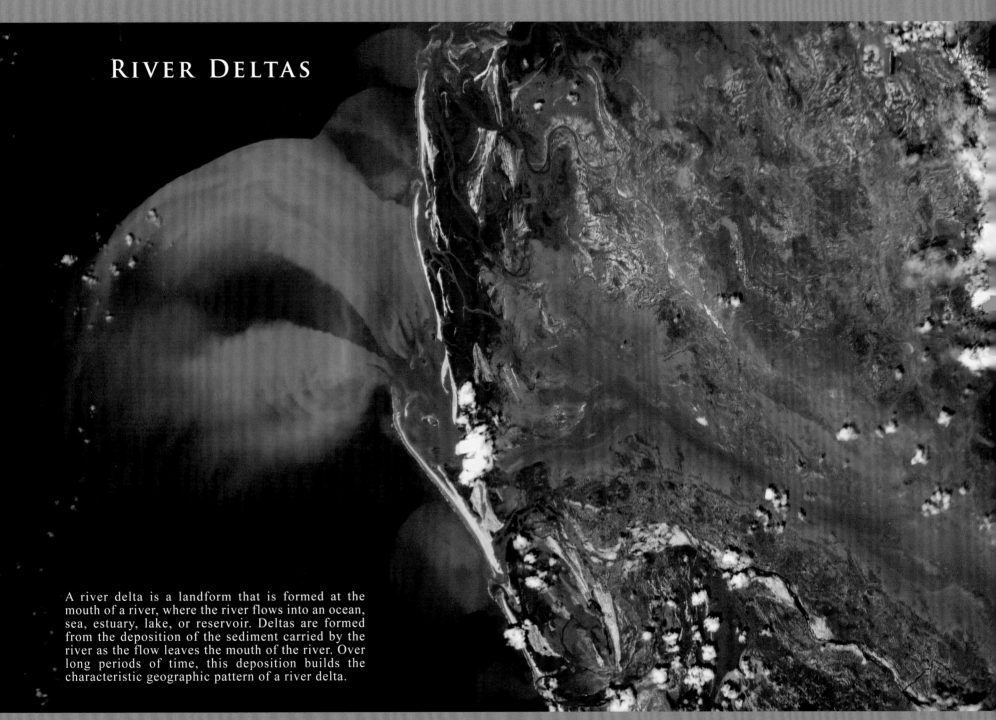

RIVER DELTAS

A river delta is a landform that is formed at the mouth of a river, where the river flows into an ocean, sea, estuary, lake, or reservoir. Deltas are formed from the deposition of the sediment carried by the river as the flow leaves the mouth of the river. Over long periods of time, this deposition builds the characteristic geographic pattern of a river delta.

"A two-dimensional fountain, a river spurting and fanning into the sea." Chris Hadfield photo, © Government of Canada/NASA (January 27, 2013 – iss034-e-034888)

The **Danube River** is the largest in the European Union, its watershed draining 801,463 square kilometers (309,447 square miles) of land across 19 countries. Where that great river reaches the Black Sea, a remarkable delta has formed—the "Everglades" of Europe. The Danube Delta is home to more than 300 species of bird and 45 species of freshwater fish.

The Danube Delta has been home to human settlements since the end of the Stone Age (the Neolithic Period), and the ancient Greeks, Romans, and Byzantines all built trading ports and military outposts along this coast. Today, the border between Romania and Ukraine cuts through the northern part of the delta. The area is a United Nations World Heritage Site, both for its natural and human history, and for the traditional maritime culture that persists in its marshes. All the while, the landscape has been shaped and re-shaped by nature and man.

Near the center of the image, the small city of Vylkove is known as the "Ukranian Venice," because of its canals.

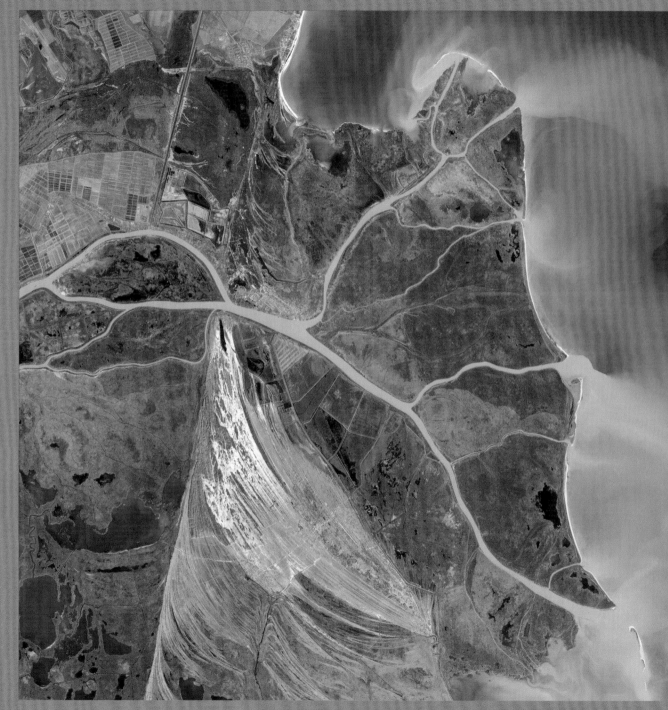

The image above was acquired on February 5, 2013, by the Advanced Land Imager (ALI) on NASA's Earth Observing-1 (EO-1) satellite. (danubedelta_oli_2013036)

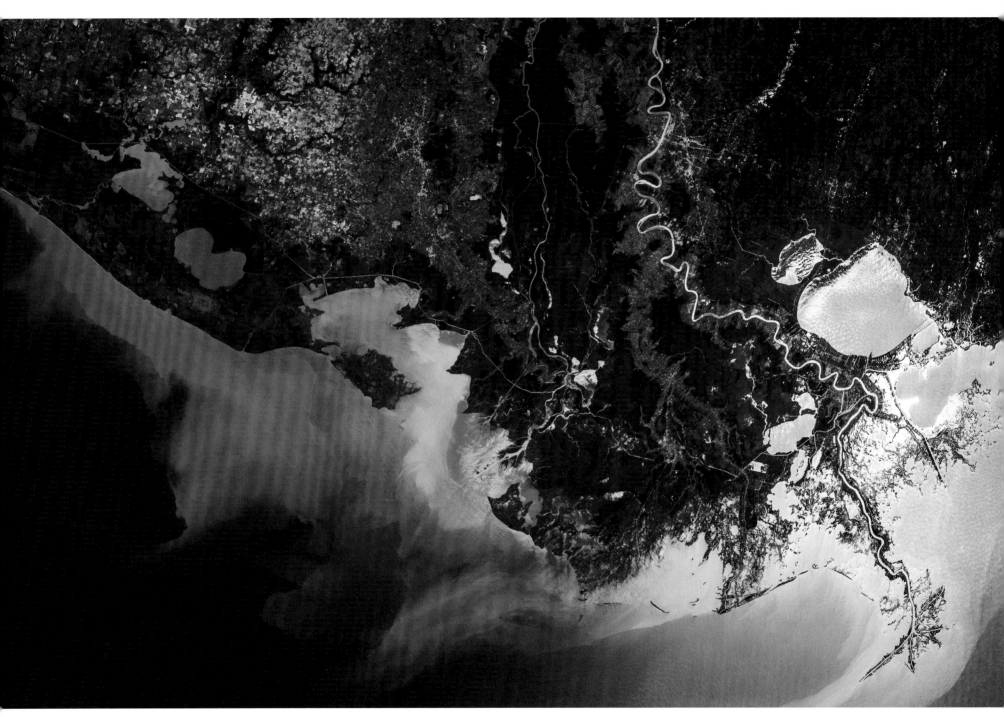

"Mississippi delta–heartland topsoil flowing relentlessly into the Gulf of Mexico."
Chris Hadfield photo, © Government of Canada/NASA (May 4, 2013 – iss035-e-039701) Location: New Orleans (top left of photo), Louisiana

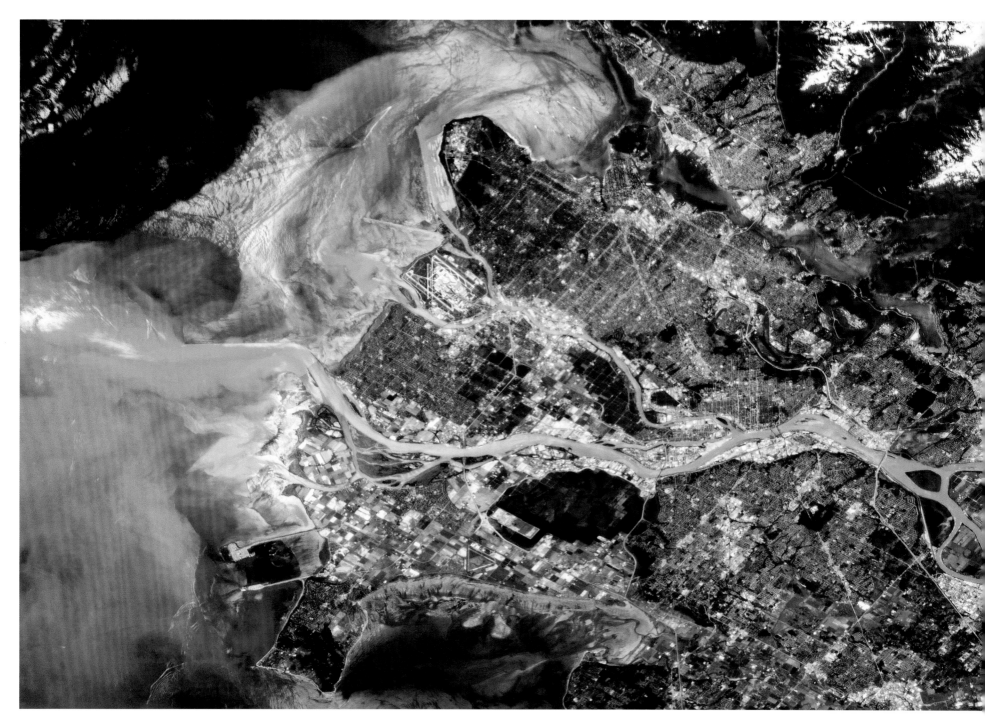

"Vancouver, with the Fraser River flowing full, roiling Spring run-off from the Rockies."
Chris Hadfield photo, © Government of Canada/NASA (May 6, 2013 – iss035-e-038735)

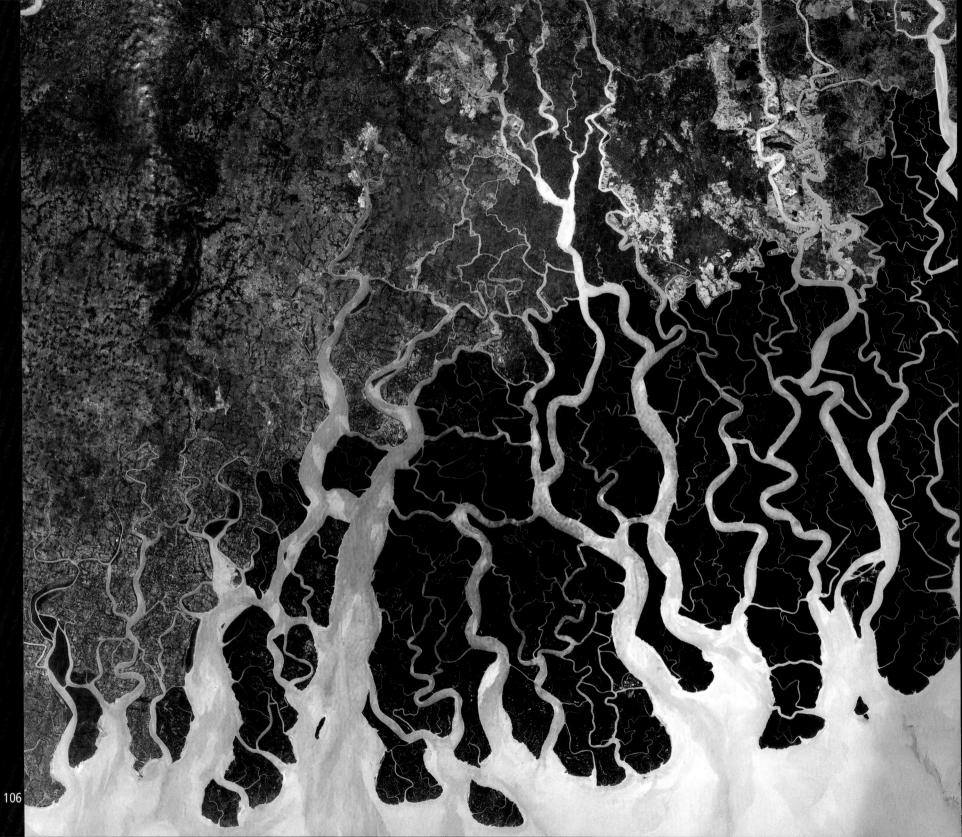

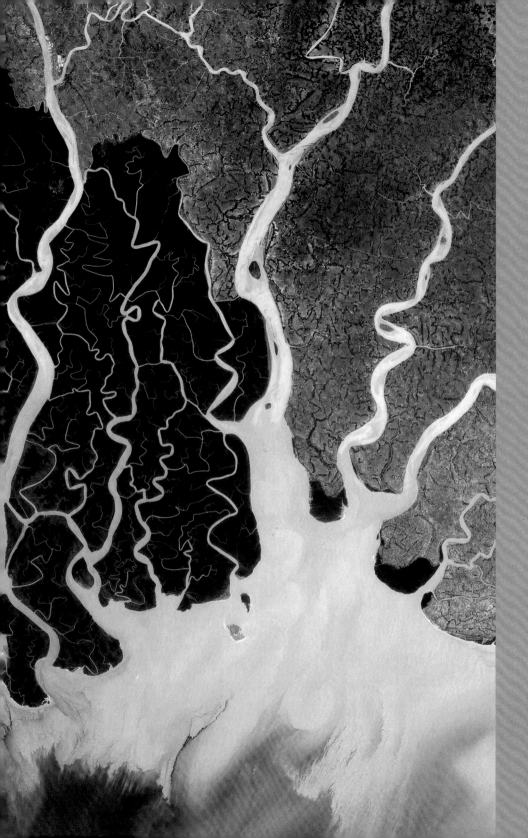

Stretching across part of southwestern Bangladesh and southeastern India, the **Sundarbans** is the largest remaining tract of mangrove forest in the world. The Sundarbans is a tapestry of waterways, mudflats, and forested islands at the edge of the Bay of Bengal. Home to the endangered Bengal tiger, sharks, crocodiles, and freshwater dolphins, as well as nearly two hundred bird species, this low-lying plain is part of the Mouths of the Ganges. The area has been protected for decades by the two countries as a National Park, despite the large human populations concentrated to the north.

This satellite image shows the forest in the protected area. The Sundarbans appears deep green, surrounded to the north by a landscape of agricultural lands, which appear lighter green, towns, which appear tan, and streams, which are blue. Ponds for shrimp aquaculture, especially in Bangladesh, sit right at the edge of the protected area, a potential problem for the water quality and biodiversity of the area. The forest may also be under stress from environmental disturbance occurring thousands of kilometers away, such as deforestation in the Himalaya Mountains far to the north.

To date, the Sundarbans has been a good example of how ecosystems can be protected and sustainably used by the people who live there. For example, the region is home to a network of tiger preserves in which populations of the Bengal tiger appear to have grown in the past few decades (monitoring is difficult in the swampy, densely forested terrain). However, human population in India and Bangladesh is growing far more rapidly, and the growth will likely intensify the pressure on the area and increase the challenge of maintaining a biologically diverse and healthy ecosystem.

NASA image created by Jesse Allen, Earth Observatory, using data obtained from the University of Maryland's Global Land Cover Facility.

One of the most famous African examples of an inland delta, The Inner Niger Delta (right), also known as the Macina, is a large area of lakes and floodplains in the semi-arid Sahel area of central Mali, just south of the Sahara desert. **Lake Débo** is formed by the seasonal flooding of the Niger River basin. It is the largest of many such seasonal wetlands and lakes which form the delta, and the largest lake within Mali. Its size is greatly reduced during the dry season of September to March, as seen in this photo. During high water stages of the river, the delta formed by lakes, creeks, and backwaters form part of Lake Débo.

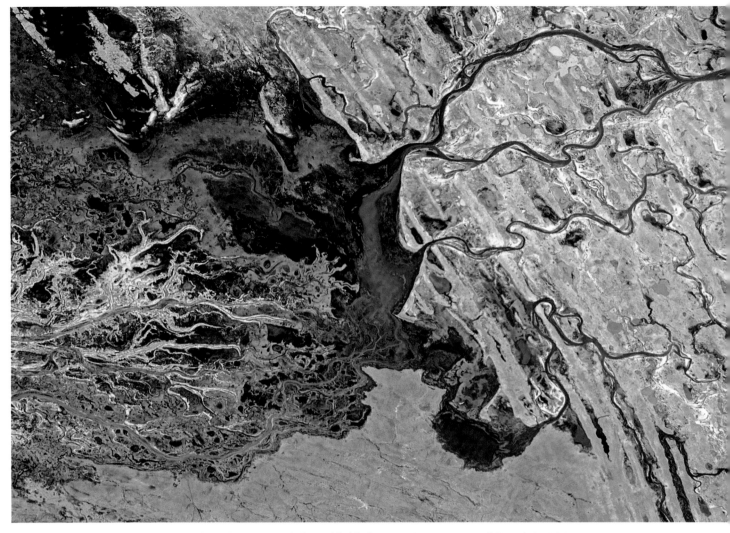

"African inland delta—surreal natural Medusan art." Chris Hadfield photo, © Government of Canada/NASA (January 16, 2013 – iss034-e-030514) Location: the delta created by Niger and Bani rivers at Lac Débo, in Mali

The Niger River is the lifeline for large parts of the Sahelian region, crossing through arid areas in Mali and Niger. Each year, it floods the Inner Niger Delta in Mali, thereby providing fisheries and water for agriculture and household use, on which some 1.5 million people and millions of migratory waterbirds depend. Hydropower dams, extensive irrigation schemes and climate change affect the water flow in this important river.

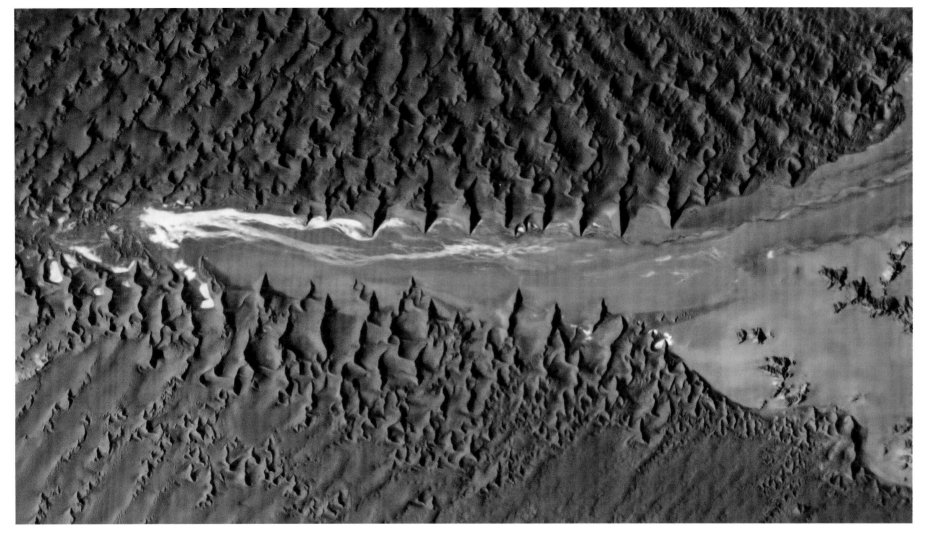

"Frozen crests of sand break over the arid rock, Namibian coast, Africa." Chris Hadfield photo, © Government of Canada/NASA (January 13 2013, iss034-e-027937)
Location: Sossuvlei river outwash in the Namib Naukluft National Park

The **Namib-Naukluft National Park** is an ecological preserve and includes Namibia's vast Namib Desert. Here, southwest winds have created the tallest sand dunes in the world, with some reaching above 200 meters (660 feet) in height. The region's highest, aptly named Big Daddy, tops out at 380 meters (1250 feet). These dunes are characterized by their vivid pink-to-orange color, a result of a high concentration of iron in the sand and the consequent oxidation processes.

And how much desert there is on the Earth! Over Africa I never saw a great expanse of green tropical rain forest. North Africa is the Sahara Desert, Southwest Africa is the Namib Desert, and south and east Africa is semi-arid grassland.

Karl Henize, USA
Challenger 8, August 1985
(*The Home Planet*)

We catch a glimpse of a huge swirl of clouds out the window over the middle of the Pacific Ocean, or the boot of Italy jutting down into the Mediterranean, or the brilliant blue coral reefs of the Caribbean strutting their beauty before the stars. And...we experienced those uniquely human qualities: awe, curiosity, wonder, joy, amazement.

Russell L. Schweickart, USA
Apollo 9, March 1969
(The Home Planet)

The boot of Italy, "Heel and toe."Chris Hadfield photo,
© Government of Canada/NASA (February 23, 2013 – iss034-e-053087)

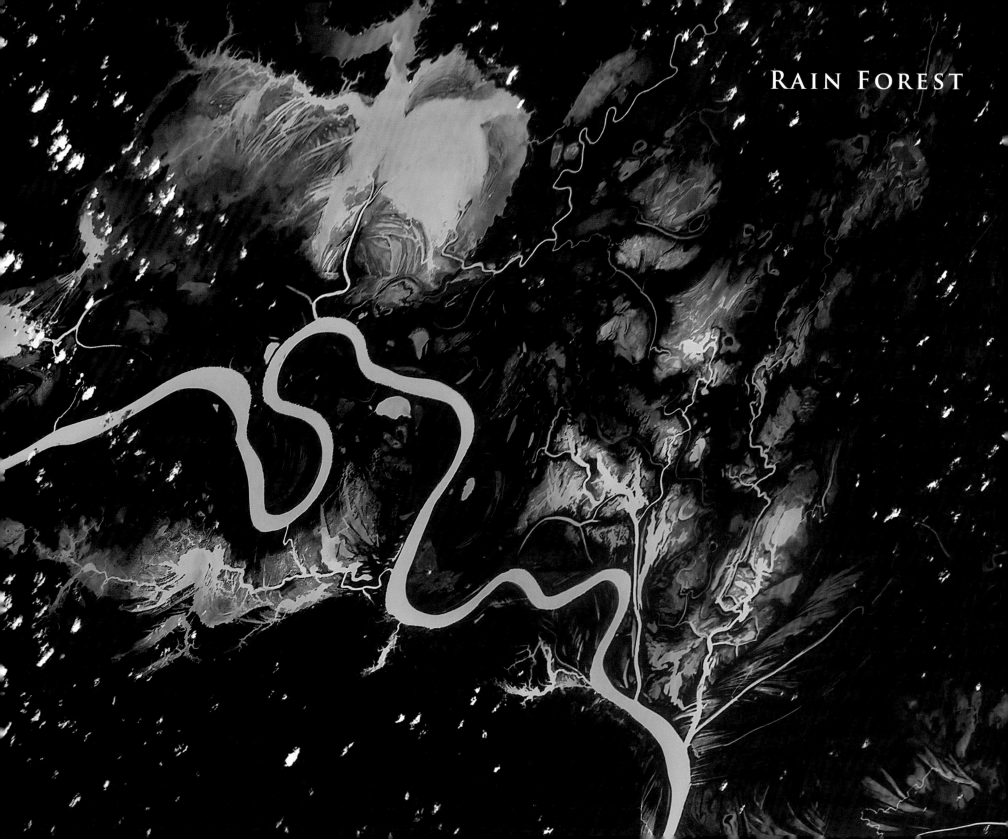

RAIN FOREST

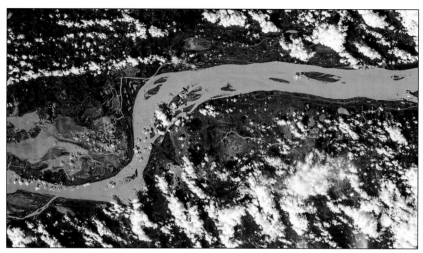

"The Amazon, as though it were clearing away the clouds.
A hugely impressive river, even from orbit."
Chris Hadfield photo, © Government of Canada/NASA
(January 4, 2013 – iss034-e-032394)

The Amazon

The Amazon River of South America is the world's largest river and the lifeblood of the world's largest ecosystem, spanning two fifths of an entire continent. It is home to a huge variety of animals and plants that dwell in its lush, evergreen environment. It is the mightiest river in the world by volume, with six times greater total river flow than the next six largest rivers combined, and the most extensive drainage basin in the world. Because of its vast dimensions, it is sometimes called The River Sea. Running about 6,400 kilometers (4,000 miles), it is regarded by most sources as the second longest river after Africa's Nile River, though this is a matter of some dispute.

In recent years, a highway has made further intrusions into the region, while Brazil has sought to keep the Amazon basin free from foreign exploitation. However, today the Amazon is ecologically endangered from reckless deforestation and a lack of public understanding of the importance of this remote region.

"The incredibly green lush wetness of the Amazon basin."
Chris Hadfield photo, © Government of Canada/NASA
(February 6, 2013 – iss034-e-034864) Location: near Aiapuá, Brazil

The first day or so we all pointed to our countries. The third or fourth day we were pointing to our continents. By the fifth day we were aware of only one Earth.

Sultan Bin Salman al-Saud
The Kingdom of Saudi Arabia
Discovery 5, June 1985
(The Home Planet)

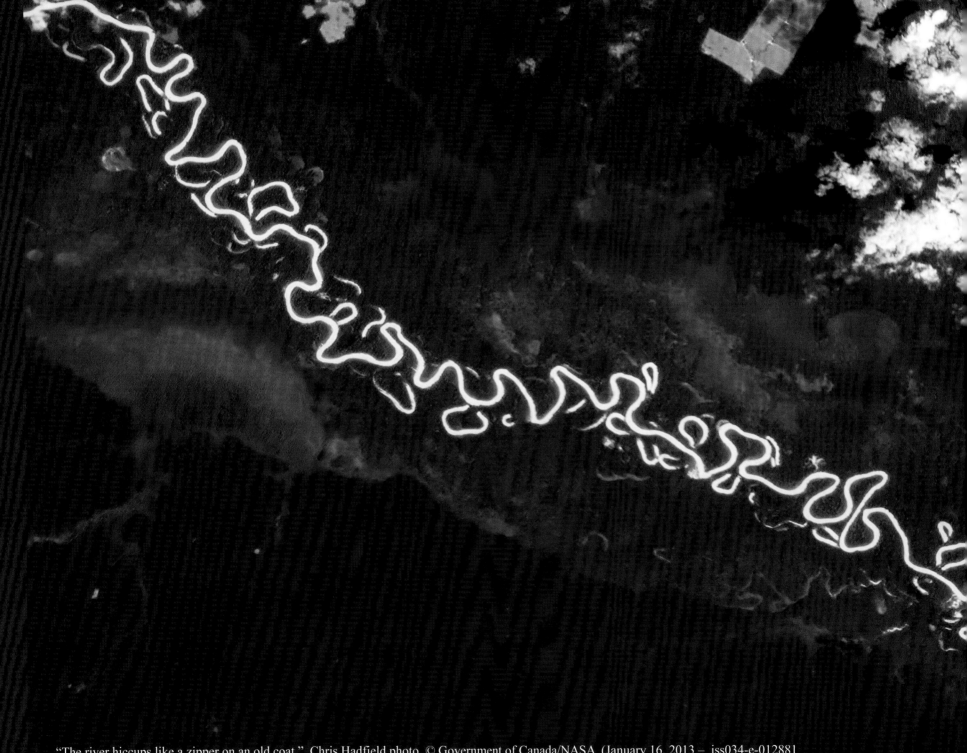

"The river hiccups like a zipper on an old coat." Chris Hadfield photo, © Government of Canada/NASA (January 16, 2013 – iss034-e-012881
Location: Rio Tahuamanu, a tributary of Rio Madre de Dios, just northeast of Lisboa, Bolivia

'Spotted through misty cloud in the Amazon rainforest. Conan Doyle's Lost World, perhaps?"
Chris Hadfield photo. © Government of Canada/NASA (January 16, 2013 – iss034-e-034871). Location: the Rondônia region of Brazil.

"Cauliflower clouds over the Amazon rainforest. A river like lightning."
Chris Hadfield photo. © Government of Canada/NASA. (January 16, 2013 – iss034-e-034862) Location: on the Rio Juruá in Brazil. Carauari is just to right of scene.

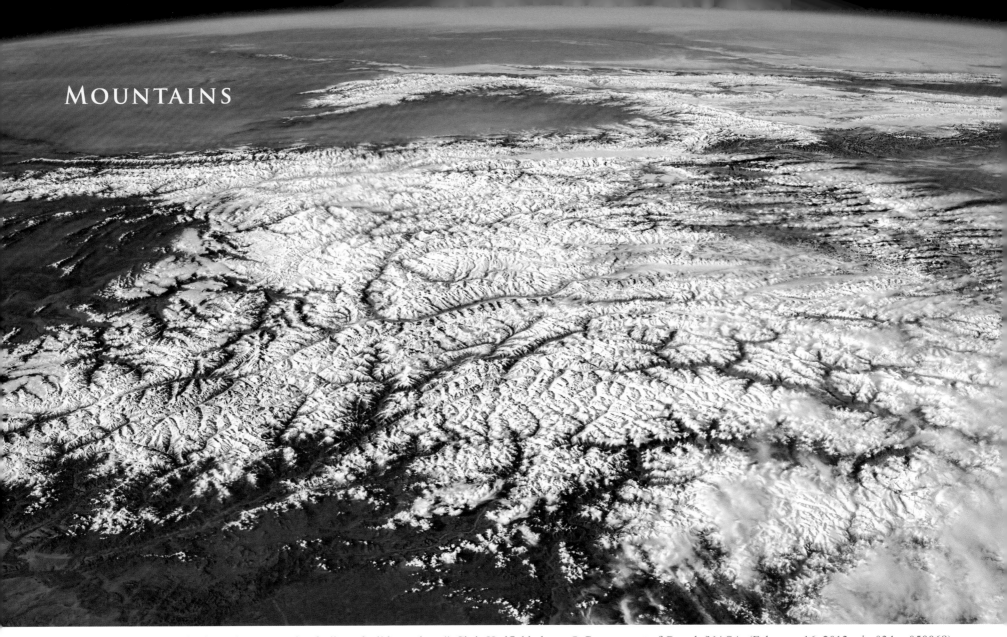

"The Himalayas to the horizon gives me such a feeling of wild grandeur." Chris Hadfield photo, © Government of Canada/NASA (February 16, 2013 – iss034-e-050068) Location: Hindu Kush and Pamir in the foreground, Himalayas are off to the right.

The soaring, snow-capped peaks and ridges of the eastern Himalaya Mountains create an irregular patchwork between major rivers in Tibet and southwestern China. Covered by snow and glaciers, the mountains here rise to altitudes of more than 5,000 meters. The Himalayas are made up of three parallel mountain ranges that together extend more than 2,900 kilometers. Uplift of the Himalayas continues today, at a rate of several millimeters per year, in response to the continuing collision of the Indian and Eurasian Plates that began about 70 million years ago.

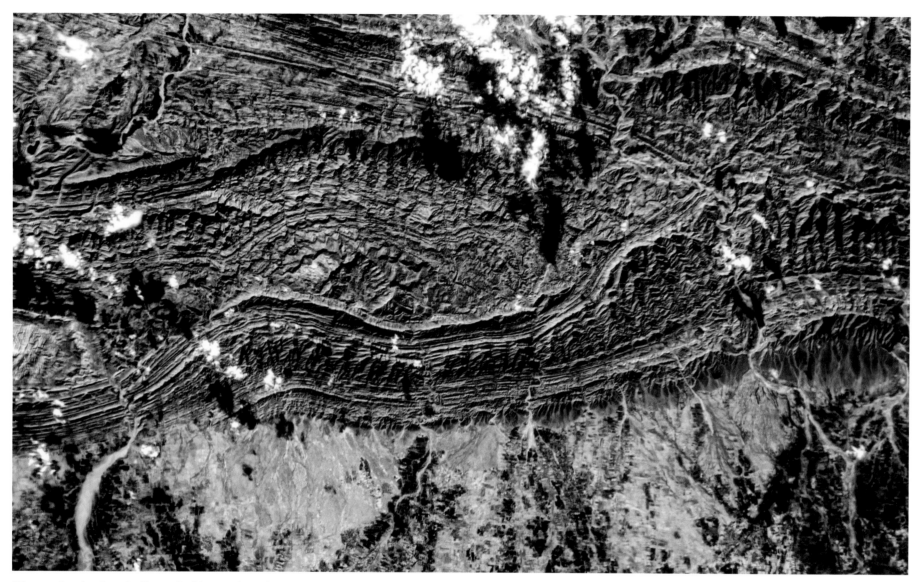

"Tortured rock where India crashed into Asia and
pushed up the Himalayas."
Chris Hadfield photo, © Government of Canada/NASA
(February 16, 2013 – iss034-e-049696)

Location: to the southwest of the Himalayas, about eight
kilometers (five miles) west of the villages of Liliani and Litra, in
the Punjab region of Pakistan. Portions of each of these
communities are visible at the bottom of this image, which
encompasses a span of about 50 kilometers (30 miles).

*We are passing over the Himalayas. We can see the mountain ranges with
the highest peaks in the world. At the end of the Katmandu valley, which
runs from north to south, I found Everest. How many people dream of
conquering Everest, so that they can look down from it, and yet for us
from above it was difficult even to locate it.*
Valentin Lebedev, Russia
Soyuz 13, December 1973
Soyuz T-5, May 1982
(The Home Planet)

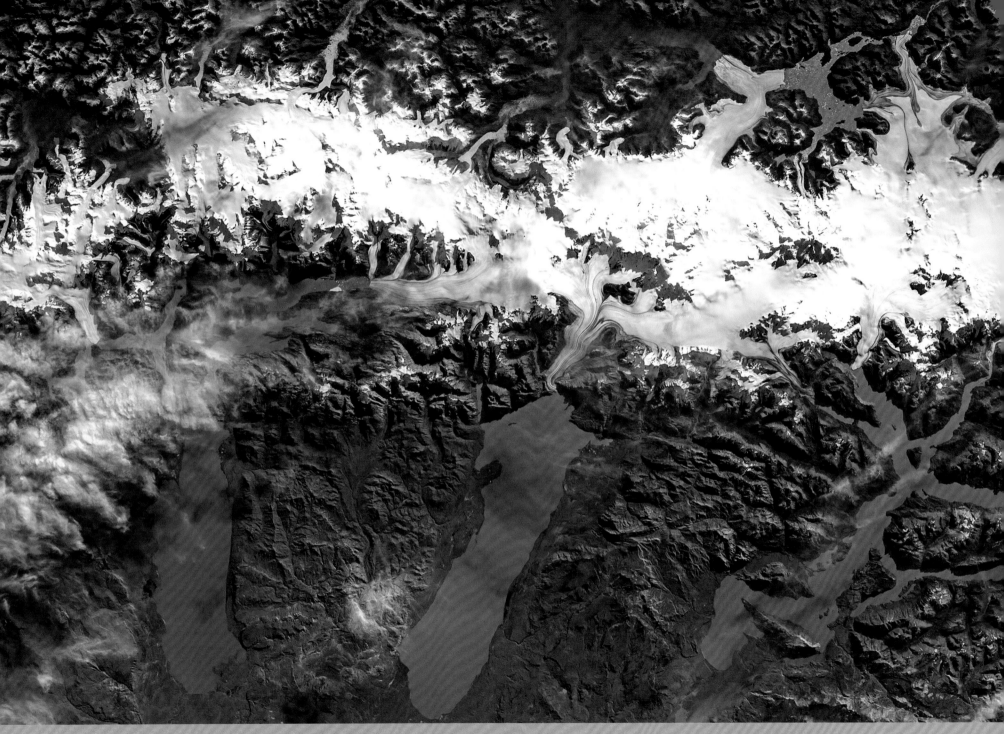

"The Patagonia glaciers that survived the summer, and the lakes they melted into." Chris Hadfield photo, © Government of Canada/NASA, (March 31, 2013 – iss035-e-013458)
Location: The large lake at left is Lake Argentino, in Los Glaciares National Park, Argentina. The Chilean border runs along the snow-capped peaks of the Andes.

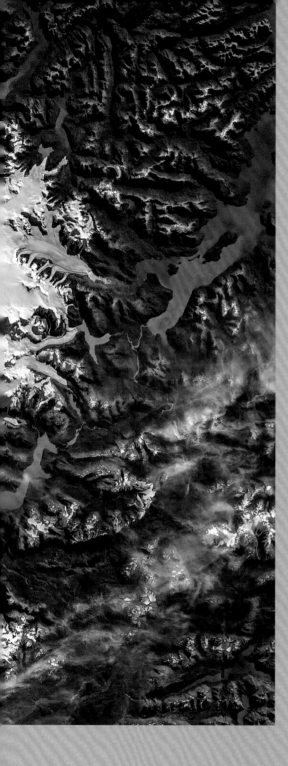

"When I look at thunderstorms from above, I see faces.."
Chris Hadfield photo, © Government of Canada/NASA
(March, 9 2013 – iss034-e-063703

Created in 1937, Parque Nacional Los Glaciares (Spanish: The Glaciers) is a national park in Argentine Patagonia. It comprises an area of 4459 square kilometers (1721square mmiles). In 1981, it was declared a World Heritage Site by UNESCO.

Its name refers to the giant ice cap in the Andes range that feeds 47 large glaciers, of which only 13 flow towards the Atlantic Ocean. The ice cap is the largest outside of Antarctica and Greenland.

Rock flour, or glacial flour is formed during glacial migration, where the glacier grinds against the sides and bottom of the rock beneath it. Because these particles are so tiny they become suspended in a lake, often giving its waters that beautiful, iridescent blue-green tint visible in these photographs.

In the mountains, the shortest way is from peak to peak: but for that you must have long legs.
Friedrich Nietzsche
German Philosopher

Man must rise above the Earth—to the top of the atmosphere and beyond—for only thus will he fully understand the world in which he lives.

Socrates, 500 B.C.

"The Andes mountains blur to the horizon in a cold Pacific fog." Chris Hadfield photo, © Government of Canada/NASA (February 1, 2013 – iss034-e-038911)

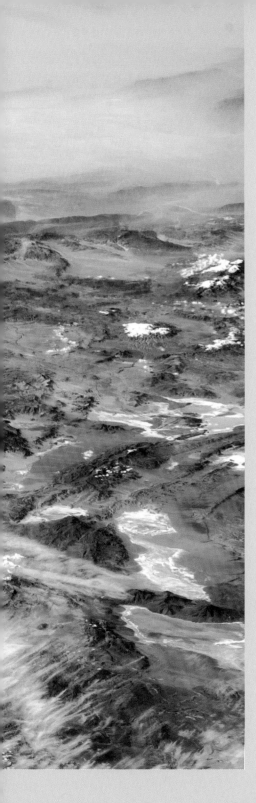

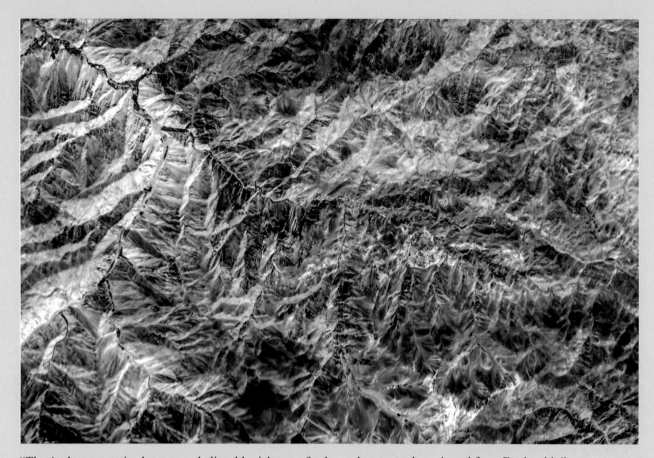

"The Andes mountains have an unbelievable richness of color and texture when viewed from Earth orbit."
Chris Hadfield photo, © Government of Canada/NASA (January 30, 2013 – iss034-e-037014)
Can you see the small agricultural fields perched precariously along the ridge line of the mountain range running up the left side of this image?

The Andes Cordillera reaches from Venezuela in the north to Tierra del Fuego at the southern tip of the continent. Some Andean peaks exceed 20,000 feet (6,100 meters) in height. The mountain soils are rocky and steeply graded. This makes farming difficult but not impossible. Farmers use terrace systems, building up step-like fields carved into the side of a mountain. Because of the limitations of the soils and the difficulty in farming them, the region supports only subsistence agricultural settlements. People in the highlands grow small plots of corn, barley, and especially potatoes on the high-altitude soils. *flowers-gardens.net*

There is a clarity, a brilliance to space that simply doesn't exist on Earth, even on a cloudless summer's day in the Rockies, and nowhere else can you realize so fully the majesty of our Earth and be so awed at the thought that it's only one of untold thousands of planets.

Virgil "Gus" Grissom, USA
Mercury 4, July 1961
Gemi 3, March 1965
(The Home Planet)

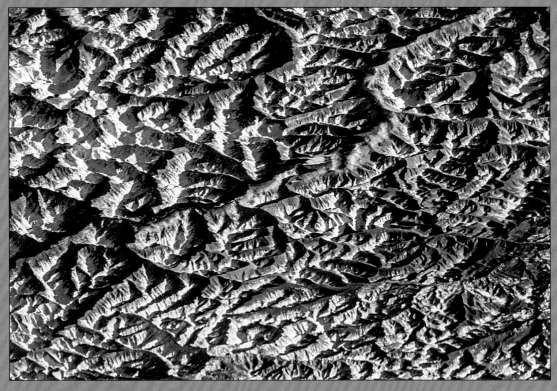

"The Rockies are beautiful, and very much so from orbit—What an amazing view!"
Chris Hadfield photo, © Government of Canada/NASA (December 13, 2012 – iss034-e-011976)
Location: near Mt. Assiniboine on the Great Divide between British Columbia and Alberta, Canada

The Rocky Mountains, commonly known as the "Rockies", are a major mountain range in western North America. The Rocky Mountains stretch more than 4,830 kilometers (3,000 miles) from the northernmost part of British Columbia, in western Canada, to New Mexico, in the southwestern United States. They were formed from 80 million to 55 million years ago during the Laramide orogeny, in which a number of plates began to slide underneath the North American plate. The angle of subduction was shallow, resulting in a broad belt of mountains running down western North America. Since then, erosion by water and glaciers has sculpted the Rockies into dramatic peaks and valleys. At the end of the last ice age, humans started to inhabit the mountain range. After Europeans, such as Sir Alexander Mackenzie and the Lewis and Clark expedition, started to explore the range, minerals and furs drove the initial economic exploitation of the mountains, although the range itself never became densely populated.

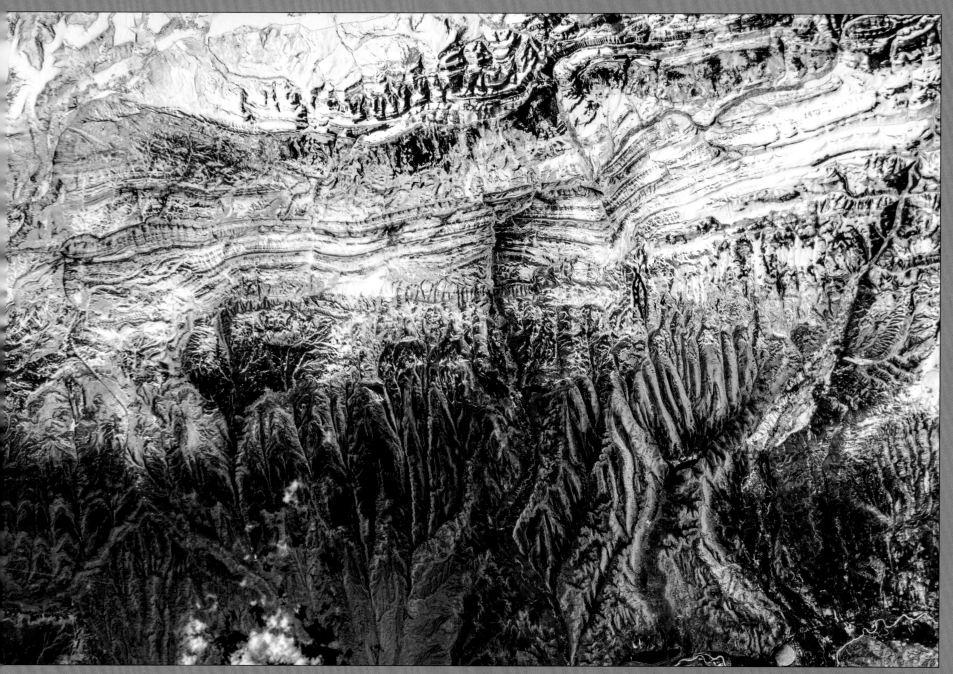

"The front range of the Rockies, rising beautifully from the plains." Chris Hadfield photo, © Government of Canada/NASA (March 9, 2013 – iss034-e-063700)
Location: about 32 kilometers (20 miles) south of Bridger National Forest in Wyoming, USA

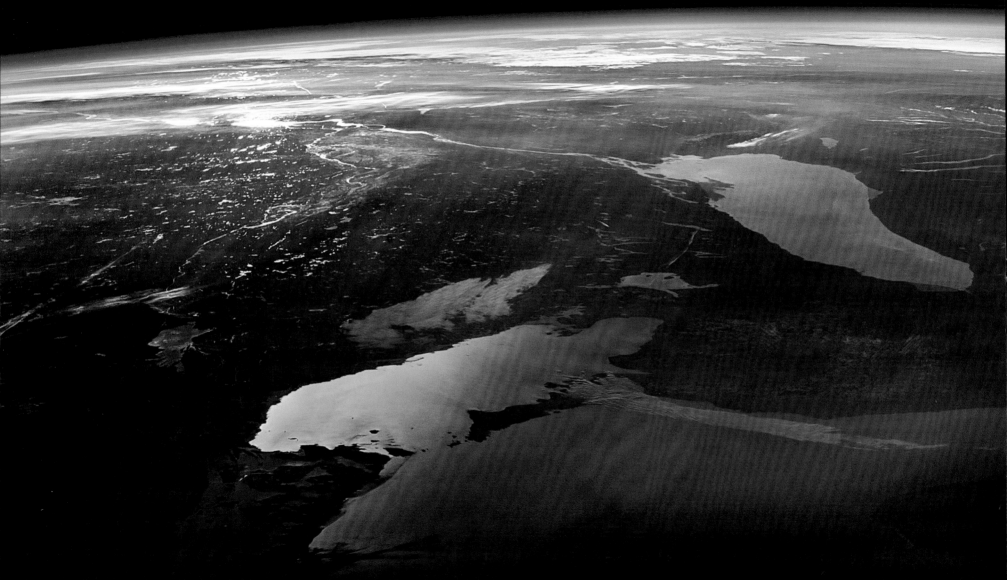

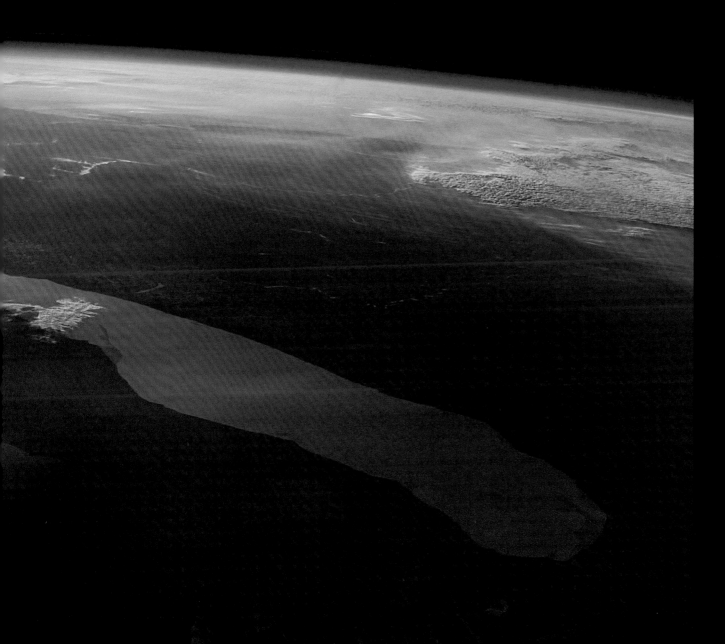

. . . Close to the window I could see that this scene in motion was rimmed by the great curved limb of the Earth. It had a thin halo of blue held close, and beyond, black space. I held my breath, but something was missing— I felt strangely unfulfilled. Here was a tremendous visual spectacle, but viewed in silence. There was no grand musical accompaniment; no triumphant, inspired sonata or symphony. Each one of us must write the music of this sphere for ourselves.

Charles Walker, USA
Discovery 1, August 1984
Discovery 4, April 1985
Atlantis 2, November 1985
(The Home Planet)

"An Easter sunrise glints across the Great Lakes. Heartland watershed."
Chris Hadfield photo, © Government of Canada/NASA (March 30, 2013 – iss035-e-013434)
People living around Georgian Bay will certainly embrace Chris's beautiful capture of this golden sun glint.

VOLCANOES

A volcano is an opening, or rupture, in a planet's surface or crust, which allows hot magma, volcanic ash and gases to escape from the magma chamber below the surface. Volcanoes are generally found where tectonic plates are diverging or converging. Erupting volcanoes can pose many hazards, not only in the immediate vicinity of the eruption. Volcanic ash can be a threat to aircraft, in particular those with jet engines where ash particles can be melted by the high operating temperature; the melted particles then adhere to the turbine blades and alter their shape, disrupting the operation of the turbine. Large eruptions can affect temperature as ash and droplets of sulfuric acid obscure the sun and cool the Earth's lower atmosphere or troposphere; however, they also absorb heat radiated up from the Earth, thereby warming the stratosphere. Historically, so-called volcanic winters have caused catastrophic famines.

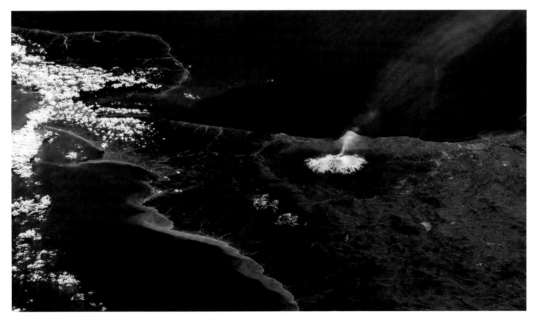

"Our Earth is mostly liquid rock. We live on the thin cool crust, with occasional hot spots, like Mt. Etna." Chris Hadfield photo, NASA (March 27, 2013 – iss035-e-006947)

"Mt. Etna erupting and shooting steam and smoke high above the cloud, as seen from space." Chris Hadfield photo, © Government of Canada/NASA (February 28, 2013 – iss034-e-057037)

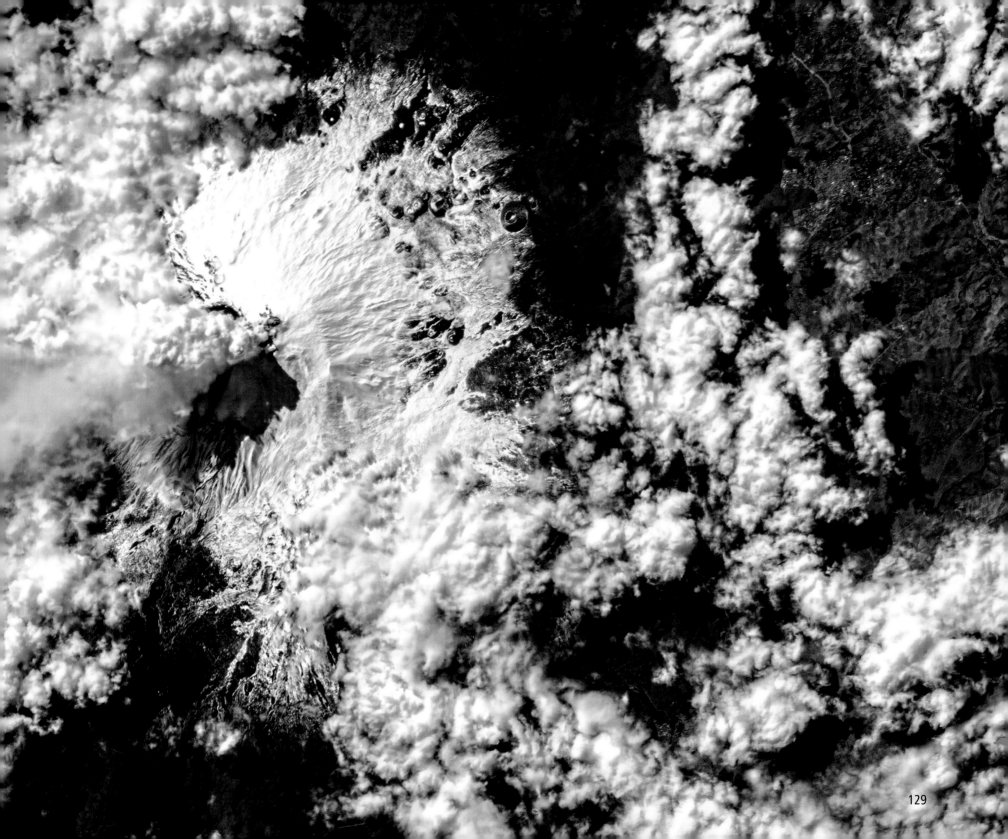

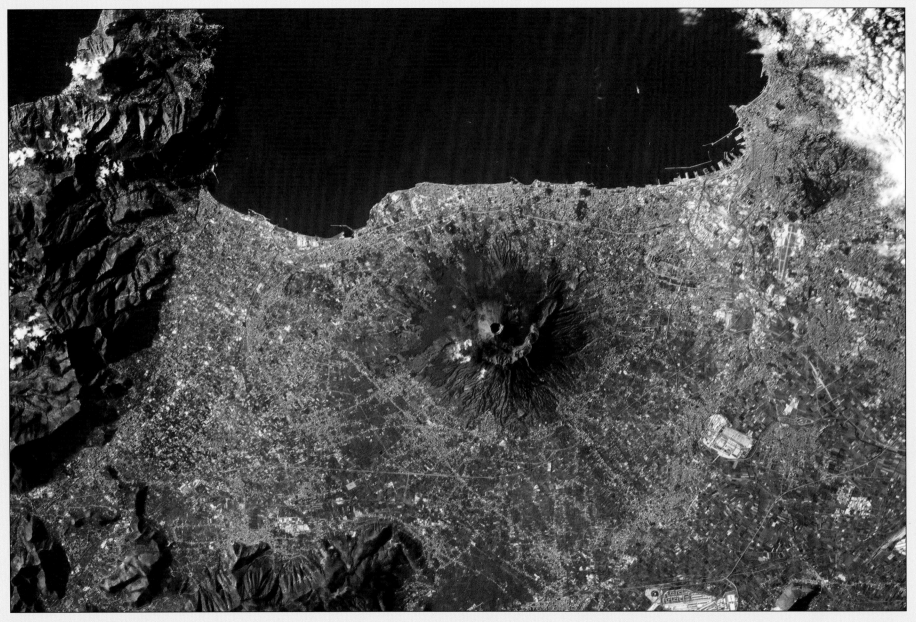

"Mt. Vesuvius, Italy (eastern outskirts of Naples), on New Year's Day, 2013." Chris Hadfield photo, © Government of Canada/NASA (January 1, 2013 – iss034-e-012267)

(Opposite) "Tokyo harbour and Mt Fuji—humanity and nature visible from space." Chris Hadfield photo,
© Government of Canada/NASA (May 5, 2013 – iss035-e-039918)
Tokyo is the large, light colored area at the center of the photo with Mt. Fuji's circular, snow-capped peak visible about 60 kilometers to the west. Mt. Fuji was designated a UNESCO World Heritage Site in June of 2013.

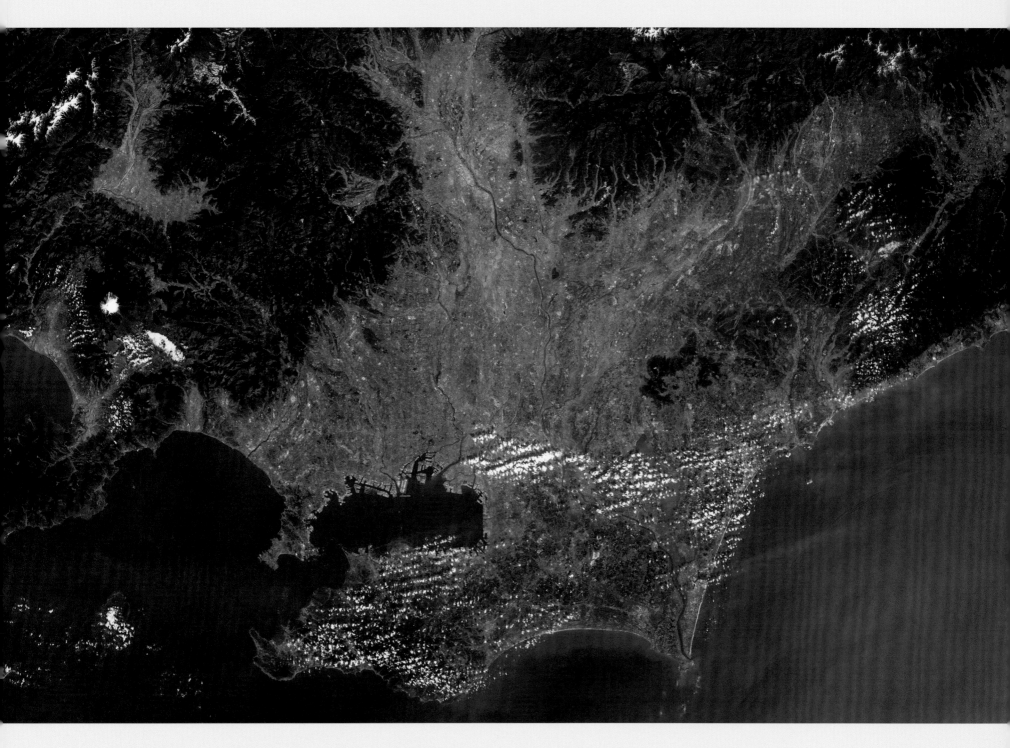

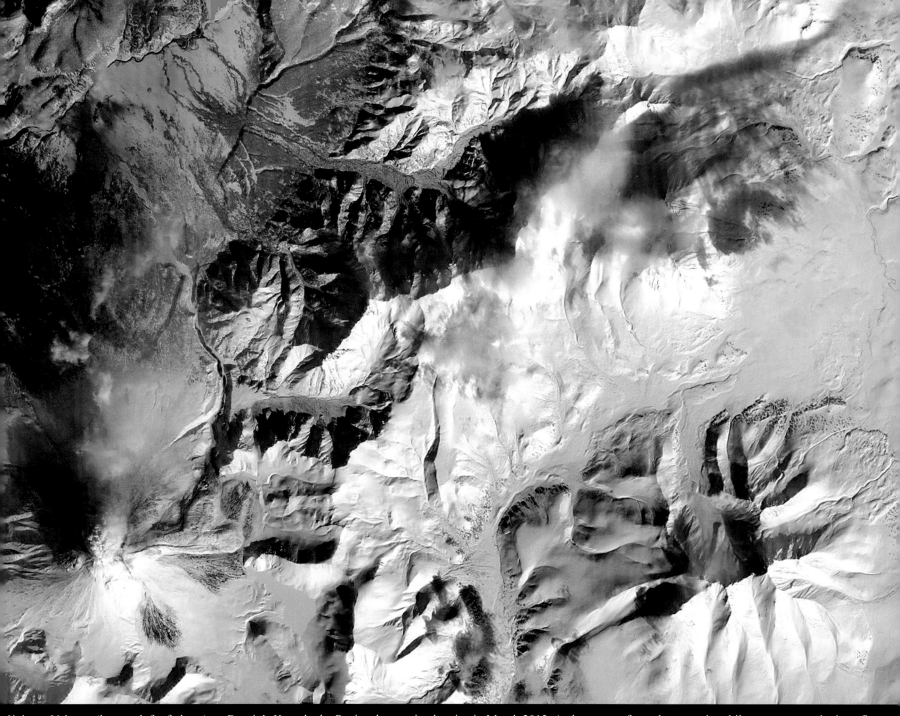

Kizimen Volcano (bottom left of photo) on Russia's Kamchatka Peninsula remained active in March 2013. A plume rose from the summit, while snow covered a lava flow on the volcano's eastern flank. That lava was actively advancing in February 2012, and still growing a year later. The volcano began showing signs of unrest in July 2009, with a swarm of seismic activity—up to 120 earthquakes a day. The Advanced Land Imager (ALI) on NASA's Earth Observing-1 (EO-1) satellite captured this natural-color image

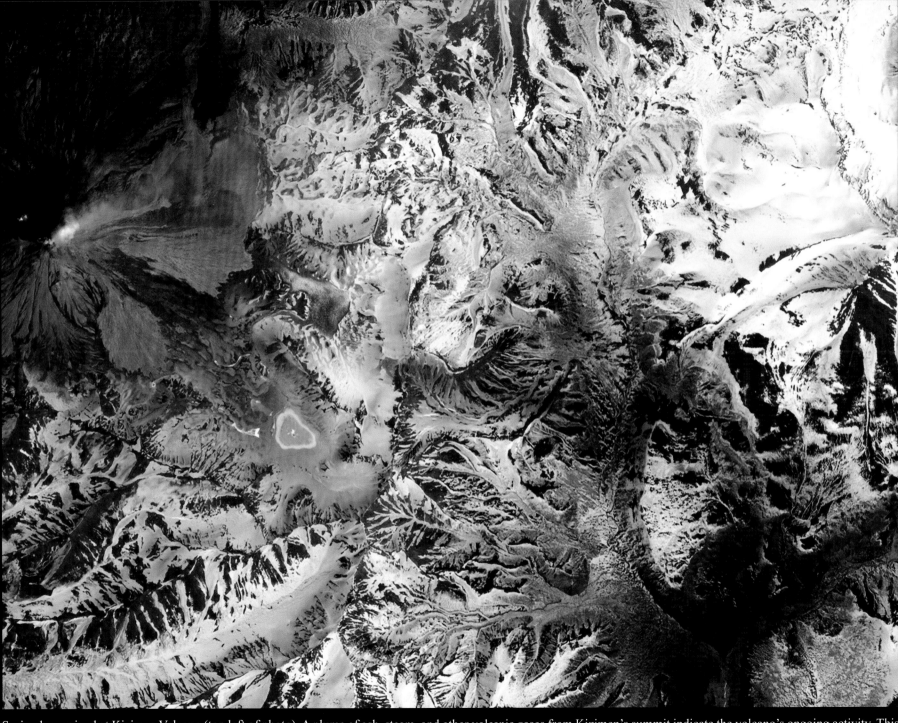

Spring has arrived at Kizimen Volcano (top left of photo). A plume of ash, steam, and other volcanic gases from Kizimen's summit indicate the volcano's ongoing activity. This natural-color image was collected in May, by the same satellite that photographed it in March (left). The mountainous landscape is covered in a patchwork of snow, ash, volcanic debris, and still dormant vegetation. As the snow melts, layers of ash that were deposited individually start to combine, resulting in a thick blanket of ash on top of the remaining snow. Jesse Allen and Robert Simmon with caption by Robert Simmon. NASA (May 25, 2013 – 2013145)

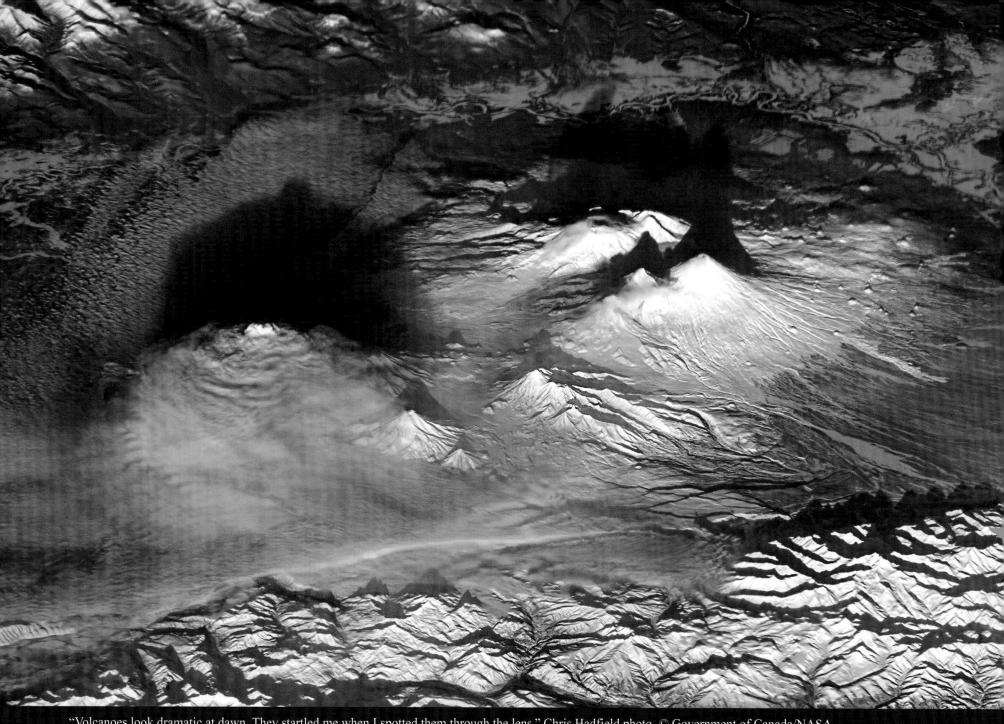

"Volcanoes look dramatic at dawn. They startled me when I spotted them through the lens." Chris Hadfield photo, © Government of Canada/NASA, (January 6, 2013 — iss034-e-024881). Location: 30 kilometers northeast of Tolbachik on Kamchatskaya Peninsula, eastern Russia.

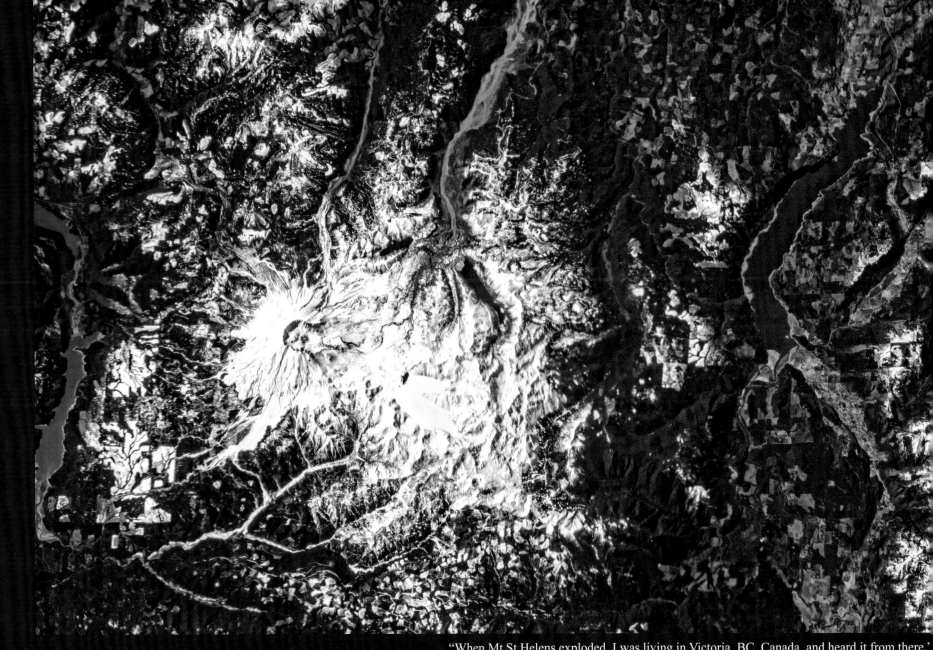

"When Mt St Helens exploded, I was living in Victoria, BC, Canada, and heard it from there."
Chris Hadfield photo. © Government of Canada/NASA. (February 28, 2013 – iss034-e-063695

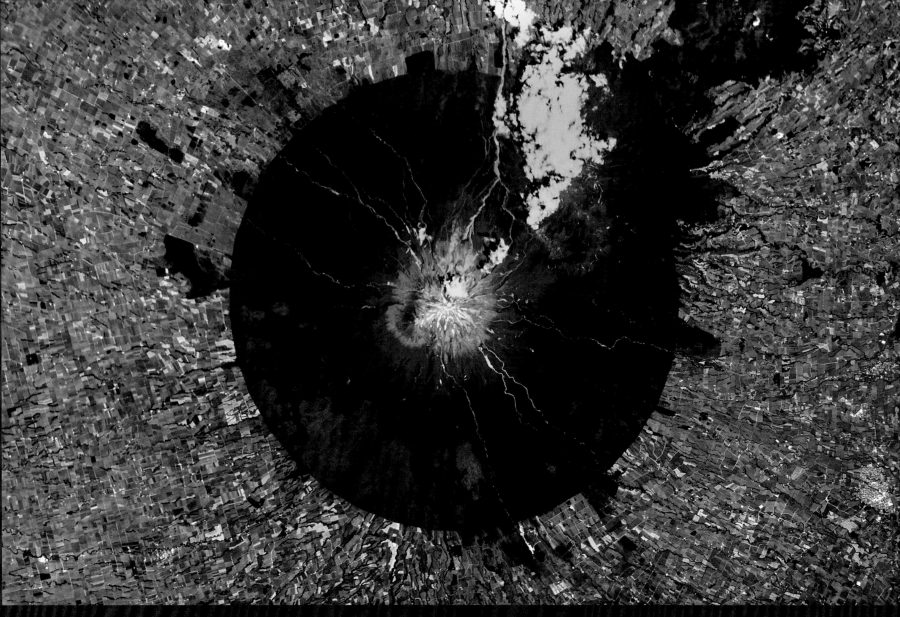

The 2518-meter-high mountain on New Zealand's North Island is one of the most symmetrical volcanic cones in the world. The circular, dark green forested area matches the Egmont National Park boundary fairly closely. Interesting to see the before and after when humans create farms from the wilderness. The most recent volcanic activity was the production of a lava dome in the crater and its collapse down the side of the mountain in the 1850s or 1860s.

Note: This volcano can be easily seen on the western point of New Zealand's North Island (opposite).
"The Taranaki Volcano looks too perfect to be real."
Chris Hadfield photo, © Government of Canada/NASA
(January 1, 2013 – iss034-e-036342)

We orbit and float in our space
gondola and watch the oceans
and islands and green hills of
the continents pass by at five
miles per second. We move
silently and effortlessly past
the ground. I want to say "over
the ground" as I write this, but
remember that in space your
sense of up or down is
completely gone and my
description must reflect this
fact. In addition, the
breathtaking speed of the ship
is in odd and confusing
contrast to the feel of
perpetually floating within the
spaceship. You do not sit before
the window to view the passing
scene, but rather you float
there and look out on the
scene, certainly not down upon
it. Are you speeding past
oceans and continents, or are
you just hovering and watching
them move beside you?

Joseph Allen, USA
Columbia 5, November 1982
Discovery 2, November 1984
(The Home Planet)

Can you spot the Taranaki Volcano
(left page) on the western tip of
New Zealand's North Island?
NASA image courtesy Jeff Schmaltz,
LANCE MODIS Rapid Response Team
at NASA GSFC.

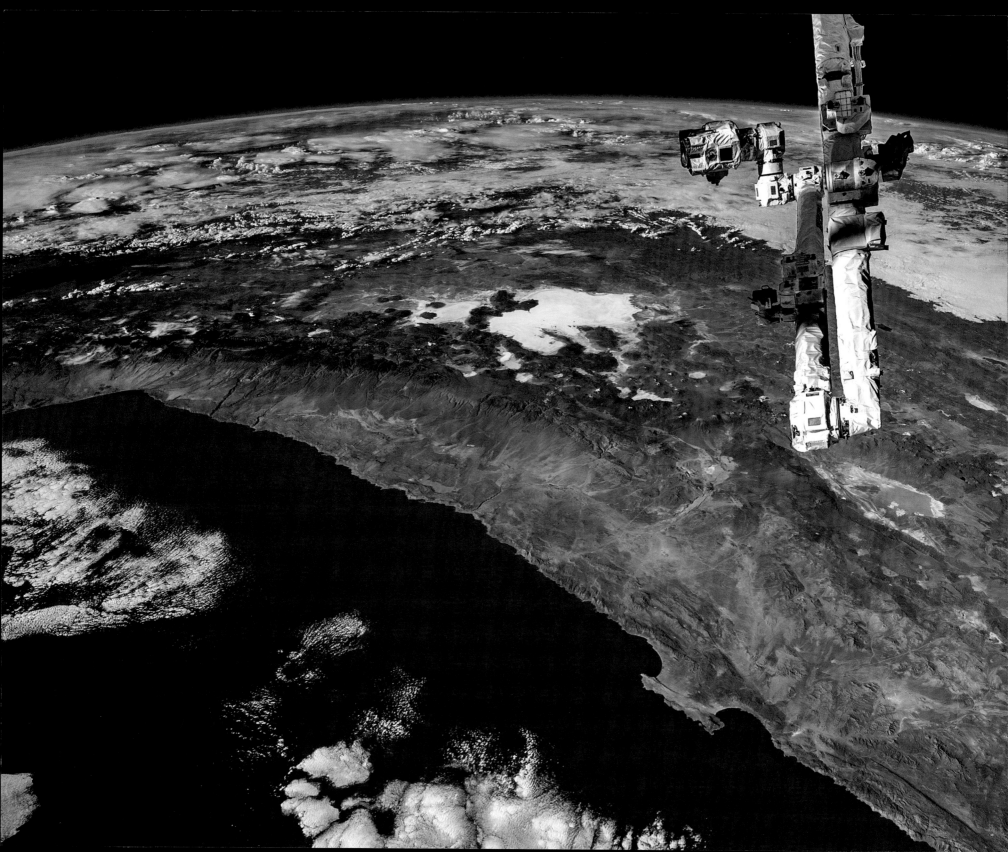

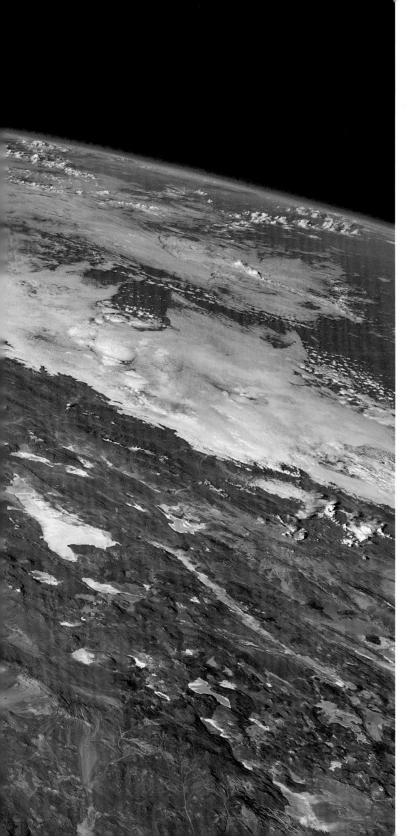

When we look into the sky, it seems to us to be endless. We breathe without thinking about it, as is natural. We think without consideration about the boundless ocean of air, and then you sit aboard a spacecraft, you tear away from Earth, and within ten minutes you have been carried straight through the layer of air, and beyond there is nothing! Beyond the air there is only emptiness, coldness, darkness. The "boundless" blue sky, the ocean which gives us breath and protects us from the endless black and death, is but an infinitesimally thin film. How dangerous it is to threaten even the smallest part of this gossamer covering, this conserver of life.

Vladimir Shatalov, Russia
Soyuz 4, June 1969
Soyuz 8, November 1969
Soyuz 10, November 1971
(*The Home Planet*)

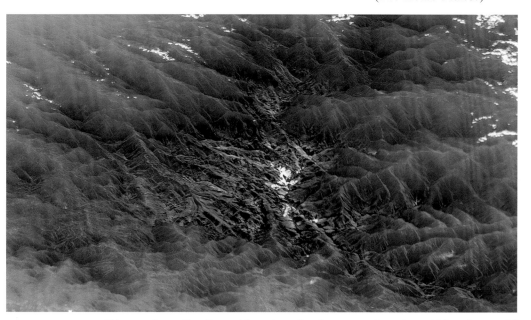

"Venezuelan valley framed by misty clouds—mysterious, beautiful and surreal."
Chris Hadfield photo, © Government of Canada/NASA (January 26, 2013 – iss034-e-034821)

"The high, dry Andes,with the wet cloud of the Amazon basin on the other side."
Chris Hadfield photo, © Government of Canada/NASA (April 8, 2013 – iss035-e-018172)
Location: Península de Mejillones jutting out from the Chilean coast underneath the Canadarm.

FLOODS

Green floodplain of the Elbe River at the German town of Wurtenburg before the flooding.
NASA, (May 6, 2013 – 2013126)

Unprecedented rainfall and flooding continued to plague central Europe in mid-June 2013, causing billions of dollars in damage. The Elbe, Danube, Saale, and other river systems rose well above their banks and breached flood defenses in Germany, Austria, the Czech Republic, Hungary, and Slovakia. Many news outlets and some government sources were describing it as the worst flooding since medieval times, surpassing the devastating floods of 2002 in many areas.

These photos dramatically illustrate the devestation brought to the German town of Wurtemburg on the Elbe River. Note how the green floodplain around the river in the May image is completely inundated with muddy water in the June image.

NASA Earth Observatory images by Jesse Allen,
using data provided by the U.S. Geological Survey.
Caption by Michael Carlowicz.

(Right) Elbe River at the height of the Spring flooding of 2013. NASA, (June 7, 2013 – 2013158)

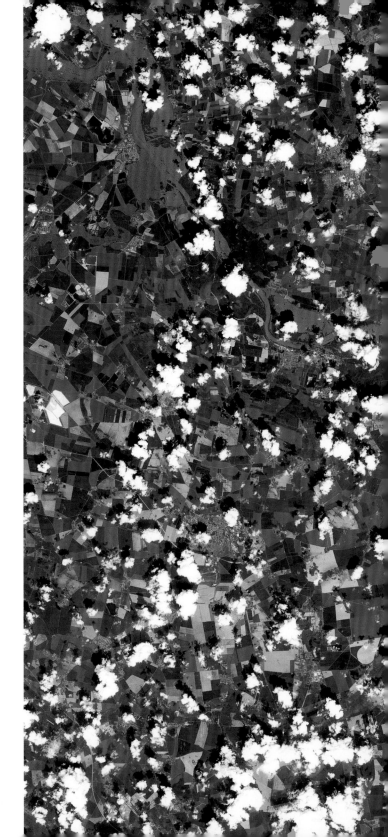

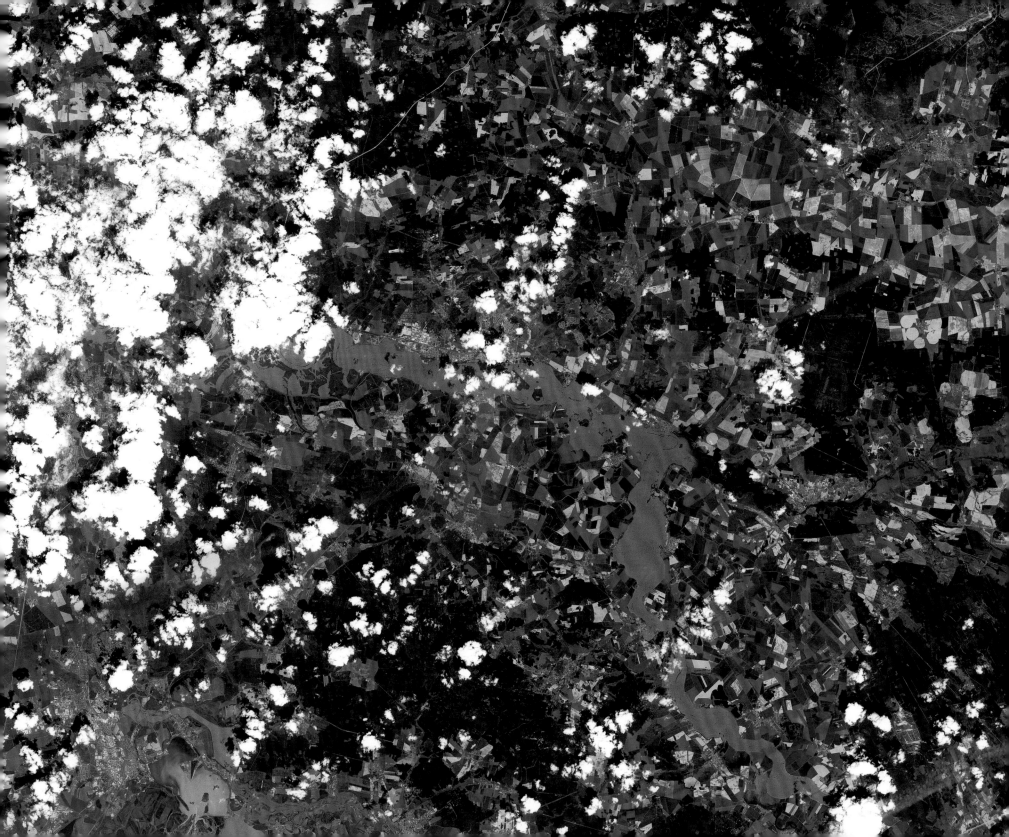

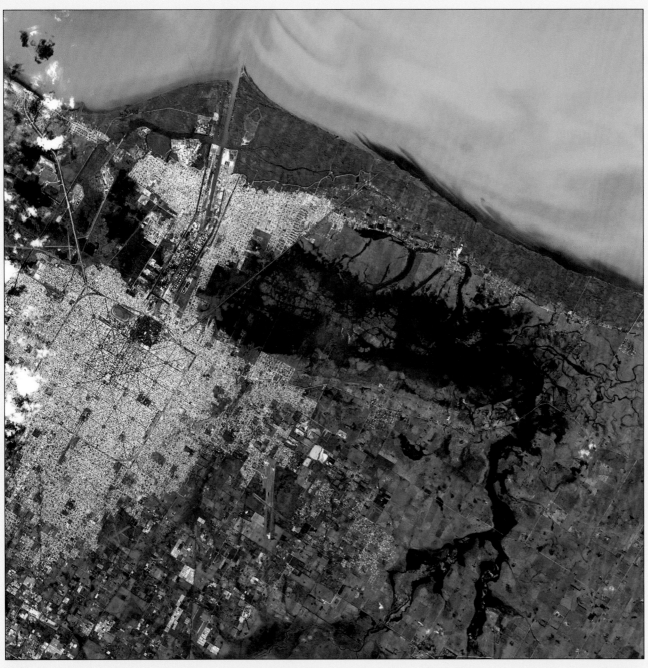

In early April 2013, severe flooding claimed more than 50 lives, and forced thousands from their homes in the Buenos Aires region, news sources said. Many of the casualties occurred in La Plata, situated about 60 kilometers (40 miles) southeast of Buenos Aires. Roughly 40 centimeters (16 inches) of rain fell on La Plata in a two-hour period April 2–3, Agence France-Presse reported.

The heavy rains turned roads into raging rivers, submerging cars, and trapping drivers and passengers. Many residents took refuge on their rooftops awaiting rescue, Agence France-Presse reported, and the strong storm activity that brought the flooding also downed trees and power lines.

NASA image courtesy NASA/GSFC/METI/ERSDAC/JAROS, and U.S./Japan ASTER Science Team. (laplata_ast_2013094)
Caption by Michon Scott.

When Canadian astronaut Chris Hadfield installed a new "disaster cam" in the Destiny module window on the International Space Station (ISS) in January 2013, little did he know that one of the first disasters photographed would come from his homeland. The camera known as ISERV snapped digital images of downtown Calgary as it was inundated by floodwaters in June 2013.

"We're glad to be able to provide images to the Canadian government to help with response to this disaster and with assessing the damage," said Burgess Howell, ISERV Principal Investigator." I am proud that we are using the unique view from the space station to help make response efforts more effective," Hadfield added.

Note: Fittingly, on July 5, 2013, astronaut Chris Hadfield traded his bulky space suit for a Stetson and a pair of Wranglers and rode a horse through dry and sunny downtown as marshal of the Calgary Stampede parade.

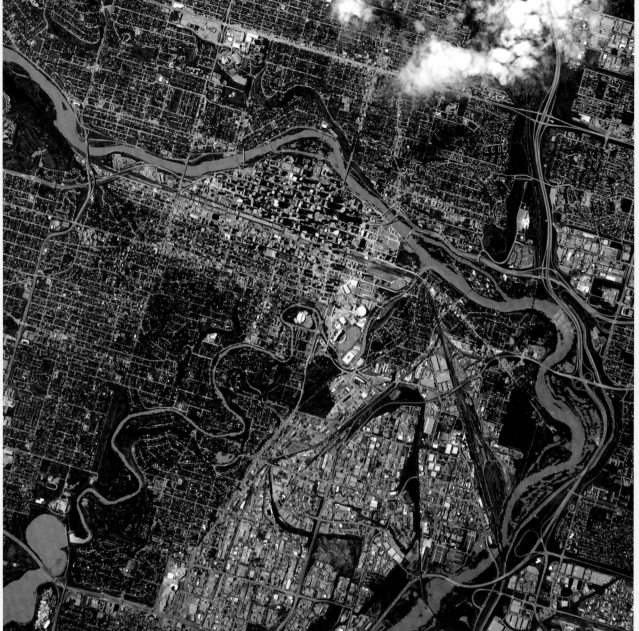

(calgary_iserv_2013622)

Downtown Calgary, June 22, 2013. Some of the worst flooding hit the grounds of the iconic Calgary Stampede, but with just three weeks to opening day, volunteers and work crews "cowboyed up" and got the grounds back in shape just in time. The large river entering the frame at top left is the Bow. The Elbow River enters the frame at bottom left. The flooded Stampede grounds can be seen near the center of the image. The city's Saddledome was flooded up to the 8th row of seating.
NASA images by Burgess Howell, SERVIR Global program. Caption by Dauna Coulter, and Mike Carlowicz,

THE POLES

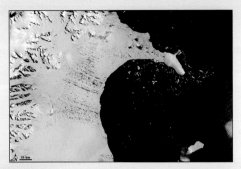

Januray 31, 2002

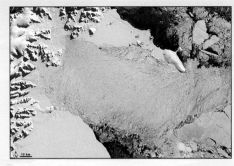

April 13, 2002

In early 2002, scientists monitoring daily satellite images of the Antarctic Peninsula watched in amazement as almost the entire Larsen B Ice Shelf splintered and and broke away from the Antarctic Peninsula during February and March, 2002—a progression observed by Terra's Moderate-resolution Imaging Spectro Radiometer (MODIS) and analyzed at the University of Colorado's National Snow and Ice Data Center. The 3,250 square kilometer piece of ice, 220 meters thick, disintegrated, meaning an ice shelf covering an area comparable in size to the US state of Rhode Island collapsed in a single season. (In the January image, meltwater can be seen accumulating on the surface of the shelf and by early April it has separated and begun to disintegrate, filling the bay it has enlarged.)

NASA/GSFC/LaRC/JPL, MISR Team

(Opposite page) Ocean scientist Norman Kuring of NASA's Goddard Space Flight Center pieced together this composite image of Europe, Asia, North Africa, and the entire Arctic. It was compiled from 15 satellite passes made by Suomi-NPP on May 26, 2012. The spacecraft circles the Earth from pole to pole at an altitude of 824 kilometers (512 miles), so it takes multiple passes to gather enough data to show an entire hemisphere without gaps in the view.

"From over the southern tip of South America, Tom and I looked south and saw Antarctica, there in the snow, ice, sea and cloud. Tantalizing."
Chris Hadfield photo, © Government of Canada/NASA
(May 6, 2013 – iss035-e-039907)

There have been many images of the full disc of Earth from space—a view often referred to as "the Blue Marble"—but few have looked quite like this. Using natural-color images from the Visible/Infrared Imaging Radiometer Suite (VIIRS) on the recently launched Suomi NPP satellite, a NASA scientist has compiled a new view showing the Arctic and high latitudes.
Image by Norman Kuring, NASA/GSFC/Suomi NPP. Caption by Michael Carlowicz (2012147)

The Earth reminded us of a *Christmas tree ornament hanging in the blackness of space. That beautiful, warm, living object looked so fragile, so delicate, that if you touched it with a finger it would crumble and fall apart. Seeing this has to change a man, has to make a man appreciate the creation of God.*

James Irwin, USA
Apollo 15, July 1971
(*The Home Planet*)

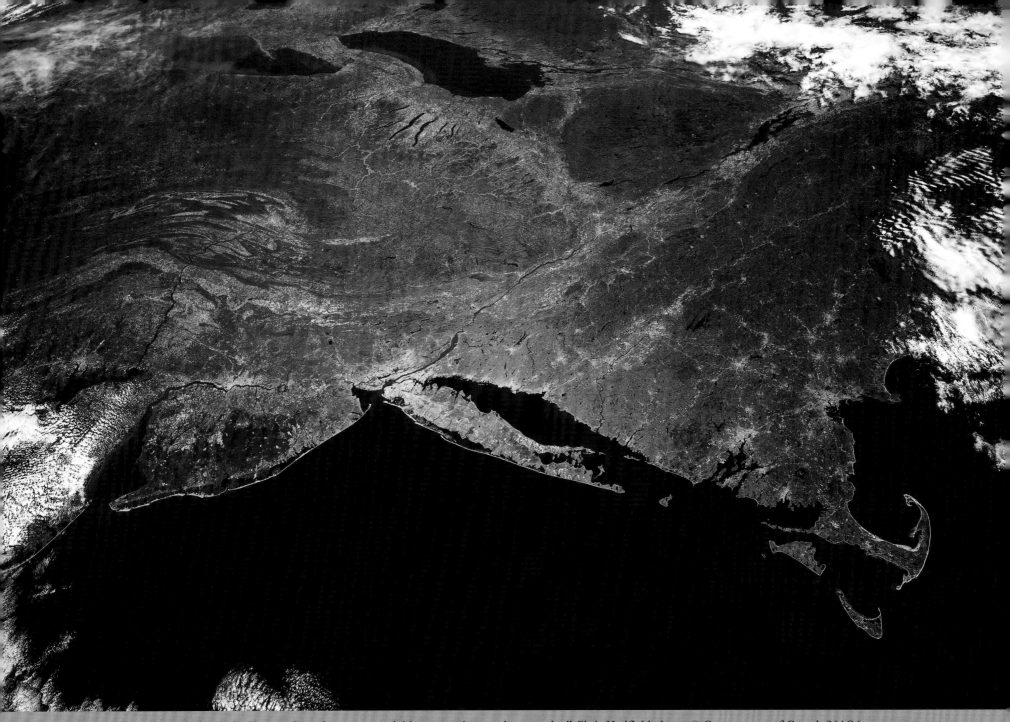

"Chesapeake to Cape Cod to Lake Huron—in a glance, so much history, geology and geography." Chris Hadfield photo, © Government of Canada/NASA, (May 2, 2013 – iss035-e-034009) Location: Left to right across the shoreline of the Atlantic Ocean we have Delaware Bay, Philadelphia, New York City, Long Island, Cape Cod and Boston. The border between Canada and the United States runs through the center of Lake Erie and Lake Ontario, at the top of this image.

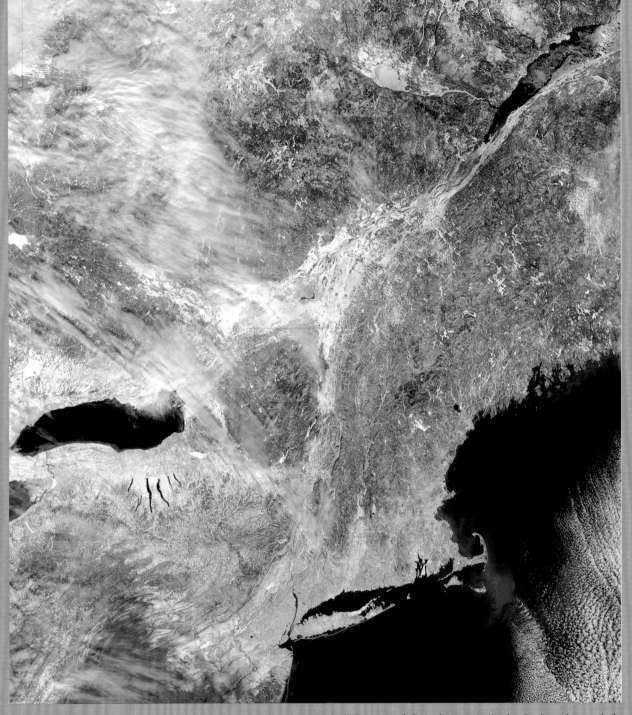

Winter view of the northeastern United States and Canada as seen in the Spring view at left.
NASA image courtesy Jeff Schmaltz, MODIS Rapid Response Team at NASA GSFC.
Caption by Michon Scott. (February 20, 2013 – 2013041)

We must look to the heavens for the measure of the earth.

Jean Felix Picard
17th century French astronomer

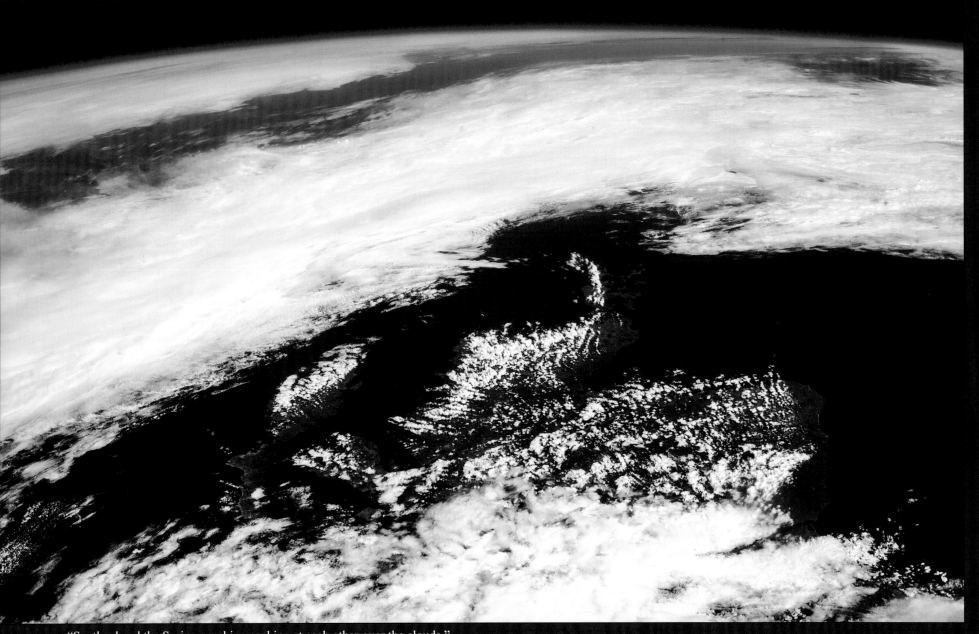

"Scotland and the Spring sunshine peeking at each other over the clouds."
Chris Hadfield photo, © Government of Canada/NASA (May 9, 2013 – iss035-e-040023)

"Ireland, Wales and Man silhouetted in the setting sun."
Chris Hadfield photo, © Government of Canada/NASA (April 20, 2013 – iss035-e-025295)

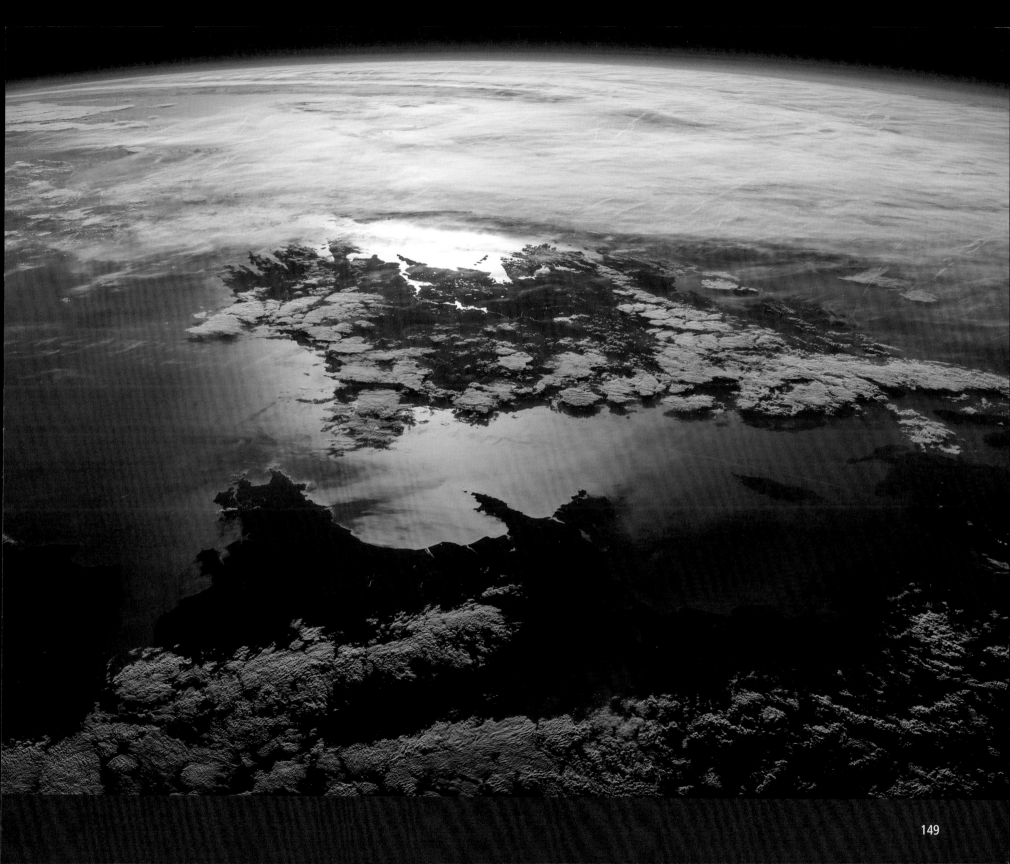

"Ships waiting their turn at the Panama Canal's western mouth. One amazing feat of engineering viewed from another"
Chris Hadfield photo, © Government of Canada/NASA (March 22, 2013 – iss035-e-007891)

The Panama and Suez Canals

As early as the 1830s, railroads had begun to usurp the position of canals as important transportation routes around the world. But two of the largest and most important of the world's canals had yet to be built: the Suez Canal in Egypt between the Mediterranean and Red Seas, and the Panama Canal in Panama between the Atlantic and Pacific. Both canals divide continents and often save ships thousands of miles of travel.

A canal across the desert from the Mediterranean to the Red Sea had been attempted more than once throughout history, but without lasting success. That is, until Ferdinand de Lesseps organized the Suez Canal Company in 1858, and with French and Ottoman support (the latter in reality coming from the Egyptian Pasha) began the digging in 1859.

As many as 20,000 Egytians would labor for roughly the next ten years, often working only with shovels, sometimes assisted by mechanized diggers on rafts and carts on railroad tracks to haul away dirt. The canal was completed in 1869.

De Lesseps, who had led the project, was not done building canals yet. He next set his sights on a canal through Panama, buying the rights for the project and beginning digging in 1882. But financial and political problems forced de Lesseps to abandon the project in 1889. The partially dug canal would lie abandoned until the United States found a sudden interest in it. The Spanish-American War caused the Americans to realize what a military advantage the canal would be – it would allow the Navy to be quicker and more flexible. But negotiations got hung up in the Colombian legislature, until the people of Panama took things into their own hands (albeit with help from the French and Americans) with a revolution. They quickly signed a deal with the U.S., and Americans resumed work in 1904. The canal was basically finished in 1914, but a landslide delayed its official opening until 1920.

Both of these canals look set to continue their profitable, productive service of linking the world and its sea routes a little closer together.

"Ships waiting for a pilot to guide them through the Suez Canal, from the Indian Ocean to the Mediterranean Sea."
Chris Hadfield photo, © Government of Canada/NASA (January 13, 2013 – iss034-e-028862)
Location: looking north from the Gulf of Suez, at the city of Suez, to Fayed on Great Bitter Lake

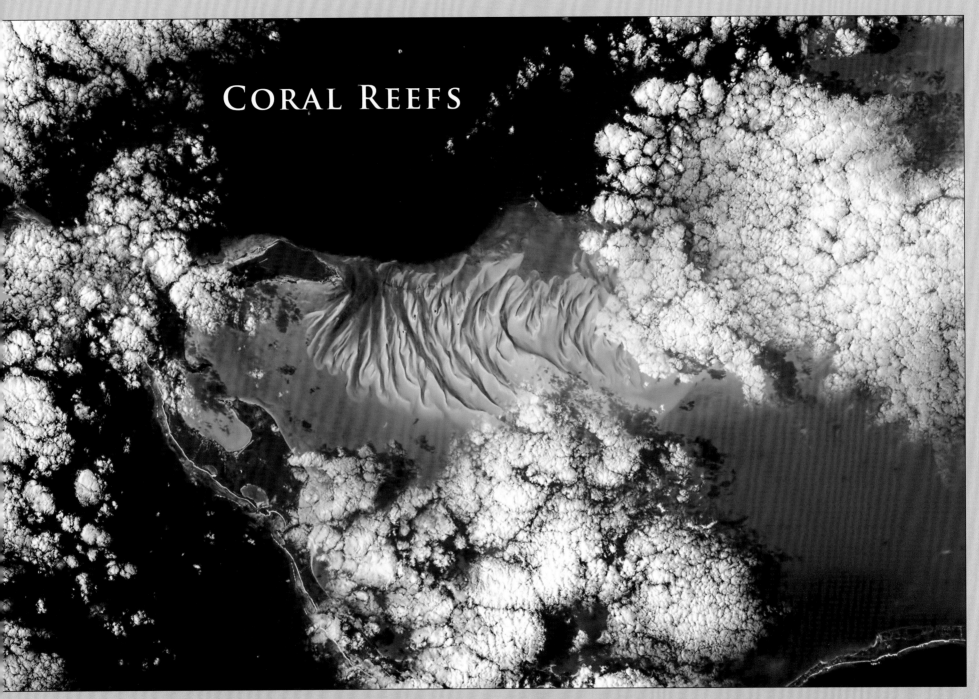

CORAL REEFS

"The beauty of the Bahamas is surreal; every blue that exists. Taken on New Year's Day, 2013 from the International Space Station."
Chris Hadfield photo, NASA (January 1, 2013– iss034-e-011679) Location: Eleuthera Island, Bahamas

Near Florida and Cuba, the underwater terrain is hilly and the crests of many of these hills compose the islands of the Bahamas. A striking feature of these photographs is the Great Bahama Bank, a massive underwater hill underlying Andros Island (overleaf) in the west, Eleuthera Island in the east, and multiple islands in between. To the north, another bank underlies a set of islands, including Grand Bahama. The varied colors of these banks suggest that their surfaces are somewhat uneven. The banks' distinct contours, sharply outlined in dark blue, indicate that the ocean floor drops dramatically around them. Over the banks, the water depth is often less than 10 meters (30 feet), but the surrounding basin plunges to depths as low as 4,000 meters.

Earth As Art, NASA

The white, twisted clouds and the endless shades of blue in the ocean make the hum of the spacecraft systems, the radio chatter, even your own breathing disappear. There is no wind or cold or smell to tell you that you are connected to Earth. You have an almost dispassionate platform—remote, Olympian— and yet so moving that you can hardly believe how emotionally attached you are to those rough patterns shifting steadily below.

Thomas Stafford, USA
Gemini 6A, December 1965
Gemini 9A, June 1966
Apollo 10, May 1969
Apollo-Soyuz, July 1975
(*The Home Planet*)

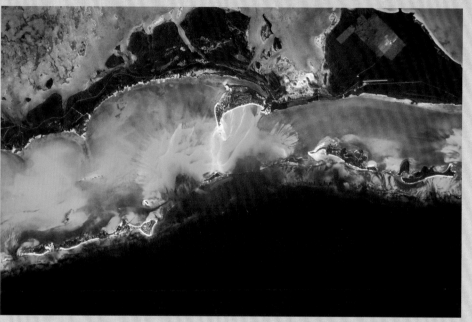

"It's hard to believe the colors of the Bahamas from space." Chris Hadfield photo, © Government of Canada/NASA (January 4, 2013 – iss034-e-015277)
Location: The central part of Abaco Island

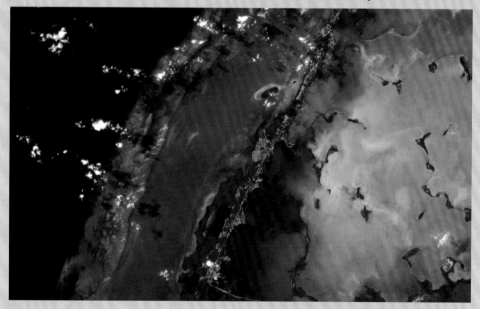

"Key Largo, FL—home of the *Aquarius* underwater habitat; I commanded a crew of six for two weeks on the ocean floor here." Chris Hadfield photo, © Government of Canada/NASA (January 4, 2013 – iss034-e-015254)

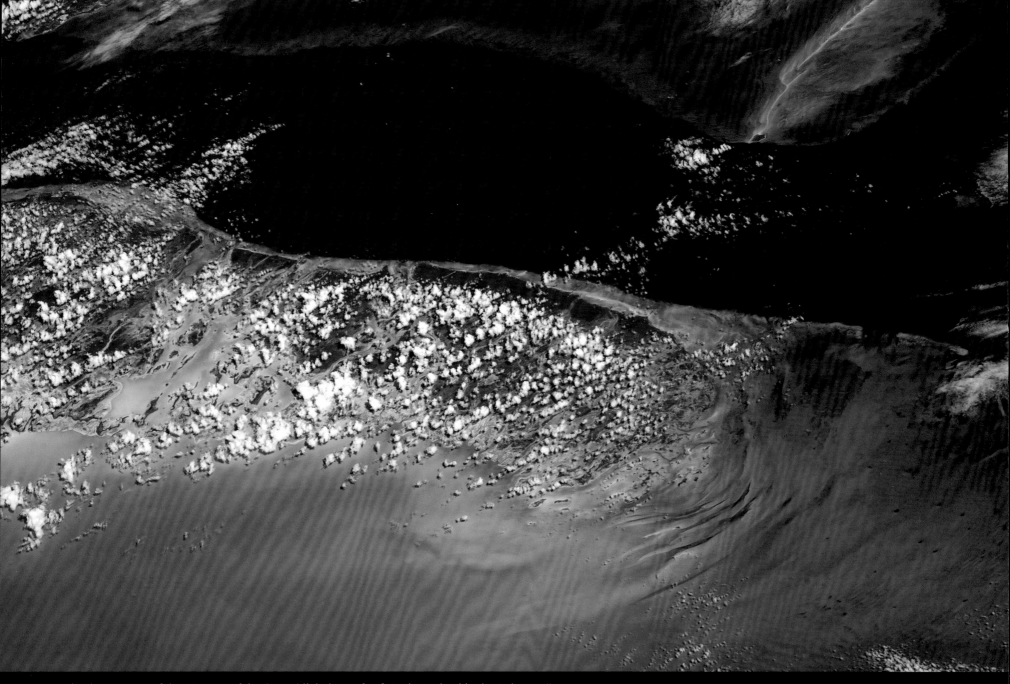

"The deep waters of the 'Tongue of the Ocean' lick the reefs of Andros Island in the Bahamas."
Chris Hadfield photo, © Government of Canada/NASA (January 1, 2013 – iss034-e-030635)

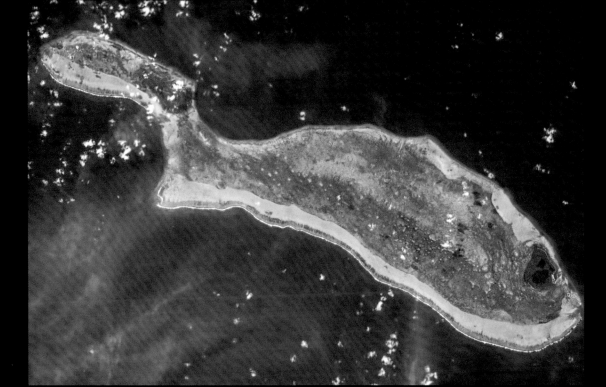

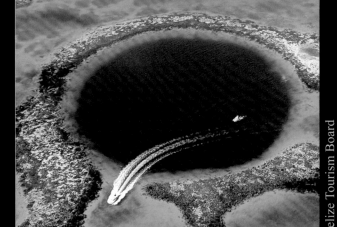

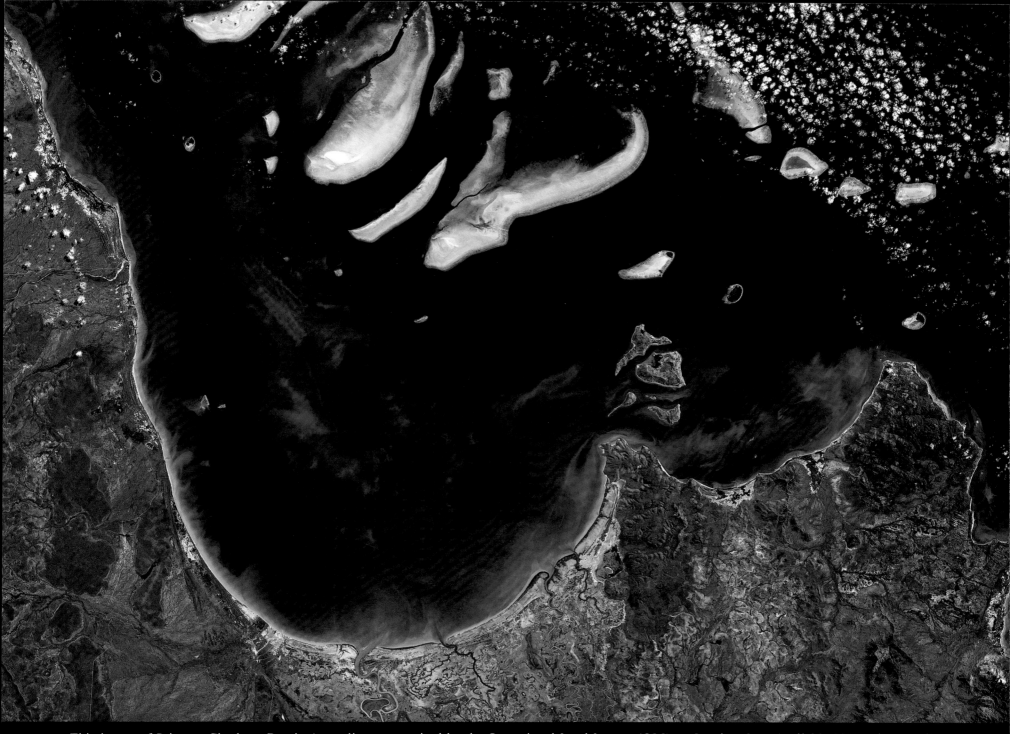

This image of Princess Charlotte Bay in Australia was acquired by the Operational Land Imager (OLI) on Landsat 8 on April 20, 2013. The area lies along the east coast of Queensland's Cape York Peninsula. The scene shows Claremont Isles National Park, where coastal waters are protected as part of Great Barrier Reef World Heritage Site. The islands are important habitat and breeding grounds for seabirds, and they are off limits to humans.
NASA Earth Observatory images by Jesse Allen & Robert Simmon, using data provided by the U.S. Geological Survey (charlottebay_oli_2013110_geo)

The concept behind Landsat is to gather images of Earth's land surfaces. But in four decades of service to science, the satellites have proven themselves quite useful for observing some blue parts of the planet as well.

The study of coral reefs has been particularly enriched by Landsat. Scientists used earlier generations of Landsats to create a global image library of coral reefs. They have also been able to do time-series assessments of the health of some reefs. For instance, researchers used 18 years of Landsat data to show a decline in the health of reef habitat across roughly 68 percent of the Florida Keys National Marine Sanctuary.

Once you have tasted flight you will walk the earth with your eyes turned skywards, for there you have been and there you will long to return.

Leonardo da Vinci, 1500

"Sand and water playing hide and seek on the African east coast."
Chris Hadfield photo, © Government of Canada/NASA
(April 24, 2013 – iss035-e-028791)
Location: Bazaruto Archipelago National Marine Park in Mozambique

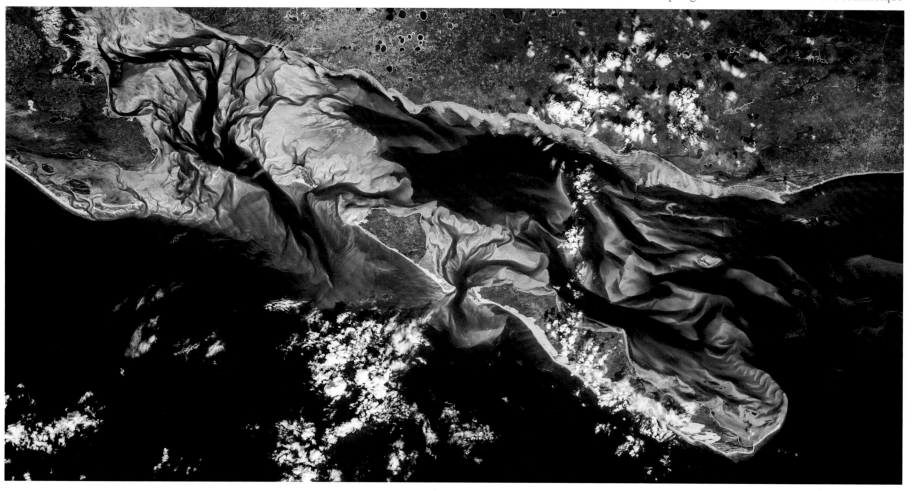

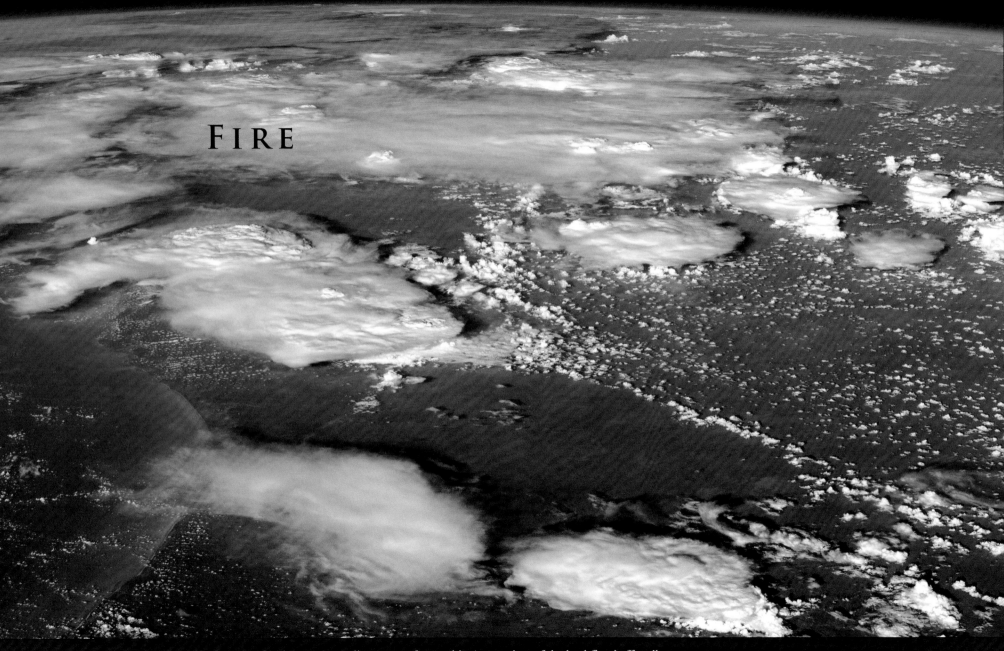

FIRE

"Tonight's finale: The pall of smoke clouds over Australia, as seen from orbit. A rare view of the bushfires' effect."
Chris Hadfield photo, © Government of Canada/NASA (January 12, 2013 – iss034-e-028539)

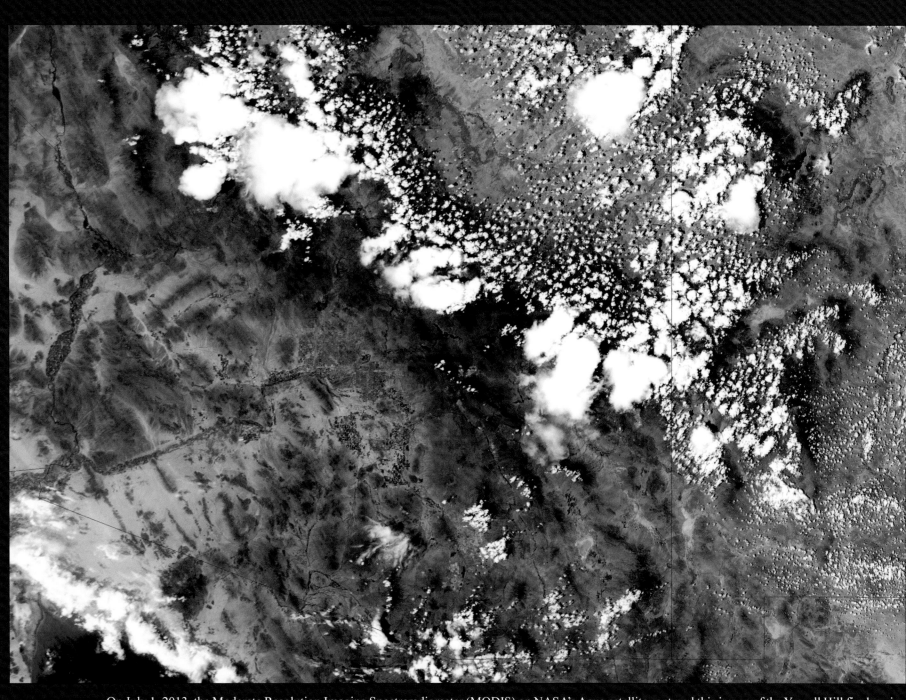

On July 1, 2013, the Moderate Resolution Imaging Spectroradiometer (MODIS) on NASA's Aqua satellite captured this image of the Yarnell Hill fire burning in Arizona near the town of Yarnell. This devasting fire killed 19 firefighters of the Grand Mountain Hot Shots Crew and destroyed more than 200 homes. NASA image by Jeff Schmaltz, LANCE/EOSDIS Rapid Response. (July 1, 2013 – arizona_amo_2013182)

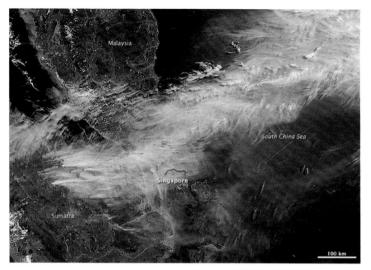

NASA (June 19, 2013)

Smoke Engulfs Singapore

On June 19, 2013, NASA's Terra and Aqua satellites captured striking images of smoke billowing from illegal wildfires on the Indonesian island of Sumatra. The smoke blew east toward southern Malaysia and Singapore, and news media reported that thick clouds of haze had descended on Singapore, pushing pollution to record levels. Though local laws prohibit it, farmers in Sumatra often burn forests during the dry season to prepare soil for new crops.

The country is separated by the South China Sea into two similarly sized regions, Peninsular Malaysia (top left) and Malaysian Borneo (bottom right). The red "hot spots" show just how many fires are burning at one time in both regions of the nation.

In looking at the large image at left, your view covers an expanse of about 720 kilometers (450 miles)
NASA image Jeff Schmaltz LANCE/EOSDIS MODIS Rapid Response Team. Caption by Adam Voiland.
(June 19, 2013 – indonesia_amo_2013170_geo)

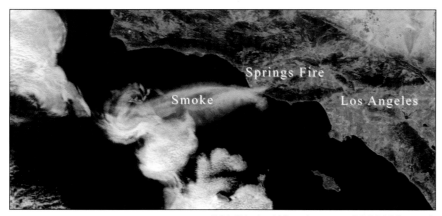

NASA (california_tmo_2013122_geo)

Spring Fire, California (right)

Fueled by hot, dry Santa Ana winds, several wildfires started in southern California in early May 2013. The National Interagency Fire Center had predicted that fire season in California would be earlier than normal because of scarce winter and spring precipitation.

On May 2, 2013, a fire started near Camarillo Springs and gusty winds blew it toward the coast, wafting smoke out over the Pacific Ocean. The same day, the Moderate Resolution Imaging Spectroradiometer (MODIS) on NASA's Terra and Aqua satellites captured this image of the fire burning about 80 kilometers (50 miles) northwest of Los Angeles, California.

The city of Los Angeles is visible in the bottom right corner
of the photographs at right and above.
NASA images Jeff Schmaltz, LANCE MODIS Rapid Response.
Caption by Mike Carlowicz.

Wildfire Smoke Over Alaska (left)

On June 19, 2013, NASA's Aqua satellite captured this image of smoke from wildfires burning in remote western Alaska. The smoke was moving west over Norton Sound.

NASA image Jeff Schmaltz LANCE/EOSDIS MODIS
Rapid Response Team. (alaska_amo_2013170_geo)
Caption by Adam Voiland.

NASA (california_amo_2013122)

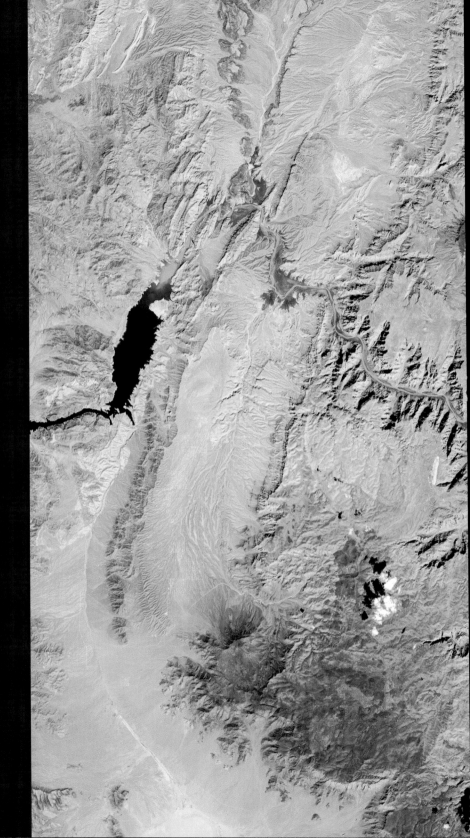

The Grand Canyon

When John Wesley Powell led an expedition down the Colorado River and through the Grand Canyon in 1869, he was confronted with a daunting landscape. At its highest point, the serpentine gorge plunged 2,400 meters (8,000 feet) from rim to river bottom, making it the deepest canyon in the United States. In just six million years, water had carved through rock layers that collectively represented more than 2 billion years of geological history, nearly half of the time Earth has existed.

> *"The wonders of the Grand Canyon cannot be adequately represented in symbols or speech,"* Powell wrote in his log. *"The resources of the graphic art are taxed beyond their powers in attempting to portray its features."*
> **John Wesley Powell, 1869**

Powell was, of course, seeing the canyon mainly from river level; there was no technology that provided views of the landscape from space then. If there had been, he would have seen something similar to what Landsat 8 did on March 29, 2013 (right).

The Colorado River—and the canyon she has carved out in the last six million years—can be seen running out of Lake Mead at left and proceeding in a giant "U", down and across the center of the photo where it then turns north, running off the page at top right.

Satellite image by Robert Simmon, using Landsat data from the U.S. Geological Survey and NASA. (20130880) Caption by Adam Voiland.

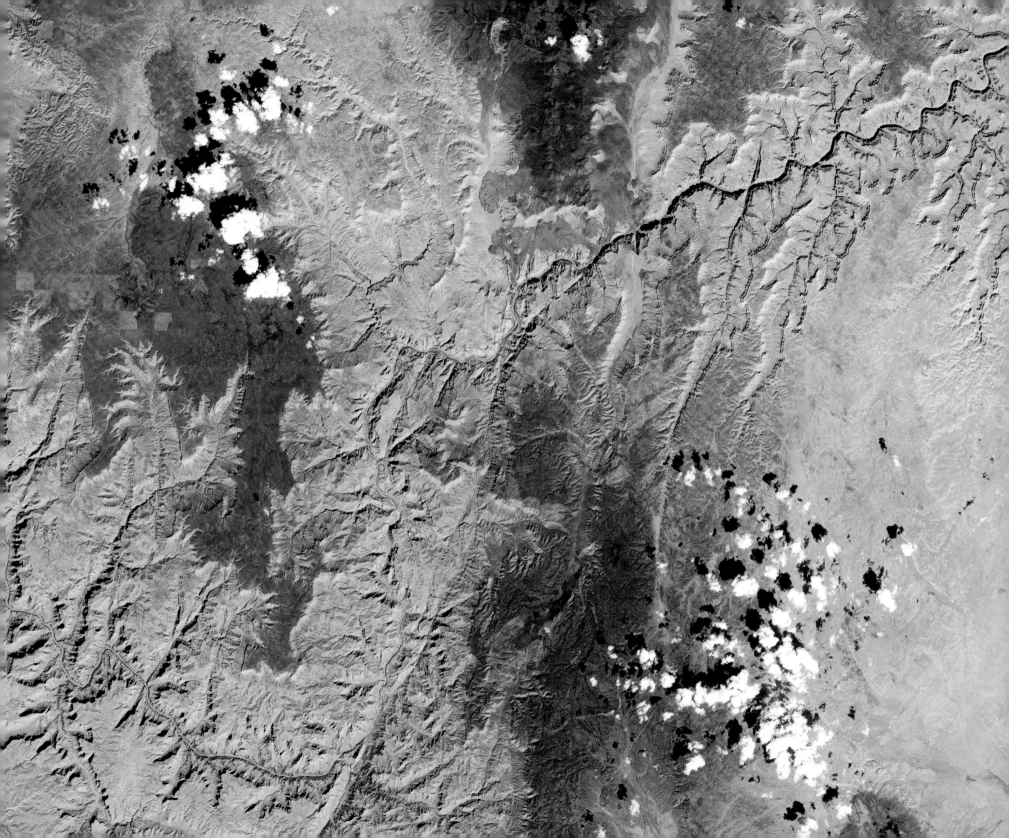

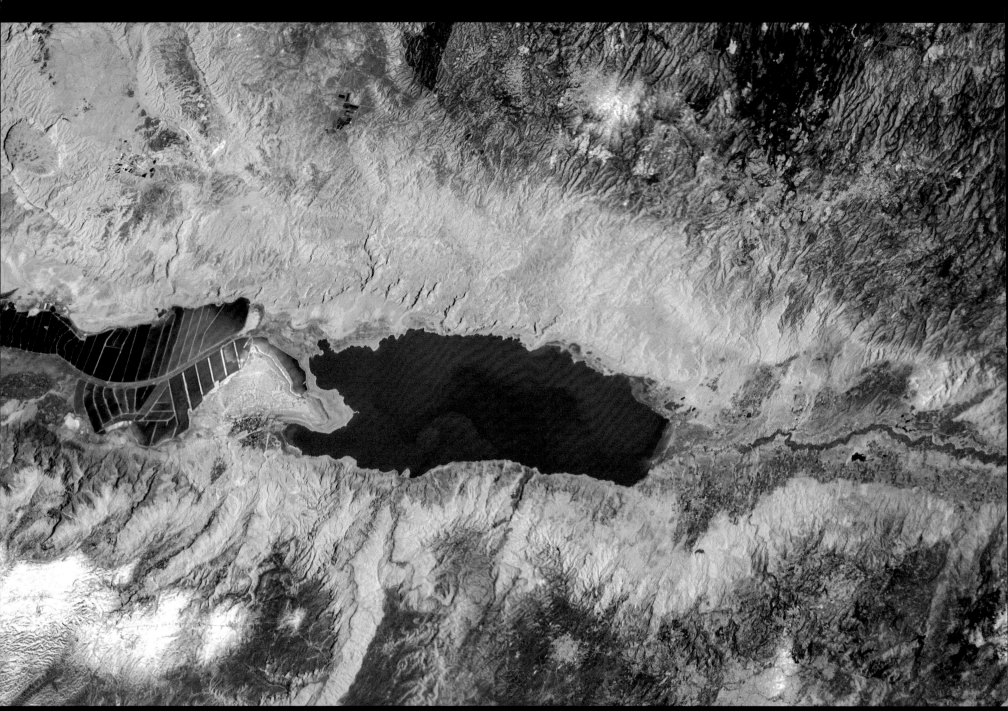

"Salt ponds and the Dead Sea. Such an abruptly apt name." Chris Hadfield photo, © Government of Canada/NASA (January 13, 2013 – iss034-e-028888)

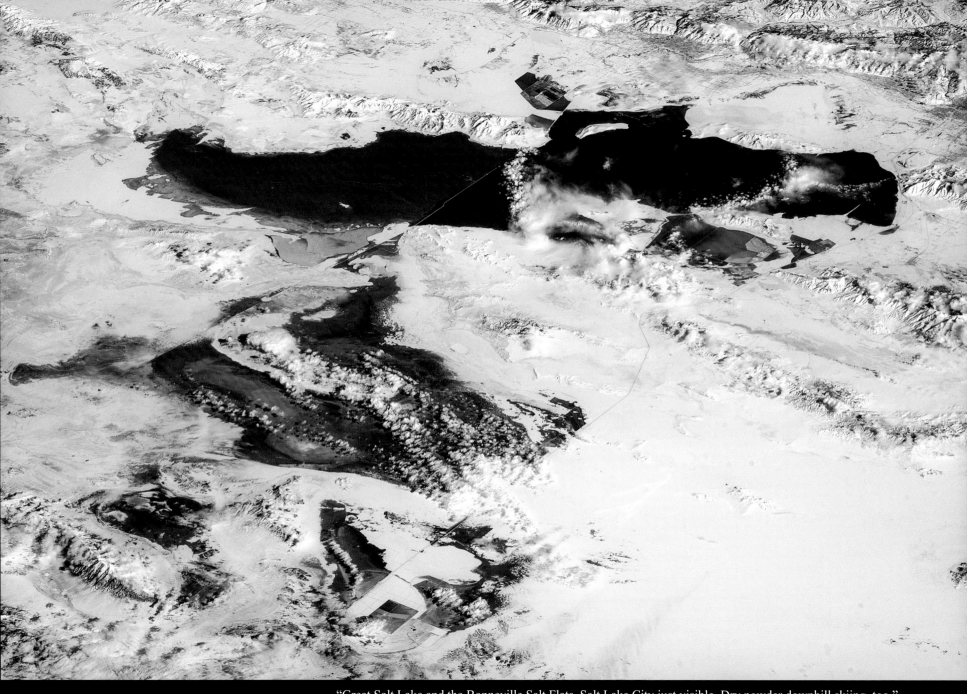

"Great Salt Lake and the Bonneville Salt Flats, Salt Lake City just visible. Dry powder downhill skiing, too."
Chris Hadfield photo, © Government of Canada/NASA (January 13, 2013 – iss034-e-028949)

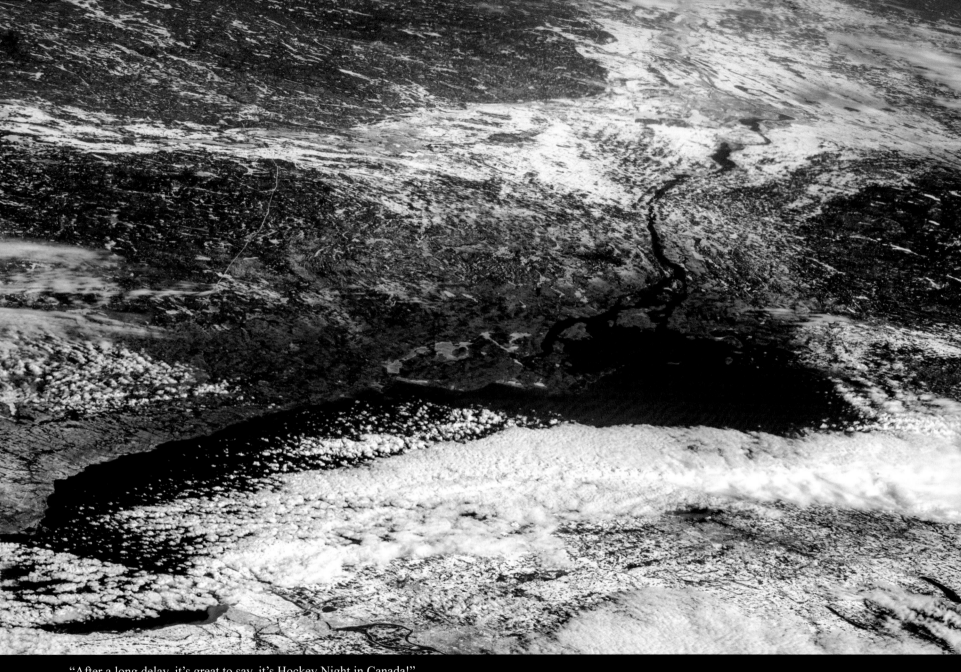

"After a long delay, it's great to say, it's Hockey Night in Canada!"
Chris Hadfield photo, © Government of Canada/NASA (January 18, 2013 – iss034-e-032326)
Location: view of Canada's Lake Ontario stretching to the east from Toronto to Montreal on the St. Lawrence River.

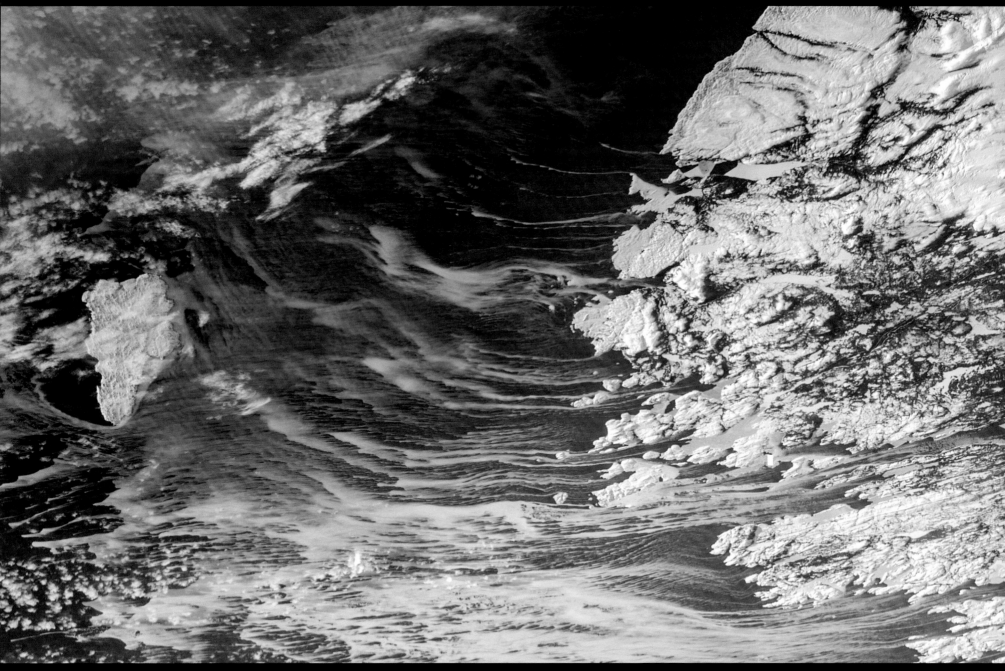

"Canada's east coast, so vividly joined to the sea." Chris Hadfield photo, © Government of Canada/NASA (January 18 2013, iss034-e-032683)

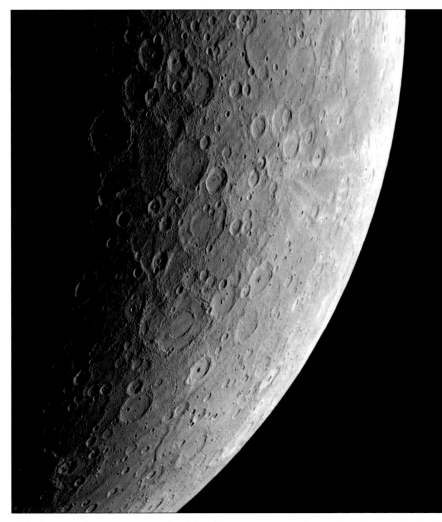

This image of Mercury, acquired by the Mercury Dual Imaging System (MDIS) aboard NASA's MESSENGER mission on April 23, 2013, allows us to take a step back to view the planet. Prior to the MESSENGER mission, Mercury's surface was often compared to the surface of Earth's moon, when in fact, Mercury and the moon are very different.

NASA/Johns Hopkins University Applied Physics Laboratory
Carnegie Institution of Washington

The Moon and Sun

Two or three times a year, NASA's Solar Dynamics Observatory (SDO) observes the moon traveling across the sun, blocking its view. While this obscures solar observations for a short while, it offers the chance for an interesting view of the shadow of the moon. The moon's crisp horizon can be seen up against the sun, because the moon does not have an atmosphere. (At other times of the year, when Earth blocks SDO's view, the Earth's horizon looks fuzzy due to its atmosphere.)

This recently inspired two NASA visualizers to overlay a three-dimensional model of the moon based on data from NASA's Lunar Reconnaissance Orbiter (LRO), into the shadow of the SDO image. Such a task is fairly tricky, as the visualizers—Scott Wiessinger, who typically works with the SDO imagery and Ernie Wright, who works with the LRO imagery—had to precisely match up data from the correct time and viewpoint for the two separate instruments. The end result is an awe-inspiring image of the sun and the moon.

Image Credit: NASA/SDO/LRO/GSFC

And tomorrow? Settlements on the Moon, voyages to Mars, scientific stations on the asteroids, contact with other civilizations ... Let us not grieve that we shall not participate in distant planetary expeditions. We shall not envy the people of the future. Of course they are lucky and things about which we can only dream will be ordinary for them. But great happiness has come our way, too, the happiness of the first steps in space. Let those who follow envy our happiness.

Yuri Gagarin, Russia
Vostok 1, April 1961
First person in space
(The Home Planet)

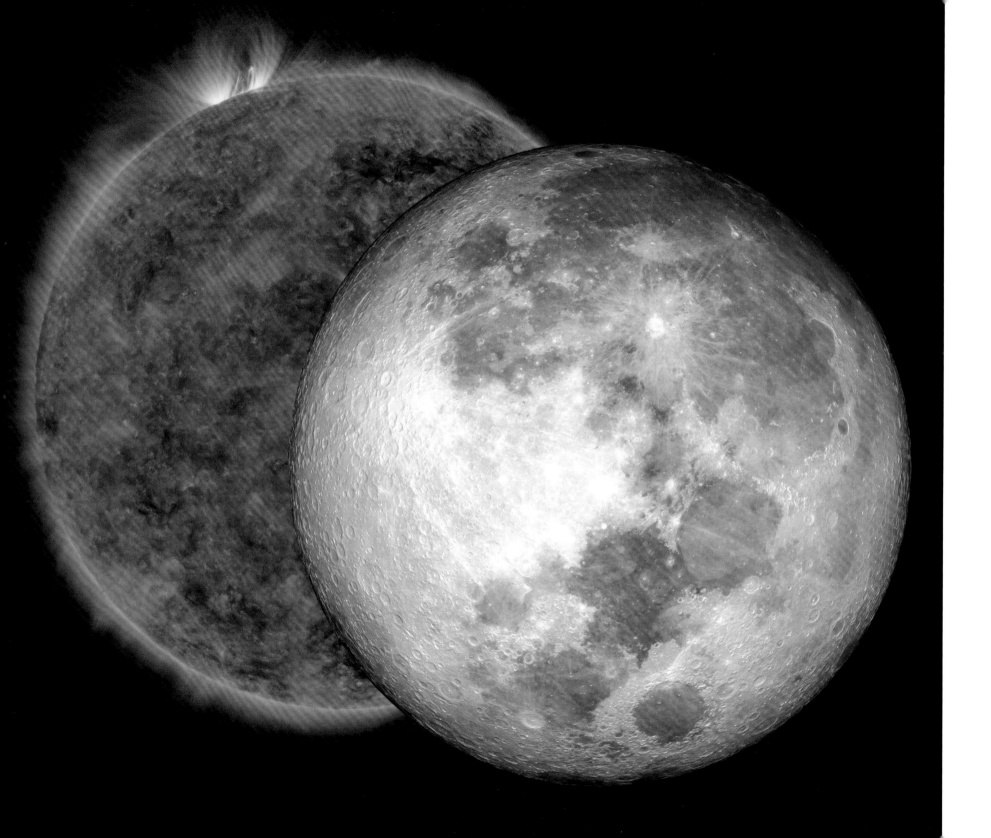

WEATHER

Earth's weather is driven by the sun. Solar energy, sunlight, heats the earth, but it does not heat it evenly. Additionally, the earth radiates heat away differentially. The dynamic processes involved leave air masses on Earth with differences in temperature, and, therefore, differences in density. We know that warmer air rises, and cooler air pushes in underneath it. If we factor in the Coriolis forces operating around the planet, we get a mix of constantly moving air.

In addition to all of this, consider that the planet is largely covered in water. With the evaporation of this water and the addition of atmospheric moisture into the equation, we arrive at a situation where atmospheric conditions are in constant flux and precipitation in many forms is involved. Predicting changes in weather is a challenge, particularly in the long term. The moisture or water cycle is a part of the weather cycle.

Before I flew I was already aware of how small and vulnerable our planet is; but only when I saw it from space, in all its ineffable beauty and fragility, did I realize that humankind's most urgent task is to cherish and preserve it for future generations.

Sigmund Jahn, Germany
Soyuz 31, August 1978
(*The Home Planet*)

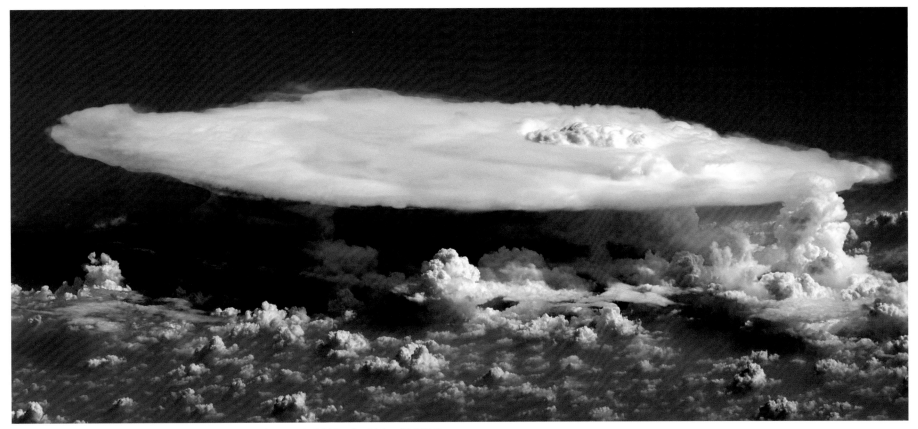

"Cumulonimbus Cloud over Africa." NASA, (February 8, 2008 – iss016-e-027426)

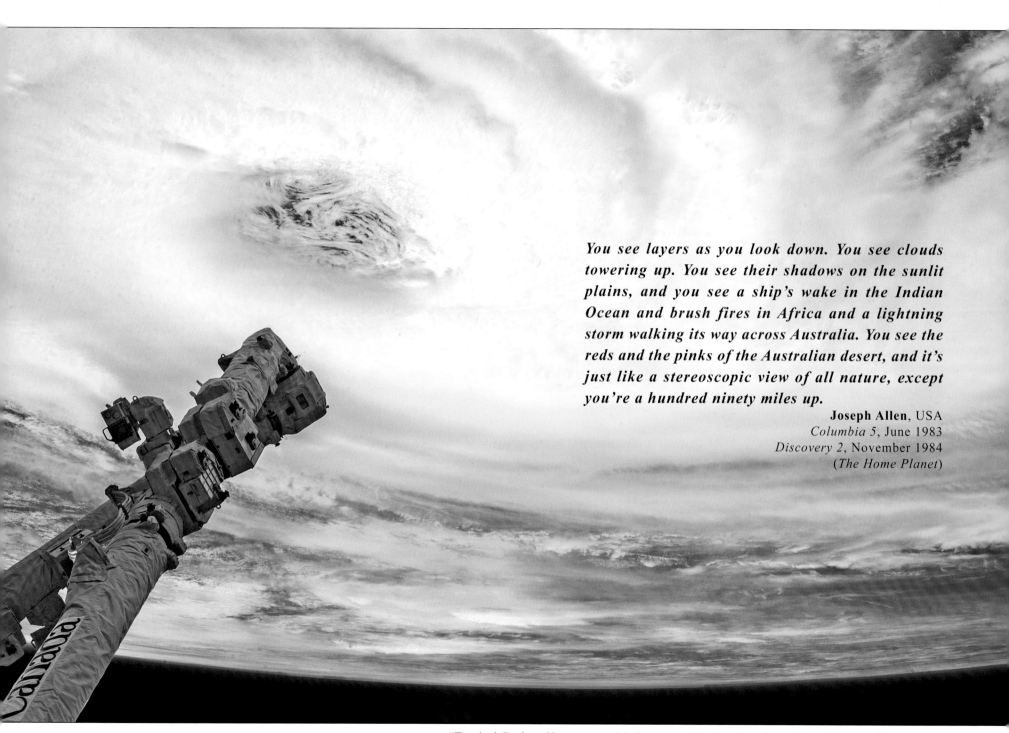

You see layers as you look down. You see clouds towering up. You see their shadows on the sunlit plains, and you see a ship's wake in the Indian Ocean and brush fires in Africa and a lightning storm walking its way across Australia. You see the reds and the pinks of the Australian desert, and it's just like a stereoscopic view of all nature, except you're a hundred ninety miles up.

Joseph Allen, USA
Columbia 5, June 1983
Discovery 2, November 1984
(*The Home Planet*)

"Tropical Cyclone Haruna, over Madagascar, with Canadarm2 pointing at the eye of the storm."
Chris Hadfield photo, © Government of Canada/NASA (February 21, 2013 – iss034-e-051635)

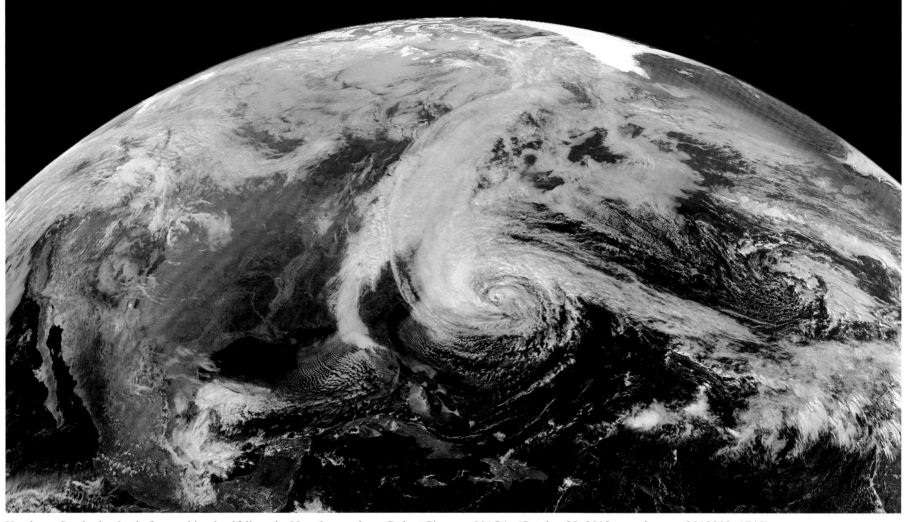

Hurricane Sandy the day before making landfall on the New Jersey shore. Robert Simmon, NASA, (October 28, 2012 – sandy_goe_2012302_1745)

The Geostationary Operational Environmental Satellite 13 (GOES-13) captured this natural-color image of Hurricane Sandy at 1:45 pm Eastern Daylight Time (17:45 Universal Time) on October 28, 2012. Note how a line of clouds from a continental weather system runs south to north along the Appalachian Mountains, approaching from the west to meet the offshore storm. Hurricane Sandy would strike the east coast the next morning, becoming the deadliest and most destructive tropical cyclone of the 2012 Atlantic hurricane season, as well as the second costliest hurricane in United States history.

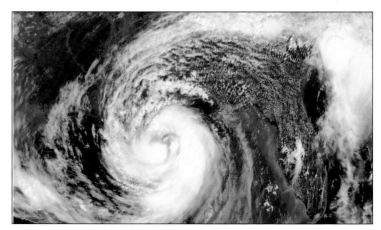

Eye of tropical Hurricane Issac forming over the Gulf of Mexico, Jeff Schmaltz, NASA, (August 28, 2012 – isaac_tmo_2012241_geo)

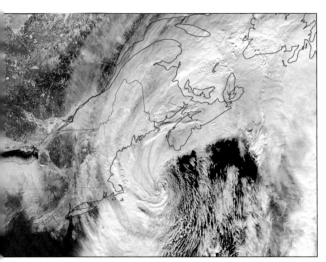

Diagram showing an outline map of the New England States and the Atlantic provinces of Canada that are completely obscured by the snowstorm of February 9, 2013 at right.

A remarkably powerful blizzard brought heavy snow and strong winds to the northeastern portion of the United States on February 9, 2013. A collision of cold air from Canada with moist air from the Gulf of Mexico brought snowfalls that extended from northern New Jersey through Maine. The storm system was a typical winter storm system pattern known as a "nor'easter", but the weather conditions were far from typical, with snowfall totals not seen since a record blizzard in 1978.

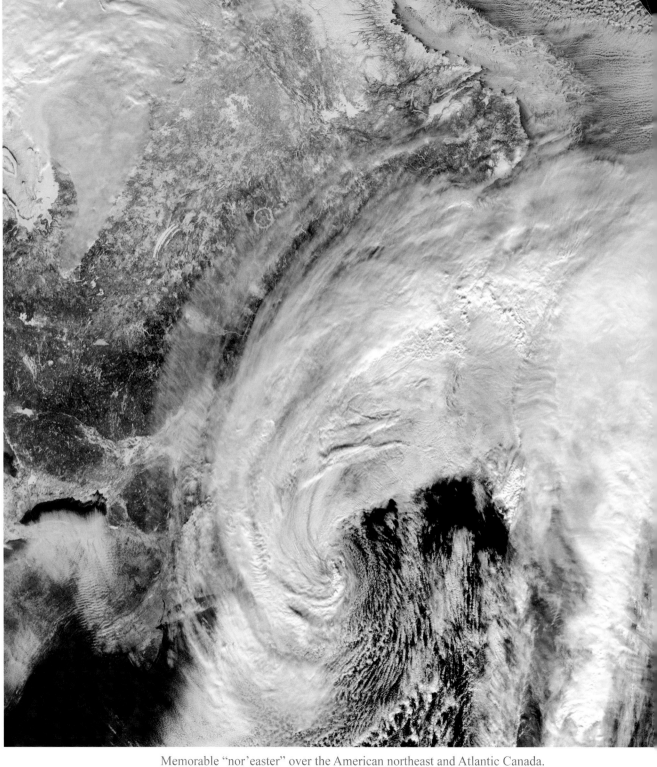

Memorable "nor'easter" over the American northeast and Atlantic Canada.
Jesse Allen, NASA, (February 9, 2013 – useast_vir_2013040)

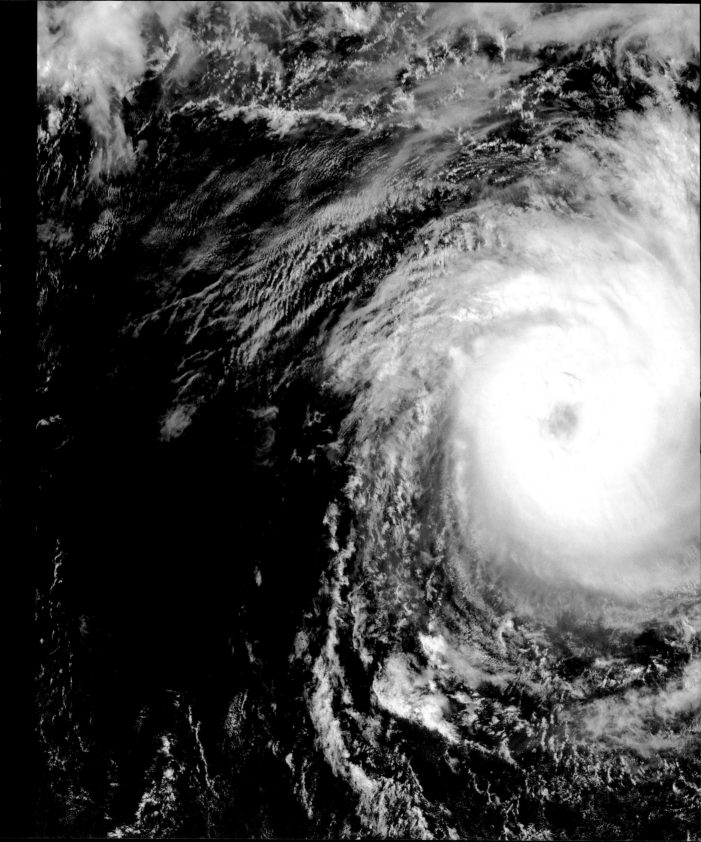

Tropical Cyclone *Imelda* was still spinning over the southern Indian Ocean on April 15, 2013. The U.S. Navy's Joint Typhoon Warning Center (JTWC) reported that Imelda had maximum sustained winds of 65 knots (120 kilometers per hour) and gusts up to 80 knots (150 kilometers per hour).

The Moderate Resolution Imaging Spectroradiometer on NASA's Terra satellite captured this natural-color image on April 8, 2013. Imelda lacked a distinct eye characteristic of strong storms, but still sported a rough apostrophe shape.

Jeff Schmaltz image.
Caption by Michon Scott.

In space, one has the inescapable impression that here is a virgin area of the universe in which civilized man, for the first time, has the opportunity to learn and grow without the influence of ancient pressures. Like the mind of a child, it is yet untainted with acquired fears, hate, greed, or prejudice.

John Glenn, Jr., USA
Mercury 6, February 1962
Discovery STS-95, October 1998
(The Home Planet)

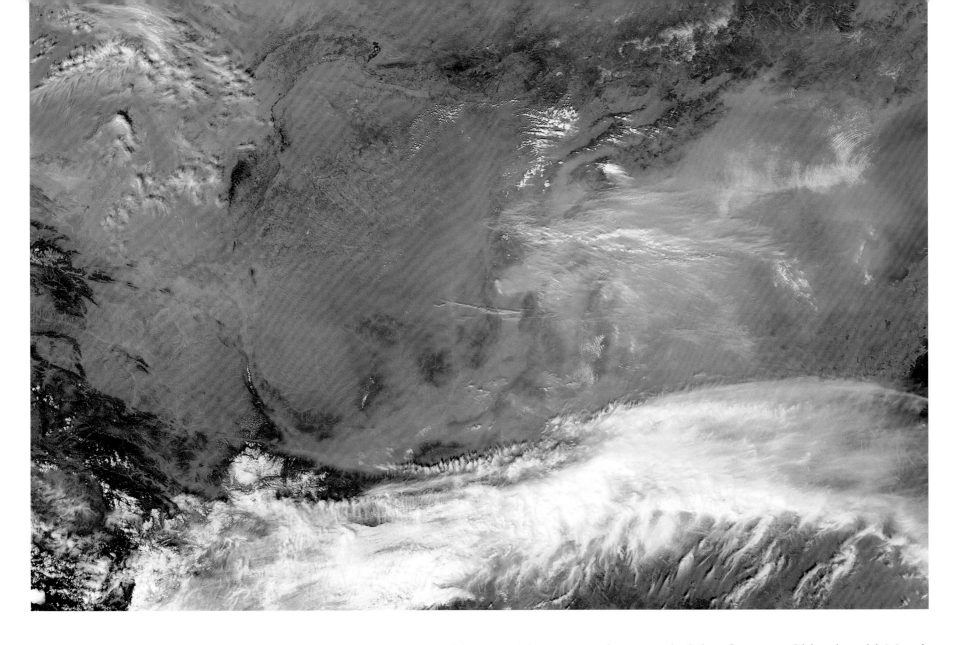

To help orient yourself here, the Taihang Shan mountains can be seen running diagonally down from the top right corner of this photograph and Beijing is nestled into the lee of this range of peaks to the east, under what appears to be a layer of haze, which characterizes this city most days.

Jeff Schmaltz and Michon Scott, NASA,
(china_amo_2013073)

Dust from the Gobi Desert blew across the coastal plain of eastern China in mid-March of 2013. Although dust hung heavy over the plain, some mountain peaks (such as those of the Taihang Shan) rose above the dust and haze. Dust had been blowing through China for several days by the time the Aqua satellite captured this image. Arising along the border between China and southwestern Mongolia, the dust extended as far south as the Sichuan Basin.

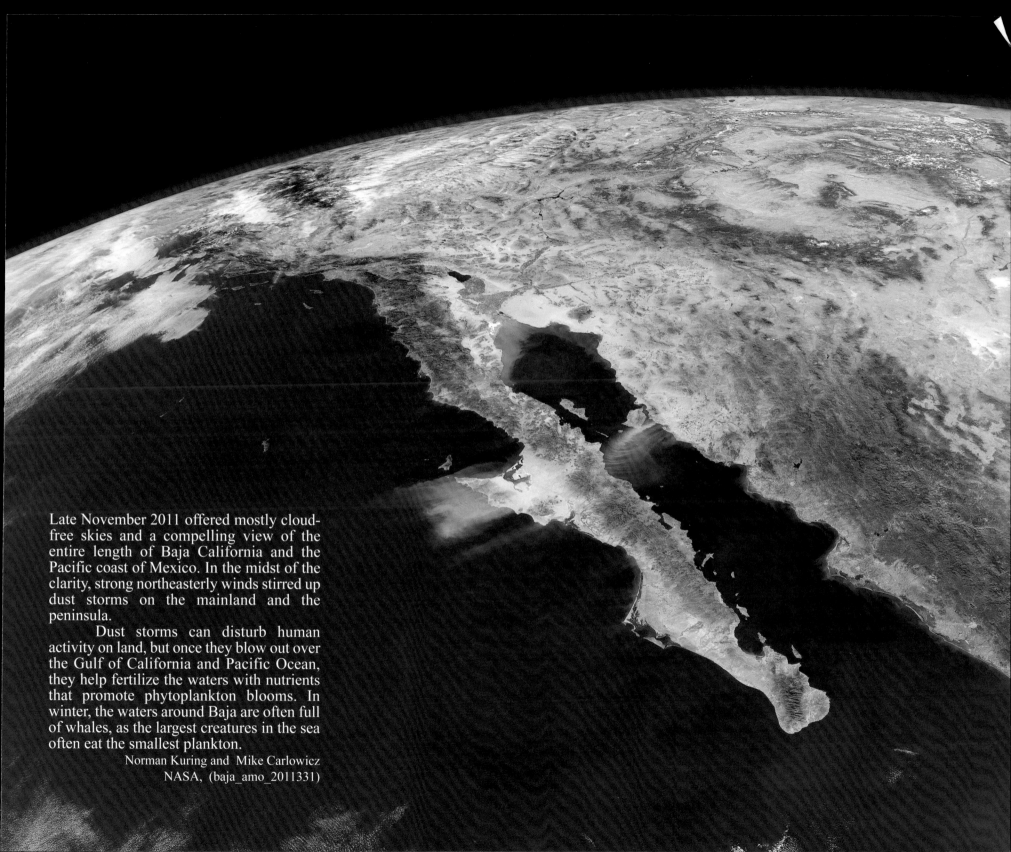

Late November 2011 offered mostly cloud-free skies and a compelling view of the entire length of Baja California and the Pacific coast of Mexico. In the midst of the clarity, strong northeasterly winds stirred up dust storms on the mainland and the peninsula.

Dust storms can disturb human activity on land, but once they blow out over the Gulf of California and Pacific Ocean, they help fertilize the waters with nutrients that promote phytoplankton blooms. In winter, the waters around Baja are often full of whales, as the largest creatures in the sea often eat the smallest plankton.

Norman Kuring and Mike Carlowicz
NASA, (baja_amo_2011331)

Lake Baikal as seen from the OrbView-2 satellite
(Baikal-S1999276045323)

Lake Baikal is the most voluminous freshwater lake on Earth, containing roughly 20% of the world's unfrozen surface fresh water, and at 1,642 meters (5,387 feet), the deepest. While it doesn't look like it from the vantage point of the International Space Station, the lake is 636 kilometers (395 miles) in length. It is also among the clearest of all lakes, and thought to be the world's oldest at 25 million years.

Similar to Lake Tanganyika, Lake Baikal was formed as an ancient rift valley, having the typical long crescent shape with a surface area of 32,000 square kilometers (12,000 square miles). Baikal is home to more than 1,700 species of plants and animals, two thirds of which can be found nowhere else in the world, it was declared a UNESCO World Heritage Site in 1996.

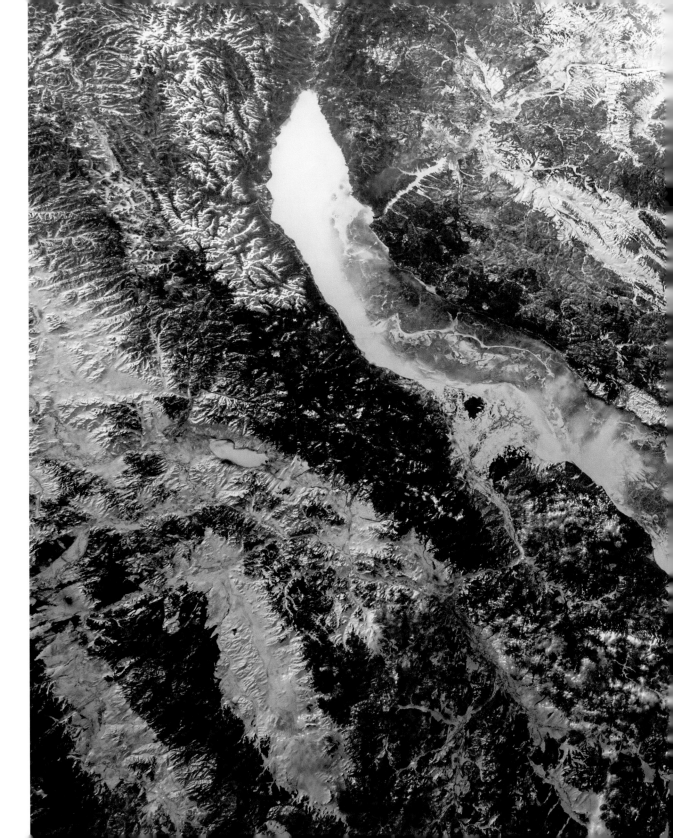

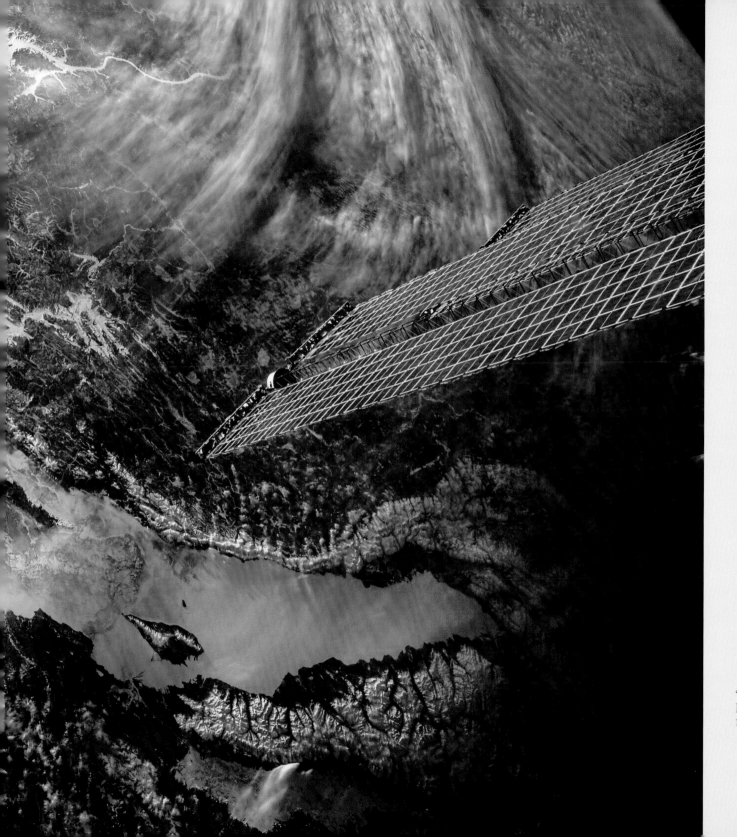

When the Russian cosmonaut tells me that the atmosphere over Lake Baikal is as polluted as it is over Europe, and when the American astronaut tells me that fifteen years ago he could take much clearer pictures of the industrial centers than today, then I am getting concerned.

Ernst Messerschmid, Germany
Challenger 9, October 1985
(The Home Planet)

"Tonight's Finale: Lake Baikal, Siberia. Immensely old and deep, it holds one-fifth of all the Earth's fresh water."
Chris Hadfield photo,
© Government of Canada/NASA
(February 21, 2013 – iss034-e-052374)

Firefly meteors blazed against a dark background, and sometimes the lightning was frighteningly brilliant. Like a boy, I gazed open-mouthed at the fireworks, and suddenly, before my eyes, something magical occurred. A greenish radiance poured from Earth directly up to the station, a radiance resembling gigantic phosphorescent organ pipes, whose ends were glowing crimson, and overlapped by waves of swirling green mist.

Consider yourself very lucky Vladimir, I said to myself, to have watched the Northern Lights.

Vladimir Remek, Czechoslovakia
Discovery 1, August 1984
Challenger 10, January 1986
(*The Home Planet*)

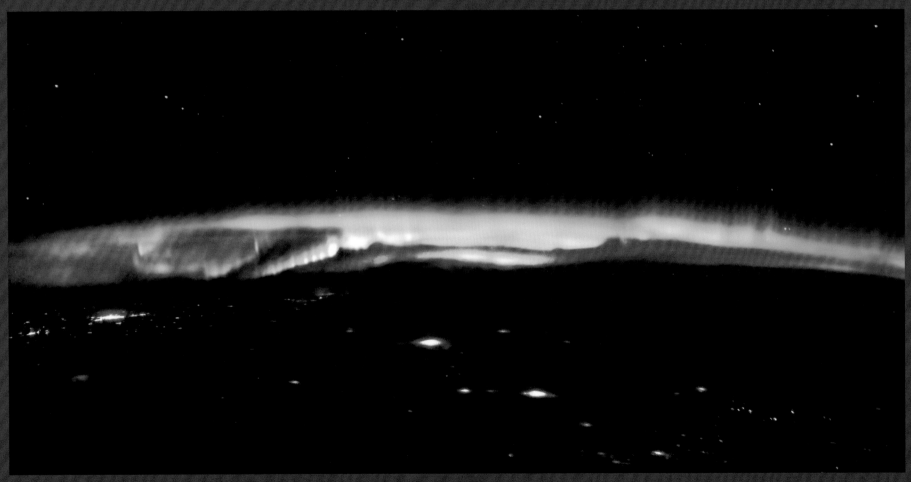

'Tonight's finale: Northern Lights—last night's aurora in green and red waves, USA and Canada below, the universe above."
Chris Hadfield photo, © Government of Canada/NASA (February 10, 2013 – iss034-e-045223)

"The spectral glory of a space sunset. Our atmosphere is a prism. In proportion, our atmosphere is no thicker than the varnish on a globe. Deceptively fragile."
Chris Hadfield photo, © Government of Canada/NASA (April 4, 2013 – iss035-e-014335)

EARTH AT NIGHT

This new image of the Earth at night is a composite assembled from data acquired by the Suomi National Polar-orbiting Partnership (Suomi NPP) satellite over nine days in April 2012 and thirteen days in October 2012. It took 312 orbits and 2.5 terabytes of data to get a clear shot of every parcel of Earth's land surface and islands.

A handful of scientists have observed earthly night lights over the past four decades with military satellites and astronaut photography. But in 2012, the view became significantly clearer. The Suomi National Polar-orbiting Partnership (NPP) satellite – launched in October 2011 by NASA, the National Oceanic and Atmospheric Administration (NOAA), and the Department of Defense—carries a low-light sensor that can distinguish night lights with six times better spatial resolution and 250 times better resolution of lighting levels (dynamic range) than before. Also, because Suomi NPP is a civilian science satellite, data is available to scientists within minutes to hours of acquisition.

Away from human settlements, light still shines. Wildfires and volcanoes rage. Oil and gas wells burn like candles. Auroras dance across the polar skies. (continued overleaf)

NASA Earth Observatory image by Robert Simmon
(dnb_land_ocean_ice)

Looking outward to the blackness of space, sprinkled with the glory of a universe of lights, I saw majesty—but no welcome. Below was a welcoming planet. There, contained in the thin, moving, incredibly fragile shell of the biosphere is everything that is dear to you, all the human drama and comedy. That's where life is; that's where all the good stuff is.

Lorne Acton, USA
STS-51F, July 1985
(The Home Planet)

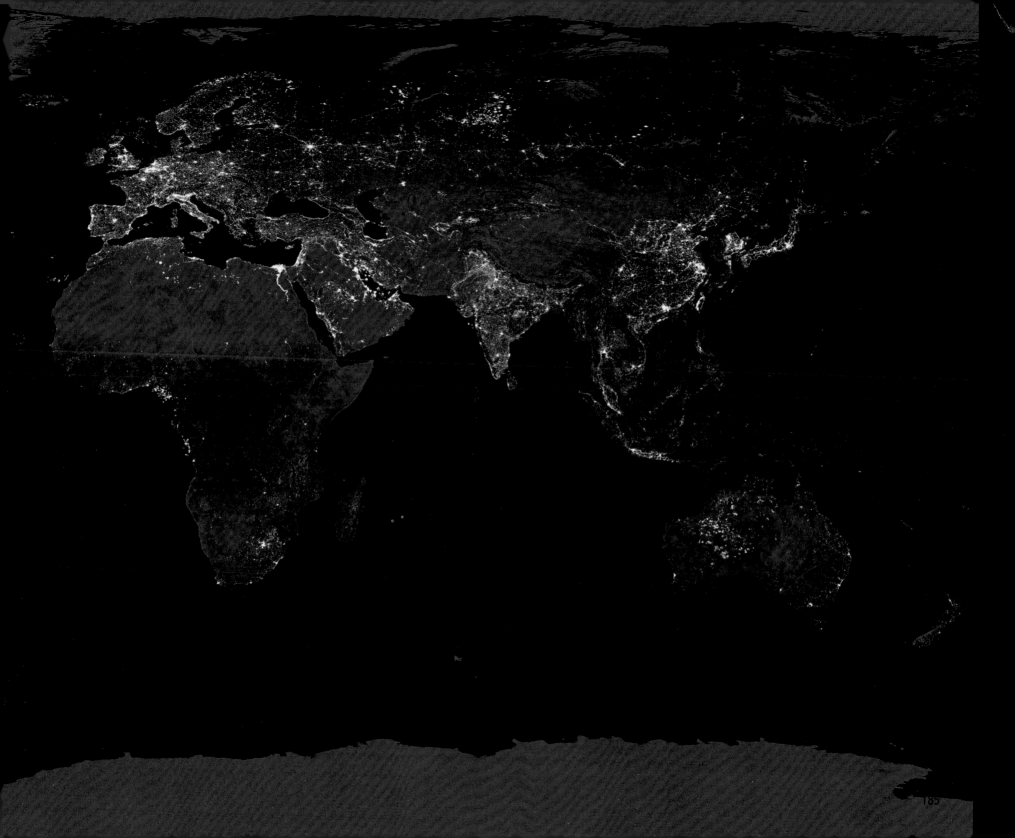

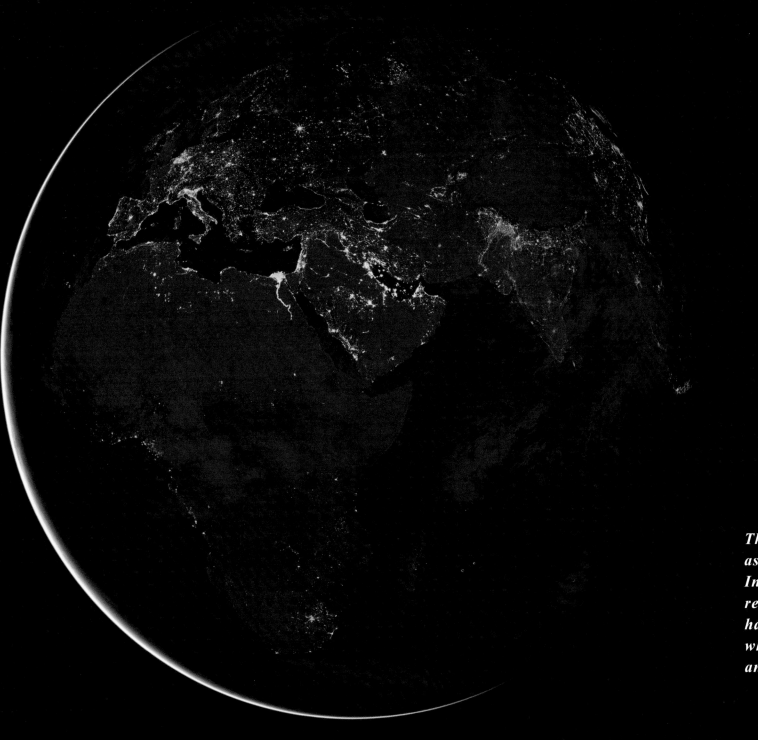

The night is nowhere near as dark as most of us think. In fact, the Earth is never really dark. And we don't have to be in the dark about what is happening at night anymore either.

Steven Miller
atmospheric scientist
Colorado State University

Moonlight and starlight reflect off the water, snow, clouds, and deserts. Even the air and ocean sometimes glow. In other places, fishing boats, gas flares, lightning, oil drilling, and mining operations can show up as points of light.

The number of rural lights is also a function of composite imaging. Fires and other lighting could have been detected on any one day and integrated into the composite picture even though they were temporary. That seems to be the case in central and western Australia (global view on previous page), where many lights appear in this map. Different areas burned with wildfire at different times that the satellite passed over, giving the impression (in the composite view) that the entire area was lit up at once.

The night side of Earth twinkles with light. The first thing to stand out is the cities. "Nothing tells us more about the spread of humans across the Earth than city lights," asserts Chris Elvidge, a NOAA scientist who has studied them for 20 years.

This image of Europe, Africa, and the Middle East at night is a composite assembled from data acquired by the Suomi NPP satellite in April and October 2012.

Michon Scott, Sciences and Exploration Directorate, NASA

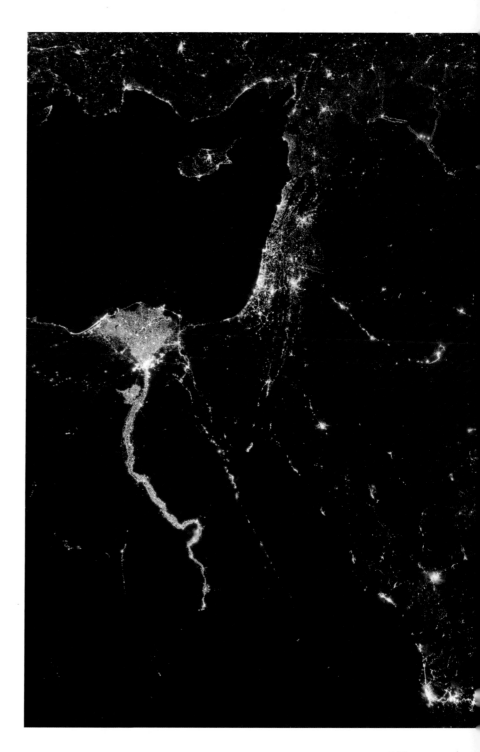

Cairo and the Suez Canal—October 13, 2012
The Nile River Valley and Delta comprise less than five percent of Egypt's land area, but provide a home to roughly 97 percent of the country's population. Nothing makes the location of human population clearer than the lights illuminating the valley and delta at night. Can you find this area on the global view at left?
Earth Observatory image by Jesse Allen and Robert Simmon. NASA (nile_vir_2012287_geo)

Europe, the Middle East, Africa, India and a portion of China—December 12, 2012
The vast empty areas of Africa including the Sahara, Congo River Basin, Great Rift Valley and the Kalahari are strikingly evident for their almost complete absence of light.
Earth Observatory image by Jesse Allen and Robert Simmon
NASA (city_lights_africa_night)

It's not just one thing!
There's beautiful imagery.
There's poetry in what's happening.
There's purpose in what's happening.
There's hope in it.

Chris Hadfield, Canada
Atlantis STS/74, November 1995
Endeavor, STS 100, April 2001
Soyuz ISS 34/35, December 2012
(Interview on CTV's Canada AM)

"Morning has broken, sunlit from Heaven,
a view to put the mind at ease."
Chris Hadfield photo,
© Government of Canada/NASA
(May 5, 2013 – iss035-e-039907)
Location: southwest of Indonesia.

SOME CITIES WHERE MILLIONS OF US LIVE

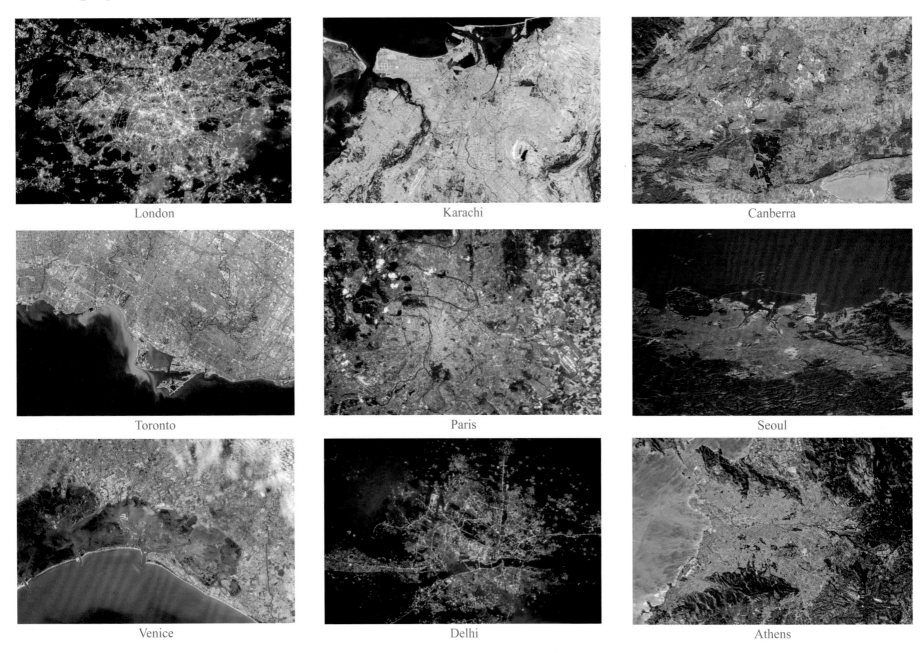

London

Karachi

Canberra

Toronto

Paris

Seoul

Venice

Delhi

Athens

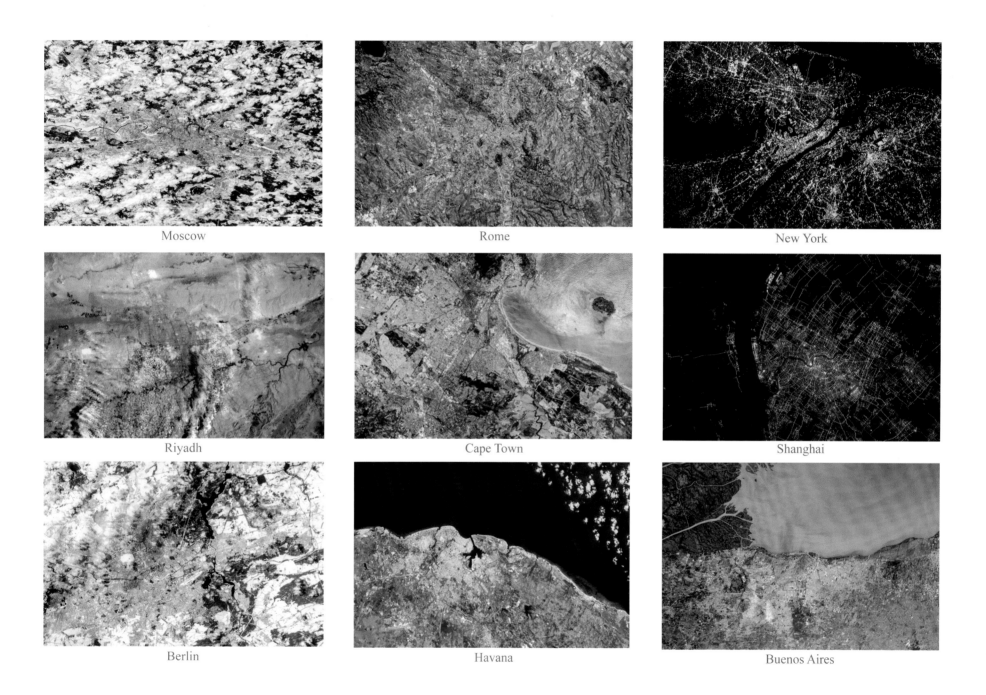

Moscow

Rome

New York

Riyadh

Cape Town

Shanghai

Berlin

Havana

Buenos Aires

Suggested Reading

Friedl, Lawrence *Earth As Art*, (NASA eBook 2012) Free PDF download: www.nasa.gov/connect/ebooks/earth_art_detail.html*
Hadfield, Chris *An Astronaut's Guide to Life on Earth* (Random House, October 2013)
Kelly, Kevin *The Home Planet* (Association of Space Explorers, 1988) www.space-explorers.org (used – on Amazon only)
Lunau, Kate *Good Morning Earth, Chris Hadfield* (a Maclean's magazine eBook, 2013) $2.99: rogerspublishingestore.com*
 *Valid when this book went to press

Special Interest

As Commander of the International Space Station, Chris Hadfield captivated the world with stunning photos and commentary from space. Now, in his first book, Chris offers readers extraordinary stories from his life as an astronaut, and shows how to make the impossible a reality.

Chris Hadfield decided to become an astronaut after watching the Apollo moon landing with his family on Stag Island, Ontario. He was nine years old, and it was impossible for Canadians to become astronauts. In 2013, he served as Commander of the International Space Station (ISS) orbiting the Earth during a five-month mission. Fulfilling this lifelong dream required intense focus, natural ability and a singular commitment to "thinking like an astronaut." In *An Astronaut's Guide to Life on Earth*, Chris gives us a rare insider's perspective on just what that kind of thinking involves, and how earthbound humans can use it to achieve success and happiness in their lives.

Astronaut training turns popular wisdom about how to be successful on its head. Instead of visualizing victory, astronauts prepare for the worst; always sweat the small stuff; and do care what others think. Chris shows how this unique education comes into play with dramatic anecdotes about going blind during a spacewalk, getting rid of a live snake while piloting a plane, and docking with space station *Mir* when laser tracking systems fail at the critical moment. Along the way, he shares exhilarating experiences and challenges from his 144 days on the International Space Station, and provides an unforgettable answer to his most-asked question: What's it really like in outer space?

Written with humour, humility and a profound optimism for the future of space exploration, *An Astronaut's Guide to Life on Earth* offers readers not just the inspiring story of one man's journey to the ISS but the opportunity to step into his space-boots and think like an astronaut—and renew their commitment to pursuing their own dreams, big or small.